ART × FASHION

ART × FASHION

Nancy Hall-Duncan
Fashion Inspired by Art

*Rizzoli*Electa

TABLE

OF
CONTENTS

PREFACE

BY
VALERIE
STEELE

Many years ago, I organized a symposium on fashion and art. I began with this general question: What is the relationship between fashion and art? Throughout much of world history, no distinction was made between the fine and applied arts: a woven textile was just as surely art as a painting or statue. But ever since the Renaissance, when European painters and sculptors asserted their difference from artisans, the Western philosophical tradition has tended to frame fashion as art's superficial, ephemeral other. Even societies such as that in France, which regarded fashion as a cherished art, usually perceived dress as a decorative art, not as one of the fine arts. By the early twentieth century, however, the "artification" of fashion had begun, especially in France, where haute couture played an important role in the luxury sector. Couturiers such as Charles Frederick Worth and Paul Poiret argued that they were artists, not mere dressmakers.

Meanwhile, traditional Western definitions of art were radically destabilized when artists created works that seemed to erase the difference between art and life. Marcel Duchamp placed vernacular objects, such as a urinal or a snow shovel, into galleries, and claimed that they were works of art. Andy Warhol was even more controversial. His notorious Brillo boxes were constructed in his studio, but they looked like something you would find at the supermarket. Later conceptual and performance artists often dispensed with the object altogether. It was enough for an artist to say that something was art, and for an informed body of art professionals and collectors to agree, for the magic transformation to take place.

If anything *could* be art, why not fashion? After all, many people argued, haute couture garments certainly qualified as beautiful, and they were often technical masterpieces. Unfortunately, these were no longer the criteria by which the experts judged something to be art. It was also problematic that many of the most acclaimed fashion creators, from Chanel to Rei Kawakubo, flatly denied that they were artists. Of course, some fashion designers, such as Yves Saint Laurent, did consider themselves artists, but this was contested within the wider society. Saint Laurent's 1983 retrospective at the Costume Institute marked the first time that a living fashion designer had been so honored at the Metropolitan Museum of Art—and the press response was so negative that decades passed before the Met presented another exhibition devoted to a single living designer. But the public was delighted to see fashion in this new context.

The growing popularity of fashion exhibitions in art museums contributed greatly to the discourse on fashion's status vis-à-vis art. Every time that a Balenciaga gown or a Comme des Garçons ensemble is displayed as an aesthetic object in an art museum, the artification of fashion advances a little

further. It is not simply fashion's presence in a museum that is important, but also that the display of fashion in museums has intensified the conversation around art and fashion. In 1996, the Biennale di Firenze organized the pioneering exhibition *Art/Fashion*, which traveled the following year to New York. Since then, many writers and curators have explored the art/fashion nexus, with the result that a growing number of influential people have come to believe that fashion is Art—with a capital A.

Today, everyone interested in the complicated and ambiguous love-hate relationship between fashion and art will want to read *Art × Fashion* and gaze at its wealth of images. The author, Nancy Hall-Duncan, is an art historian who has published extensively on art, photography, and fashion. Just as fashion has long been dismissed as art's superficial, commercial other, so was photography once dismissed as the mechanical shadow of inspired art. Fashion photography, in particular, was looked down on as commercial. In her book *The History of Fashion Photography*, Hall-Duncan showed how fashion photography eventually attained recognition as art. In this book, *Art × Fashion*, she makes a similar case for fashion itself.

Like your favorite art history professor, she pairs examples of art from all eras (ancient Egypt, Ming Dynasty China, fin-de-siècle Vienna, twentieth-century New York) with related images of modern fashion. Who can forget when Yves Saint Laurent was inspired to create his Mondrian dresses? Or when John Galliano's collections for Christian Dior drew on sources as diverse as the gold death mask of the Egyptian pharaoh Tutankhamun and Gustav Klimt's *Portrait of Adele Bloch-Bauer* (*The Lady in Gold*). The contemporary Chinese couturier Guo Pei was similarly inspired by Ming dynasty blue-and-white vases.

The exhibition *Art/Fashion* began with Futurist reconstruction of fashion—a subject that Hall-Duncan also addresses when she investigates what happens when artists create in the realm of fashion. Futurist artists not only painted pictures, but also responded to Giacomo Balla's "Futurist Manifesto of Men's Clothing" by creating violently colored Futurist men's vests. Sonia Delaunay also worked both in both painting and fashion. Salvador Dalí's notorious collaborations with Elsa Schiaparelli, such as the lobster dress, are also highlighted. More recently, Gianni Versace was inspired by Warhol's Marilyns to create an evening gown adorned with Hollywood idols. Not only is fashion central to Cindy Sherman's photographs, but a number of them were specifically created as fashion advertisements.

Hall-Duncan has also surveyed the role artists have played in designing accessories. Niki de Saint Phalle, for example, turned many of her sculptural themes into jewelry. Luxury houses such as Louis Vuitton, which rely heavily on sales of accessories, have hired well-known artists to create special editions of popular handbag styles. In 2003, Marc Jacobs invited Takashi Murakami to put some of his cute characters, like panda, on Louis Vuitton handbags. Jeff Koons took the idea a step further when he put images of other artists' famous paintings, such as Fragonard's *Girl with a Dog*, on handbags. Much as I love these handbags as fashion, I can't help doubting that we will end up thinking of them as art. But maybe that's not the best way to frame the question. Perhaps the art-fashion binary is too simplistic.

In the past, art was conceived in terms of Old Master paintings and classical music. Over time, photography, film, and jazz were gradually accepted as art. Fashion seems to be in the process of being redefined as art, but I believe that the categorization is not entirely accepted. Moreover, I doubt whether all items of fashionable dress will ever be accepted as art. However, if artists, art professionals, and connoisseurs, as well as key fashion insiders, collectively decide that at least some fashion will be accorded the status of art, then it will happen. This book gives us precious material to help us make up our minds.

INTRODUCTION

BY
NANCY
HALL-DUNCAN

VIRTUALLY EVERY TYPE OF ART FROM EVERY PERIOD AND SCHOOL—EGYPTIAN, GREEK, BYZANTINE, MEDIEVAL, RENAISSANCE, BAROQUE, IMPRESSIONIST, AND ALL MANNER OF MODERN AND CONTEMPORARY ART, AS WELL AS CHINESE, JAPANESE, AND KOREAN PAINTING—HAS SERVED AS INSPIRATION FOR FASHION.

Painting has not been the only medium to influence and excite the fashion world; sculpture, mosaics, Japanese screens and masks, stained glass, and ceramics have all played a role in the creative mix. Occasionally, the tables have been turned and fashion has influenced art, as when Coco Chanel's swimsuits spurred Picasso to create his 1918 painting *Bathers*, now in the Picasso Museum in Paris (see page 68).

Art has woven its way into fashion in myriad ways. Sometimes, an artwork is recreated directly in the form of fashion, as when Keith Haring's trademark "radiant baby" was transcribed onto the front of a Jean-Charles de Castelbajac dress. More often, art has been a launchpad for a fashion designer's interpretation, as in John Galliano's take on Egyptian art for his Spring 2004 couture collection.

By the early decades of the twentieth century, many fashion designers—albeit not all—considered themselves artists, but that has not always been the case. In the hierarchical system in place at the start of the nineteenth century, art represented classical ideals and high cultural production, whereas fashion was considered ephemeral and frivolous, lacking the higher values of truth and beauty. Art, the exalted discipline, conferred upper-class status.

The shift that followed later in the nineteenth century and firmly took hold by the twentieth was largely set in motion by Charles Frederick Worth. Worth was the father of Parisian haute couture and a celebrated designer in the latter half of the nineteenth century. He fancied himself a genius artist and may have been the first designer to label himself as such. He strategically referenced art of the past, drawing on works of the Renaissance and Rembrandt and other Old Masters. In doing so, Worth elevated not just his own garments, but the very idea of fashion itself. He insisted that, like a painter or sculptor, he needed to be inspired to create a dress, and he was the first to affix a label that in effect signed and thus authenticated a dress, as if it were a valuable artwork. (The authentication of fashion has been inverted in our time with designer names and logos affixed to the *outside* of clothing and accessories

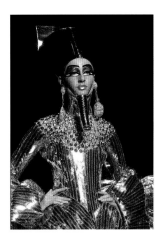

John Galliano for Christian Dior, Spring/Summer 2004 Haute Couture. **See page 20.**

instead of appearing on a label discreetly tucked inside and seen only by the wearer.) In Worth's wake, fashion evolved in public perception from mere craft—and moneymaking effort—to high art. In a bid to encourage the art world's cachet and air of exclusivity to rub off on fashion, designers increasingly began to interact and collaborate with art and artists.

In another link between the two spheres, many fashion designers—Yves Saint Laurent and Tom Ford among them—were and are avid art collectors. Saint Laurent drew inspiration for his collections from painters, including Tom Wesselmann, Georges Braque, Vincent Van Gogh, and, most famously, Piet Mondrian. Closer to our own time, artists such as Andy Warhol and René Magritte created memorable fashion illustrations, and blue-chip artists such as Cindy Sherman and Jeff Koons created eye-catching fashion advertising and marketing. Perhaps the most unlikely art-fashion collaboration of modern times was the 1965 design for a Jacques Kaplan fur coat by one of the most acclaimed sculptors of the twentieth century, Frank Stella.

Of course, calling a fashion designer an artist begs the question of who decides, but many designers have decided for themselves. Worth clearly saw himself as an artist, as did the Parisian couturier Paul Poiret, who in his 1931 memoir *King of Fashion* wrote, "Am I a fool when I dream of putting art into my dresses, a fool when I say dressmaking is an art? For I have always loved painters, and felt on an equal footing with them. It seems to me that we practice the same craft, and that they are my fellow workers." Yves Saint Laurent maintained a public image as a fragile, tortured artist of clothing, while Viktor Horsting and Rolf Snoeren (of label Viktor & Rolf) are self-described "fashion artists." The iconic fashion photographer Irving Penn concurred: "It has been helpful, in orientation, to think of myself, a contemporary fashion photographer, as stemming directly from painters of fashion through the centuries."

Late fashion designer Alexander McQueen's colleagues often termed him an artist. The head of the Givenchy atelier was quoted by Bee Wilson in a 2015 *Guardian* article as saying that McQueen used "fabrics and embellishments" to create sculptures "that happened to be worn." McQueen referenced painting in a graphic manner in the legendary finale to the show of his Spring/Summer 1999 collection, when model Shalom Harlow stood on the runway and an automatic sprayer created fashion in the moment by spewing paint onto the white cotton muslin dress she wore.

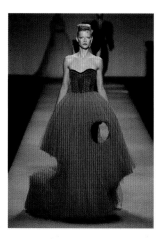

Viktor & Rolf, Spring/Summer 2010 Ready-to-Wear.
See page 70.

Naturally, as art changed, fashion followed. At the turn of the twentieth century, traditional forms of art (painting and sculpture) predominated but, as the years passed, there was a shift from art as an elitist and exclusive activity to one linked to popular culture. Midcentury Pop Art was the most potent force causing this change. Suddenly, art was informed by advertising logos, brands, celebrities, and pop culture that appealed not only to the elite but to the masses. Art scholarship changed too. Where it had previously revolved around a European standard, it opened up to Asian, African and African-American, Russian, Scandinavian, and feminist theory and practice. The Internet broke down geographic and cultural boundaries, rendering information, ideas, and visual influences accessible to an exponentially expanded worldwide audience. Simultaneously, manufacturing, distribution, and marketing became global as well. A broadcast media—and later a dense social media network—hungry for content began covering the red carpet before events and awards shows, including the Met Gala, Oscars, Emmys, Grammys, and Country Music Association Awards. This vastly increased the audience for unique and sometimes outrageous fashions—and designers were happy to oblige by providing increasingly outré creations.

One of the leading factors contributing to the acceptance of fashion as an art form was the emergence of the fashion exhibition in museums. In 1983, Diana Vreeland organized an exhibition of the work of designer Yves Saint Laurent, the first museum exhibition of a living designer. Though critical reception of this particular exhibition was mixed, it paved the way for future museum exhibitions of fashion, not previously conceived of as fodder for museums.

The floodgates had opened, and the result was a tsunami of exhibitions devoted to fashion. Designers such as Giorgio Armani, Balenciaga, Elsa Schiaparelli, Jean Paul Gaultier, Charles James, Versace, and Prada became the subjects of major museum exhibitions worldwide. The most notable of these was undoubtedly the 2011 blockbuster *Alexander McQueen: Savage Beauty* at the Metropolitan Museum of Art, which drew rave reviews and record-breaking attendance of more than 660,000. Artists' wardrobes have also been curated and displayed as art. In 2017, sixty-two rare items from Georgia O'Keeffe's closet were the focus of the exhibition *Georgia O'Keeffe: Living Modern* at the Brooklyn Museum, and, in 2013, Miyako Ishiuchi photographed Frida Kahlo's wardrobe. The museum-going public's interest in fashion grew beyond clothing to accessories: Stephen Jones's hats were shown at the Bard Graduate Center in New York, African headwear at the Dallas Museum of Art, Manolo Blahnik shoes at the Design Museum, and Van Cleef & Arpels jewelry at the Smithsonian's Cooper-Hewitt, National Design Museum. Artist-designed jewelry was shown at the Bass Museum in Miami.

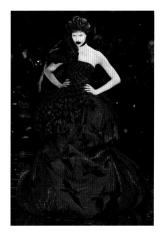

Alexander McQueen, Fall 2009 Ready-to-Wear.
See page 74.

Jean Paul Gaultier, Spring 2003 Ready-to-Wear.
See page 88.

ARTISTS COLLABORATING IN FASHION

Just as fashion designers began to infiltrate the art world, major artists—like John Baldessari and Malick Sidibé—crossed boundaries in the other direction to do advertising and editorial work for *W*, *Vogue*, and *The New York Times*, while Cindy Sherman has produced one of the most eye-catching and important bodies of contemporary fashion advertising to date. Paintings by Gerhard Richter served as imagery for stunning fashion outfits, and sculpture by John Chamberlain inspired fashion designer Mary Katrantzou. Major fashion houses—Gucci, Prada, Stella McCartney—have initiated collaborations with both major established artists and emerging creatives.

Notably, high-end handbag maker Louis Vuitton has partnered with an impressive list of artists: Takashi Murakami, Yayoi Kusama, Richard Prince, Jeff Koons, Daniel Buren, Dinos and Jake Chapman, and 2004 Turner prizewinner Jeremy Deller. For his editioned Louis Vuitton handbag covered with faux insects, artist Damien Hirst worked off of one of the most startling accessories of the twentieth century: a 1938 Elsa Schiaparelli necklace made of a then-new clear plastic called Rhodoid and covered with colored metallic insects that appeared to crawl across the wearer's neck. There have been technologically derived handbags, like those Nicolas Ghesquière created with video displays recalling Times Square billboards. Dior gave free rein to thirty-eight sculptors and twenty-eight photographers to create an artistic interpretation of its iconic Lady Dior handbag, resulting in an exhibition titled *Lady Dior As Seen By* that kicked off a world tour in Shanghai in 2011.

Handbags are just one category of accessories influenced by art. Hats, shoes, and jewelry are also covered in this book. Jewelry has always walked the fine line between art and fashion, which perhaps explains why an extraordinary number of the twentieth century's greatest artists have dabbled in jewelry. They include Alphonse Mucha, Salvador Dalí, Alexander Calder, Niki de Saint Phalle, Georges Braque, Pablo Picasso, Arman, Louise Nevelson, Jean Arp, and Kenny Scharf. Collaboration between artists and designers in jewelry stretches back even farther than it does in clothing. Already in 1920, Paul Poiret designed a silver cuff in collaboration with Raoul Dufy. Elsa Schiaparelli's jewelry featured cutting-edge interpretations of Surrealist themes: Jean Cocteau's famous eye brooch, lobster pins, and the ruby lips with pearl teeth designed by Salvador Dalí. Today, artist-designed jewelry has gallery representation and even dedicated auctions. In 1973, Joan Sonnabend opened the Sculpture to Wear Gallery in New York, and Didier in London sells artist-designed jewelry. Christie's has conducted auctions of artist-designed jewelry and described artist jewelry for an online sale as designed "to transform their wearer into a walking artwork." Hats have taken the wildest and most creative forms imaginable: guitars,

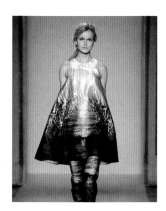

Gabriele Colangelo, Spring 2012 Ready-to-Wear.
See page 94.

Mary Katrantzou, Spring/ Summer 2012 Ready-to-Wear.
See page 130.

hands, shoes, Brillo boxes, swarms of butterflies, and, in one case, a complete sailing ship made to sit atop the head. Stephen Jones and Philip Treacy are two of the premier hat artists who create whimsical, innovative, and fantastical chapeaux that are often more eye-catching than the outfits they accompany. Surrealism influenced hats with two memorable examples: the Hands of Fate hat by Jean Barthet of Paris and Elsa Schiaparelli's famous Shoe Hat, inspired by a photograph of Salvador Dalí wearing a shoe on his head.

From Imelda Marcos to celebrity sneakerheads, shoes are an enduring collectible obsession. Andy Warhol started as an illustrator of shoes, while French photographer Guy Bourdin produced shocking advertisements for Charles Jourdan shoes early in his career in the 1970s. Art/fashion collaborations in footwear abound, from KAWS working with Vans to Kenny Scharf's indoor/outdoor slippers for Dior. And that is barely scratching the surface of this prolific area for artist/designer collaboration.

TAKING IT TO THE STREETS

Street fashion and street art by the likes of KAWS are among the most important cultural developments of the twentieth century, representing a shift in focus from elitist "gilded cage" versions of art and clothing to what "real" people—and often young people—wear and create. Both draw on various niches—from body art to graffiti tags—and play off of each other.

There were many cultural and aesthetic developments early in the twentieth century that led to the development of streetwear. One was the influence of Coco Chanel, whose personal fixation with health, sports, and casual dressing moved fashion in the direction of comfortable beach-inspired clothing in affordable jersey fabric. One could draw a straight line from the relaxed fashions of Chanel to the swimsuits and dresses designed by Ukrainian-born French artist Sonia Delaunay. Delaunay wanted to see fashion made accessible, and she paid heed to real-world needs.

Stephen Jones Peek-a-boo boater, John Galliano for Dior Picasso Collection, Spring/Summer 2001
See page 156.

Numerous others contributed to the burgeoning sportswear trend. American designers, including Claire McCardell, Bonnie Cashin, and Vera Maxwell, developed sundresses, denim wraparound housedresses, pedal pushers and capri pants, one-piece swimsuits and bikinis, Bermuda shorts, pants, knits, and a raft of other elegant, simple clothing that suited leisure activities.

Just as Pop Art marked the democratization of aesthetics and culture, positioning a Campbell's soup can as just as important a subject of art as the Venus de Milo, in fashion sportswear leveled the playing field and

gave weight to the wild diversity and outright defiance of individual styles, such as mod, punk, goth, and hip-hop.

In the 1970s, spray-paint graffiti in New York subways and on city walls began to wield significant influence on art and style. Graffiti was first done by "taggers." Pseudonyms allowed graffiti artists to remain anonymous and avoid arrest for vandalism. By the 1980s, as authorities cracked down on using subway cars as canvases, tagging shifted to the roofs of buildings. What started in defiance of the mainstream commercial art world was eventually assimilated into the world of high-end art. Today, the work of graffiti artists such as Keith Haring, Jean-Michel Basquiat, KAWS, and Banksy sells for millions on the fine art market.

Graffiti art—with its dramatic graphics and striking colors—was a favorite inspiration for fashion. The best-known graffiti artist, Keith Haring, was deeply involved with the fashion world of his day. In 1983, he collaborated with British designer Vivienne Westwood, famed for her punk and new wave fashions. His signature smiling faces appeared on hip-hop inspired jersey clothing in her Fall/Winter 1983 collection. In fall 1988, Haring collaborated with American designer Stephen Sprouse, who in 2001 also teamed up with Marc Jacobs on a sold-out line of graffiti-splattered handbags for Louis Vuitton. Jean-Michel Basquiat was another graffiti artist whose work was and is still favored for fashion. His images have been used by Coach, Off-White, Uniqlo, Supreme, and numerous other brands.

THE IMPORTANCE OF FASHION TODAY

Fashion today is how we dress—how we choose to present ourselves. That may sound simple, but how we dress lies at the very core of twenty-first-century sensibility. It speaks to the issues of our age: sustainability, gender, and racial identity. The way we present ourselves through clothing indicates who we are and how we feel. Each of our selections—think of iconic choices such as a T-shirt or a qipao—gives others a sense of our values, lifestyle, age, and sometimes our politics or religion. Fashion is a potent indicator of our diversity.

In every decade from the beginning of the twentieth century to the present, fashion and art have mirrored social change. In the decade that opens this book, the 1910s, American women's social, political, and economic opportunities broadened dramatically. World War I necessitated women entering the industrial workforce, and the suffrage movement was pushing toward passage of the Nineteenth Amendment guaranteeing women the vote. Women broke out of the tight-laced corsets of Edwardian costume and

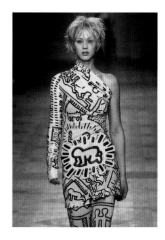

Jean-Charles de Castelbajac, Fall/Winter 2002 Ready-to-Wear. **See page 134.**

Pyer Moss, Spring/Summer 2019 Ready-to-Wear. **See page 140.**

conventional restrictions and rushed headlong toward the social, sexual and fashion freedoms of the Roaring Twenties. Simultaneously, the art world was freeing itself of its own strictures. Surrealism and Cubism were transforming the lens through which the world was viewed. It was inevitable that as both art and fashion threw off the bonds of an earlier era, the border between the two would become more porous, and art and fashion began to intermingle.

The boundary walls between art and fashion continue to tremble and crumble today. Who can say which is which? Other disciplines are also making their way into the equation. The work of Haitian-American designer Kerby Jean-Raymond, for example, uses the artwork of African-American artist Derrick Adams to incorporate issues of race, activism, debate, and social commentary into fashion. This fashion/art/politics intersection seems destined to expand further as our culture blooms in all directions rather than following a straight line of progression. Wherever dressing goes from here, it seems likely that the richly complex interaction between art and fashion will persist in unexpected and diverse ways. Fashion, its inspirations, and its collaborations will continue to be a subject of fascination and intrigue.

INSPIRAT

ART
INFLUENC

19

ON:

ING

FASHION

DEATH MASK OF TUTANKHAMUN

Created circa 3123 B.C.E., discovered 1925.
Museum of Egypt, Cairo

JOHN GALLIANO
FOR CHRISTIAN DIOR

Spring/Summer 2004 Haute Couture

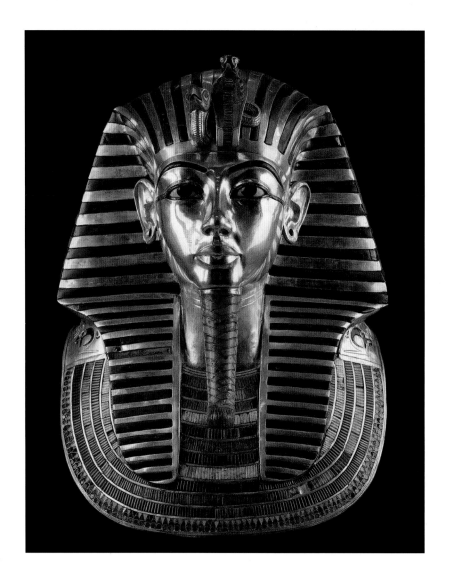

The solid gold death mask of the boy king Tutankhamun—who ascended the Egyptian throne at age nine and died ten years later— was the most dazzling find English archaeologist Howard Carter discovered in Tut's intact tomb in 1922. Egyptomania swept the world, influencing music, art, dance, and fashion. Later in the century, the six-city exhibition *Treasures of Tutankhamun* (1976–79) became, according to David Kamp writing in *Vanity Fair* in 2013, "one of the most all-encompassing cultural phenomena of the second half of the twentieth century."

This gown, the Tutankhamun-inspired opening look in a John Galliano collection for Christian Dior in 2004, featured a gold- and jewel-encrusted breastplate and what Galliano called "the sphinx line: elongated, tight, attenuated." Galliano also explained that he drew on the fashion photographs of Richard Avedon and Irving Penn to inject this and other looks with elegance, so that they would stand as fashion and not merely as costume. Every detail was coordinated: eight embroidery houses were used for the collection and nearly all of the fabrics were painstakingly hand-dyed; make-up artist Pat McGrath created metallic gold lips and gem-encrusted eye makeup, and London milliner Stephen Jones handcrafted the Egyptian headdress and the plaited Egyptian false beard.

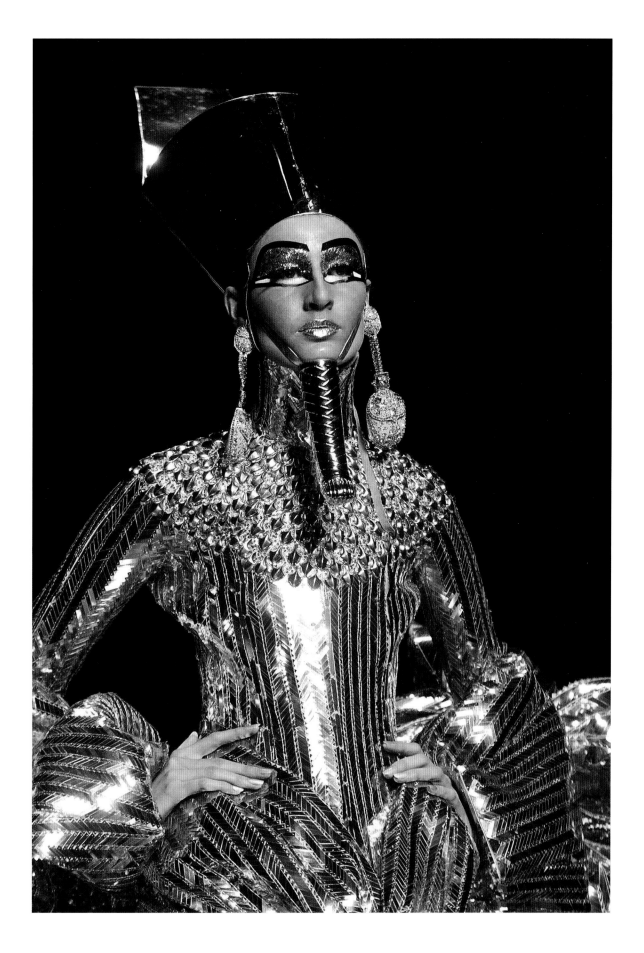

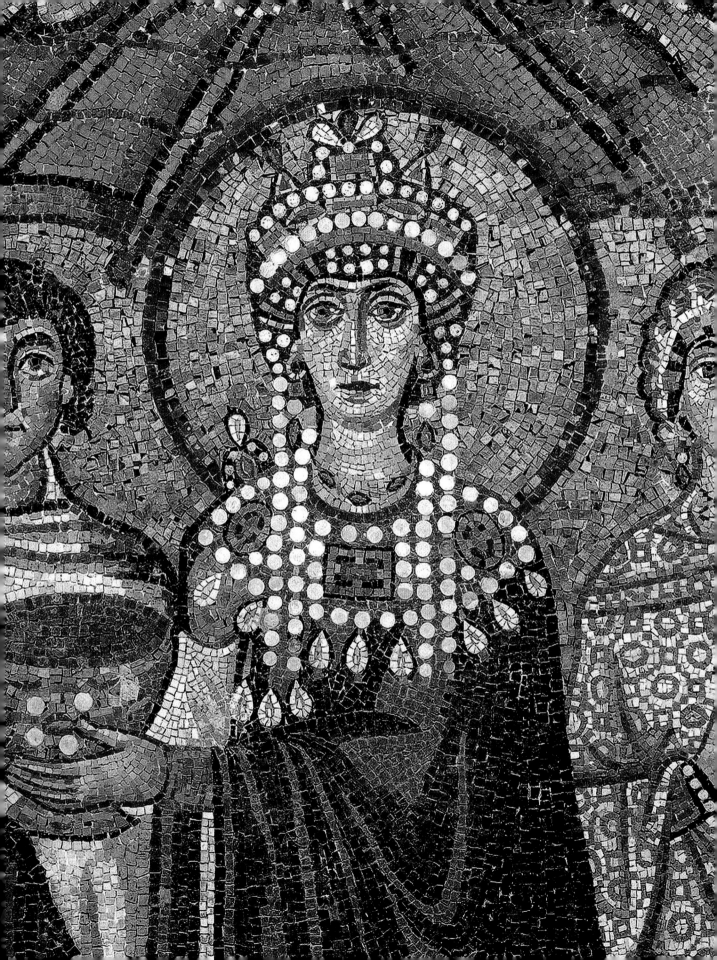

EMPRESS THEODORA

Detail of sixth-century wall mosaic
in the Church of San Vitale, Ravenna, Italy

KARL LAGERFELD
FOR CHANEL

Pre-Fall 2010

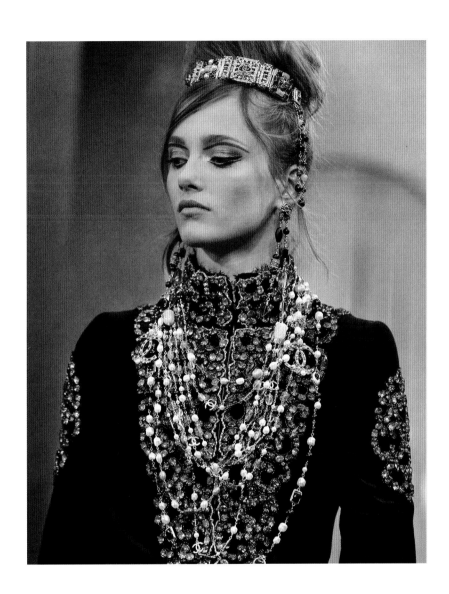

The sixth-century Basilica of San Vitale in Ravenna, Italy, with its mosaic decoration, is an important surviving example of early Christian Byzantine art and architecture. One notable San Vitale mosaic depicts Empress Theodora, the wife of Emperor Justinian, who wielded considerable political power as one of her husband's chief advisors. This look by Karl Lagerfeld for Chanel's Métiers d'Art collection is a modern fashion interpretation of that mosaic.

For this ready-to-wear collection, Lagerfeld employed couture techniques and made extensive use of Parisian haute couture ateliers, tapping over two dozen businesses specializing in various métiers d'art, from lacemaking to jewelry design. The inspiration for Lagerfeld's Paris-Byzantium theme was Coco Chanel's collection of Byzantine jewelry and the Basilica of San Vitale.

After Lagerfeld finished his sketches, a preliminary muslin of the outfit was made to define the structure of the garment. Once the velvet and cashmere coat was created, the venerated Paris embroidery studio Lesage beaded the coat by creating a color-coded diagram showing where each bead was to be placed. A team of seamstresses then spent 312 hours stitching the beads together and meticulously applying them to the garment. Finally, a jeweler at the atelier Desrues, renowned for its Chanel buttons, applied enamel to the handcrafted headpiece.

LARGE DRAGON JAR

Ming dynasty, 1426–1435

GUO PEI

Fall/Winter 2010

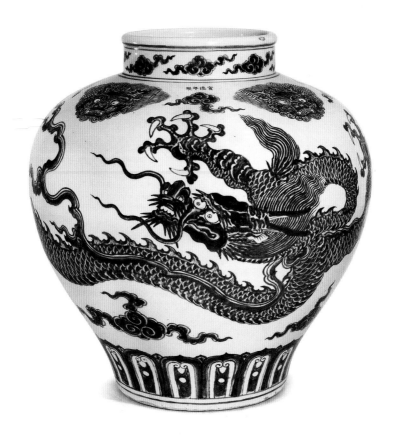

Chinese blue-and-white porcelain became popular in the first half of the fourteenth century, when Asian trade routes opened, and the blue mineral cobalt oxide began to be exported from Persia. This vase dates from the fifteenth century and features rich blue coloration and motifs, including a five-clawed dragon amid swirling clouds and a lappet border grounding the celestial scene to the earth.

This hand-embroidered dress, known as the Ming vase gown, is by Chinese designer Guo Pei. In 2015, Pei was the first designer born and raised in Asia to be invited to become a guest member of the then-147-year-old Chambre Syndicale de la Haute Couture in Paris, the governing body of the high-fashion industry. Pei rose to international prominence that year when her work was chosen for the Metropolitan Museum exhibition *China: Through the Looking Glass*,

and Rihanna stepped onto the Met Gala red carpet wearing her canary yellow silk cape weighing fifty-five pounds.

The gown uses traditional Chinese porcelain colors and designs—lotus blossoms, meander (linked squares or spirals), clouds, mountains, and waves. These patterns were first hand-painted on silk-satin, then embroidered and embellished with thousands of Swarovski crystals by Pei's team of 500 artisans.

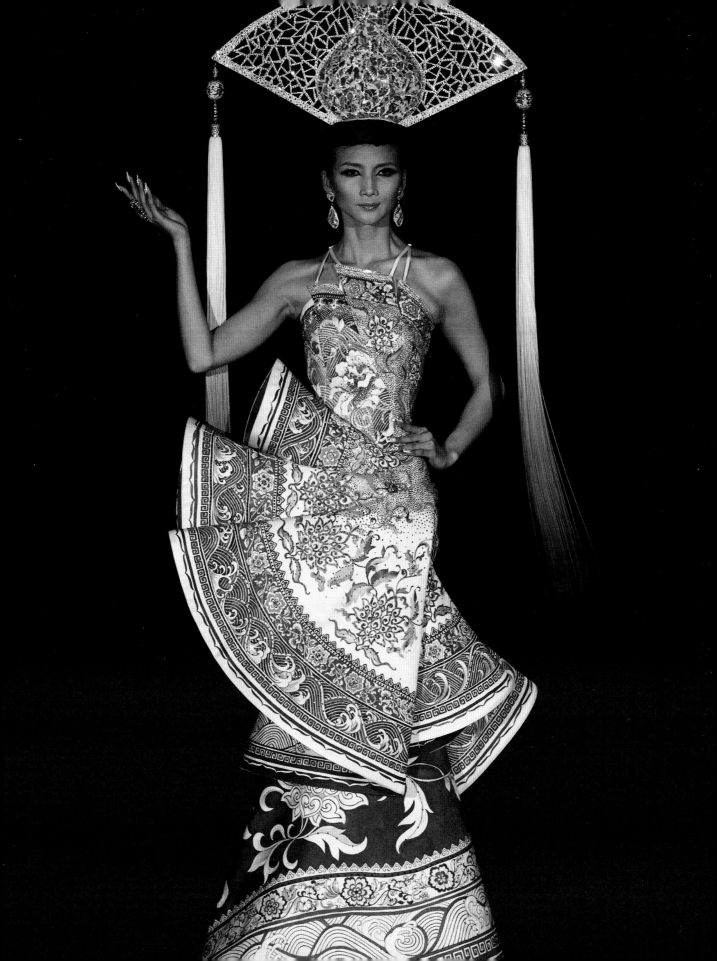

JAPANESE DEMON MASK

Red lacquered mask from
the Momoyama period, 1590

KANSAI YAMAMOTO

Marie Helvin photographed by Clive
Arrowsmith *Vogue UK*, October 1971

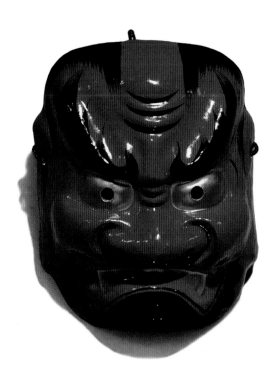

Kansai Yamamoto, renowned for fusing his country's traditional aesthetic with modern fashion, was profoundly influenced by Japanese art. Kansai—who used his first name professionally—is considered the father of *basara*, a Japanese concept associated with excess, love of color, and flamboyance. He opened his first boutique in Tokyo in 1968; three years later, in 1971, his collections debuted in the United States. In the same year, he was the first Japanese designer to show in London, and that October his work was featured in British *Vogue*, where this photograph was published. Later, he debuted in Paris in 1975.

The red-and-white face seen here on both the voluminous kimono-like garment and the hand-knit jumpsuit meant to be worn under it were influenced by Japanese masks and kabuto (helmets) of the Momoyama period (1573–1600). The face derives from Japanese demon masks. The helmets worn by wealthy samurai during the Momoyama period were another influence; these were created so individuals wearing them could be easily identified on crowded battlefields.

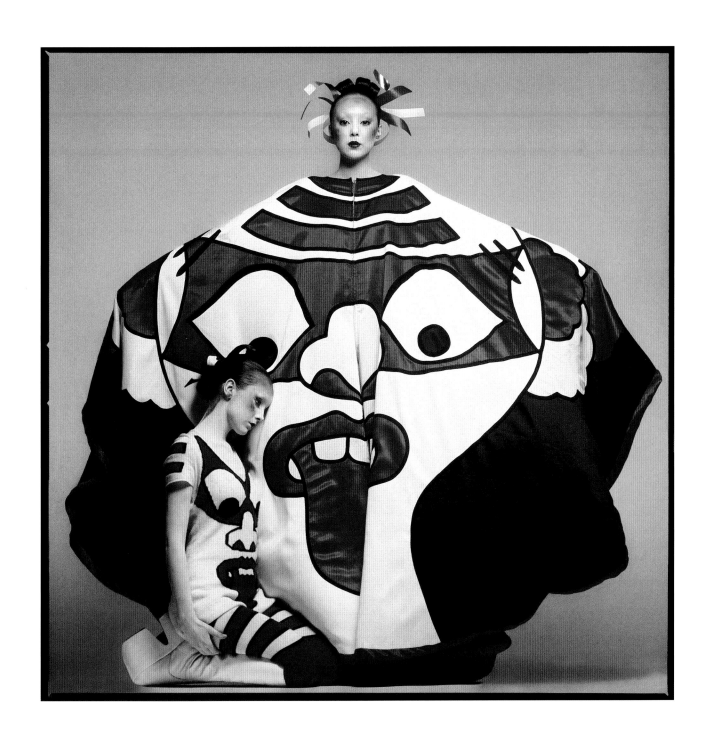

QUEEN ELIZABETH OF ENGLAND

Unidentified artist, circa 1592.
Palazzo Pitti, Florence

SARAH BURTON

FOR ALEXANDER MCQUEEN

Fall/Winter 2013
Ready-to-Wear

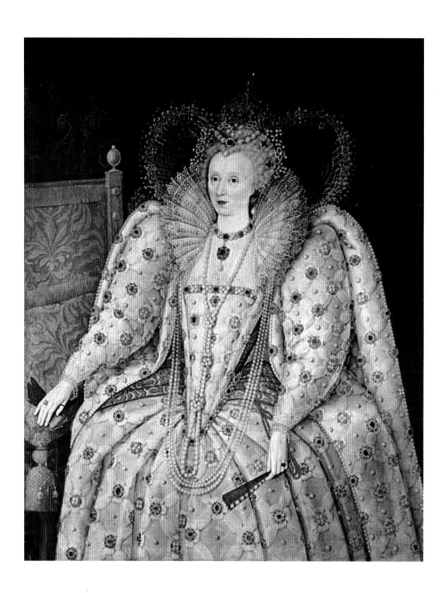

The Ditchley Portrait of Queen Elizabeth I was painted by Flemish artist Marcus Gheeraerts (circa 1561–1636), the most fashionable portraitist of the 1590s. It was commissioned by Sir Henry Lee, the Queen's Champion for more than thirty years, who had fallen into disfavor with the queen after his retirement in 1590. Two years later, the queen visited Lee's grounds in Ditchley, Oxfordshire, and sat for her portrait.

This painting is one of numerous *Ditchley Portrait* variants, many of which softened the face of the aging queen. The queen's face was scarred from smallpox she had contracted in 1562. As camouflage, she wore a mixture of white lead and vinegar called Venetian ceruse and bright red lipstick made of gum arabic, egg whites, fig sap, and cochineal, an expensive dye of crushed dried beetles native to Mexico considered magical and

healing. In this portrait, the jewels, silks, and lace, as well as the sheer volume of her outfit, communicate royal power.

Sarah Burton's inspiration from the portrait of Queen Elizabeth I featured many of the details of the Virgin Queen's outfit: a white gown with gold-lattice-embroidered embellishment, a frothy lace ruff, and a bodice crafted with gold filigree and a profusion of pearls.

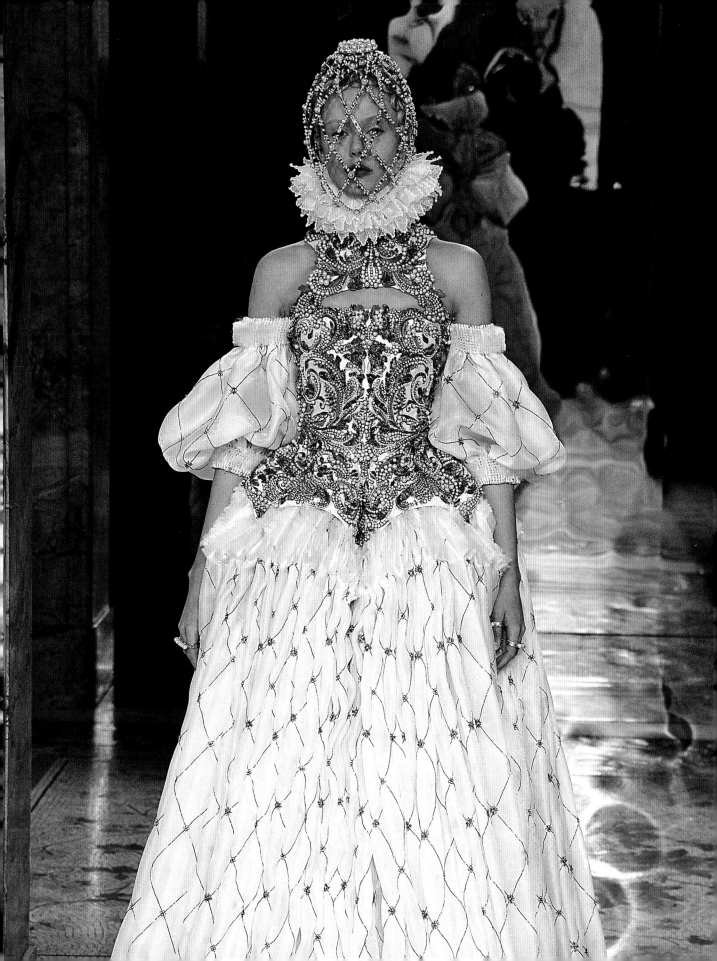

FOURTEENTH-CENTURY STAINED GLASS

All Saints Church, Fourteenth-century stained glass of the Nativity, York, UK

JEAN PAUL GAULTIER

Spring 2007
Haute Couture

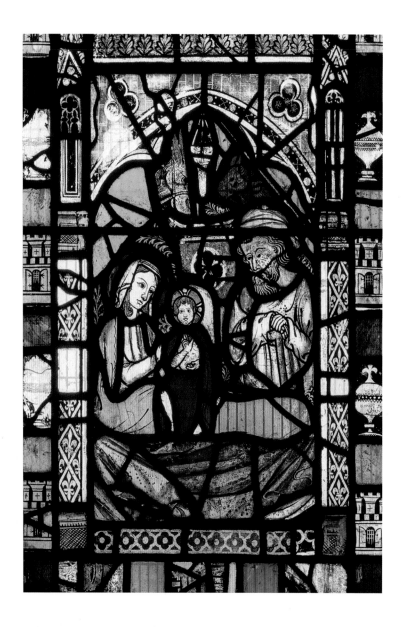

Jean Paul Gaultier's 2007 couture collection tackled the relationship between religious art and fashion. Stained glass, whose history dates back more than 1,000 years, was a major form of pictorial art in the medieval period and Renaissance. Glorious stained-glass cycles were created for cathedrals, including Notre-Dame and Sainte-Chapelle in Paris and cathedrals in Chartres, Reims, and Rouen, and mosques such as Nasir-ol-Molk in Shiraz, Iran.

The fabric of Gaultier's gown mimics stained glass, which is made from many individual pieces of glass slotted into a framework of lead cames (the channels that hold the individual pieces of glass together). The fabric depicts the Baby Jesus pressed against the side of Gaultier's model, representing the Virgin Mary. This model wears a black halo and headdress and cries glass tears, transforming her into a weeping saint. However, Gaultier's outfit failed to capture the glowing light and color that were the glories of medieval stained glass.

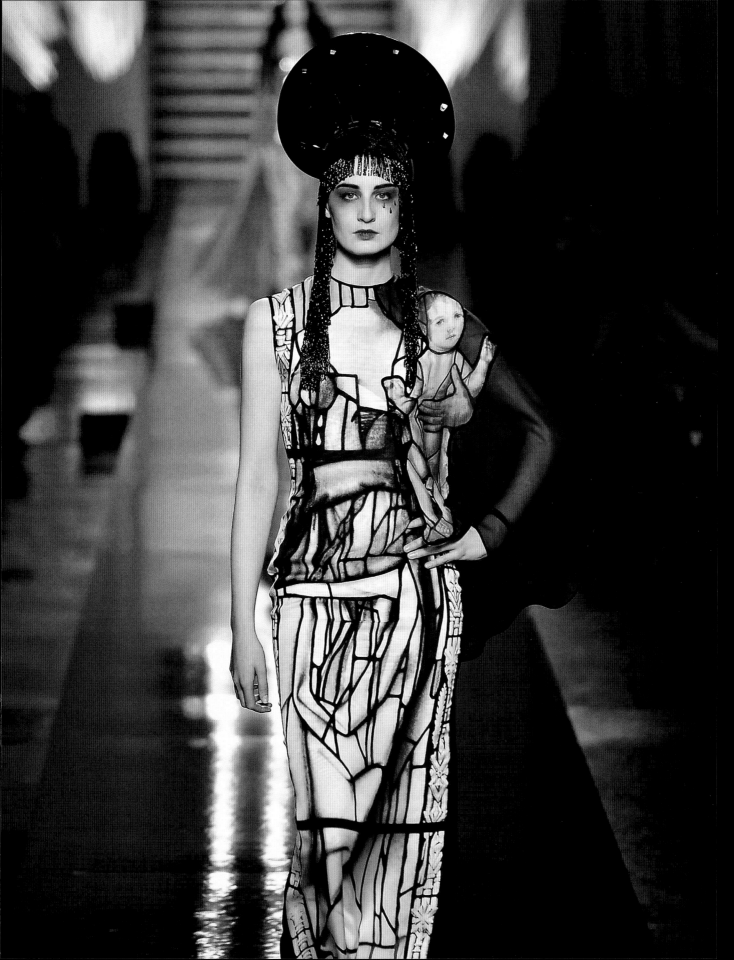

GIUSEPPE ARCIMBOLDO

Rudolf II of Habsburg as Vertumnus, 1590.
Skokloster Castle, Habo, Sweden

JOHN GALLIANO

FOR MAISON MARTIN MARGIELA

Spring 2015 Couture

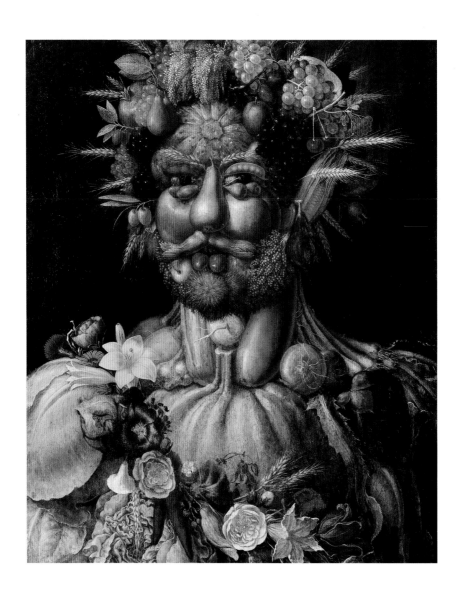

Giuseppe Arcimboldo (1527–1593) crafted a portrait of Holy Roman Emperor Rudolf II that depicts him as Vertumnus, the Roman god of growth and the change of seasons. Though today it looks whimsical, even silly, at the time, according to Arcimboldo expert Thomas DaCosta Kaufmann, it symbolized "the majesty of the ruler, the copiousness of creation, and the power of the ruling family over everything."

John Galliano's couture dress for Maison Margiela draws on Arcimboldo's portraiture technique. This dress is part of a collection using found elements, including toy cars and shells. Like Arcimboldo, Galliano rethinks those materials and combines them to create something that is much more than the sum of its parts.

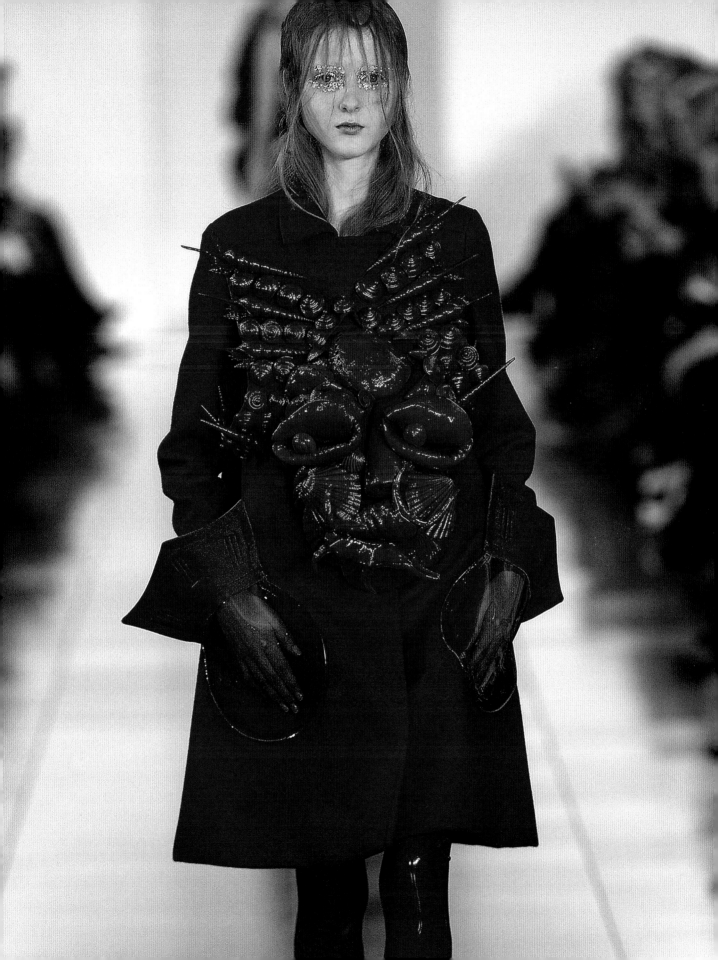

DIEGO VELÁZQUEZ

Mariana of Austria, 1652–1653.
Museo del Prado, Madrid, Spain

GUO PEI

Spring/Summer 2014

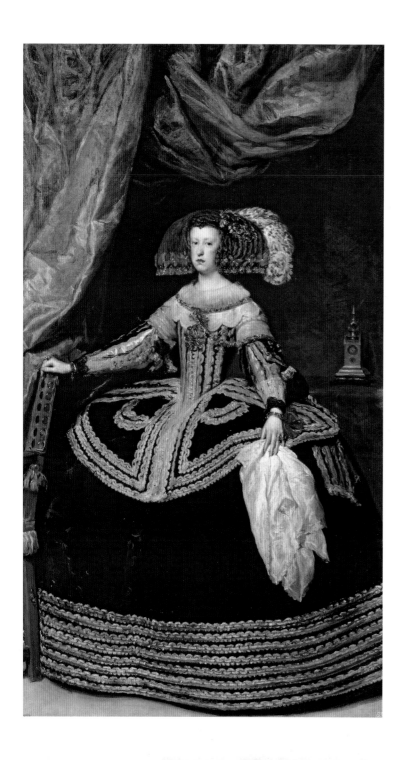

Diego Velázquez (1599–1660), the most important painter of the Spanish Golden Age, executed numerous portraits of the Spanish royal family. Among these was one of the wife of Spain's King Philip IV, Mariana of Austria, wearing a *guardainfante*, a type of framework worn under clothing to support an enormous skirt. This garment reached peak popularity during the reign of Queen Mariana (which lasted from 1649 to 1665), when its physical size served as a symbol of Spain's power.

The Spanish court valued the *guardainfante* for its theatrical presentation and because it effectively showcased the exquisite and costly fabrics of court costume. But the *guardainfante* did restrict women's movement: its rigid structure and size—up to 7 feet wide—made sitting, walking, and passing directly through doorways impossible. In 1639, a sumptuary law banned the *guardainfante* for all women except prostitutes, though this dictate was not followed by members of the royal court, and it remained in use there past 1700.

Guo Pei's interpretation of the *guardainfante* reframes the garment's broad front panel as a canvas for hand-stitched embroidery. The panel is banded on either side by ermine fur, a longstanding symbol of European royalty. Pei creates haute couture by fusing inspiration from sources as diverse as Spanish bullfighting jackets, Gothic fairy tales, and Japanese origami with materials and motifs from her Chinese heritage. Allusions to Chinese porcelain, calligraphy, filigree, cloisonné, and imperial grandeur define her unique style.

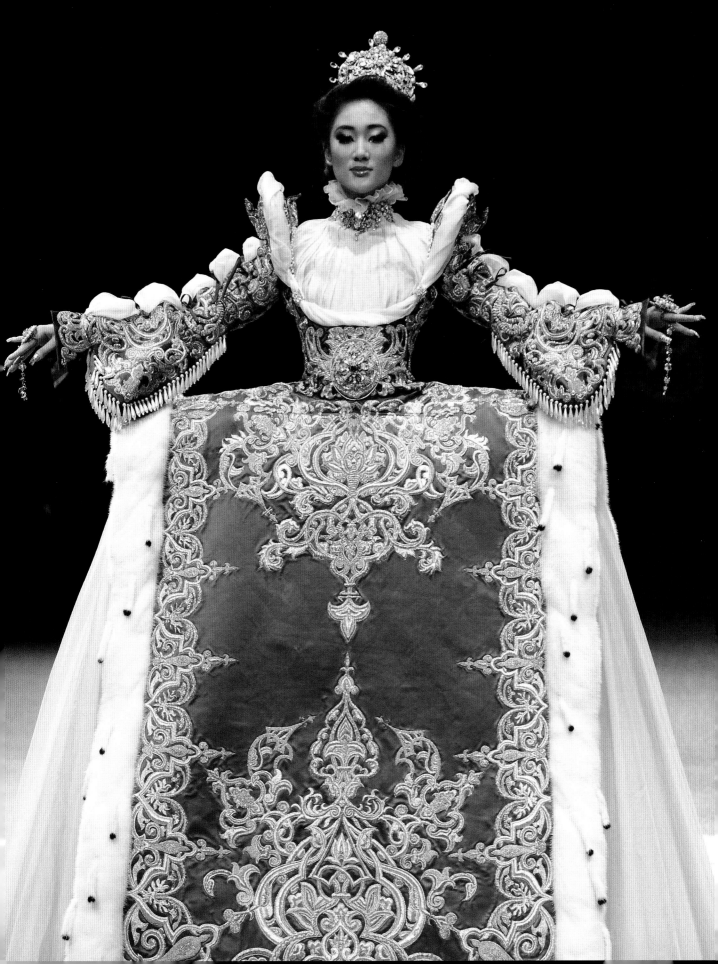

SIR GODFREY KNELLER

Charles Montagu, 1st Earl of Halifax, circa 1690–1695. National Portrait Gallery, London, UK

CHRISTIAN LACROIX

Spring 2009
Haute Couture

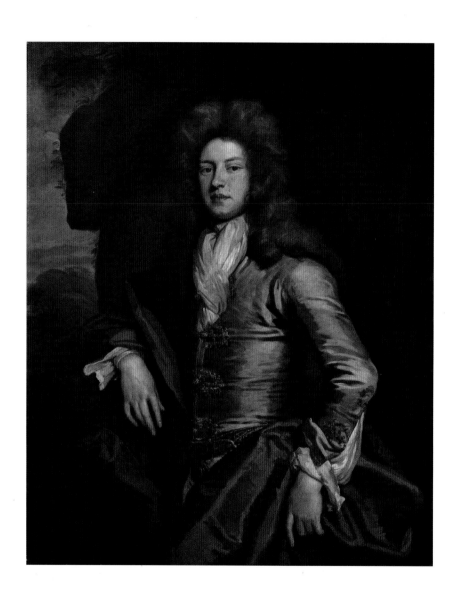

Christian Lacroix is revered as a designer of impressive originality, an innovator who contributed significantly to haute couture. In 1987, historian Anne Hollander called the then-emerging Lacroix "daring like Picasso."

Lacroix's fashion house, which closed in 2009, was known for designs inspired by the seventeenth and eighteenth centuries. This particular look was influenced by both military uniforms and seventeenth-century aristocratic men's clothing, such as that pictured in Sir Godfrey Kneller's circa 1690–1695 portrait of Charles Montagu, First Earl of Halifax. The earl wears a tight-fitting silk jacket with gilt closures over a shirt with a jabot and voluminous sleeves.

Lacroix tailored the women's pantsuit of dove gray silk and modernized the look by pairing the nip-waisted jacket with slouchy trousers, a gilded heart-shaped locket, and enormous glittery earrings.

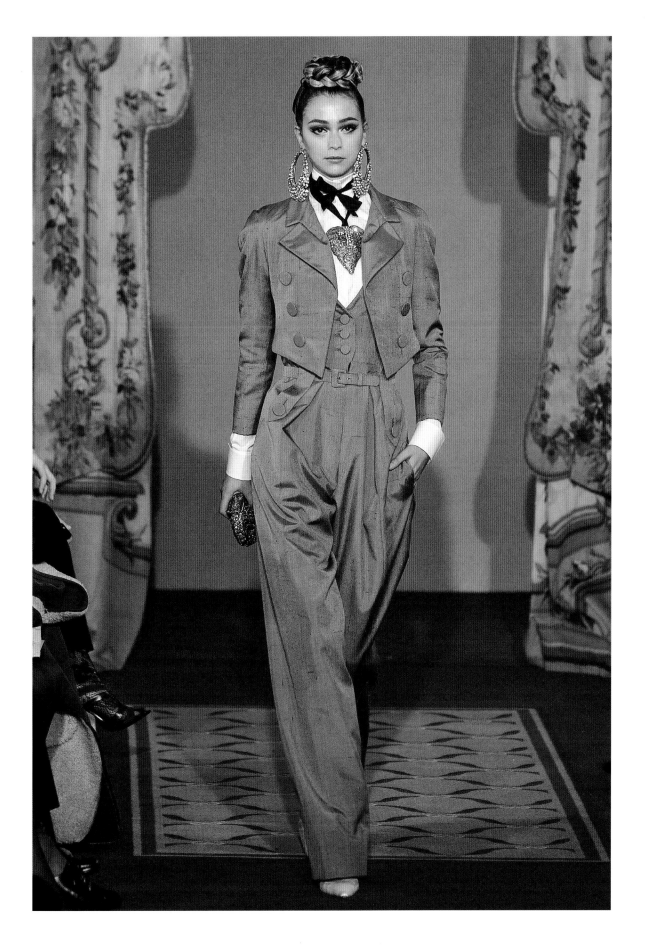

FRANÇOIS BOUCHER

Madame de Pompadour, 1756. Bayerische Staatsgemäldesammlungen–Alte Pinakothek München, Munich, Germany

FRANCESCO VEZZOLI

Nikki Minaj as Madame de Pompadour, *W* magazine's 2011 art issue

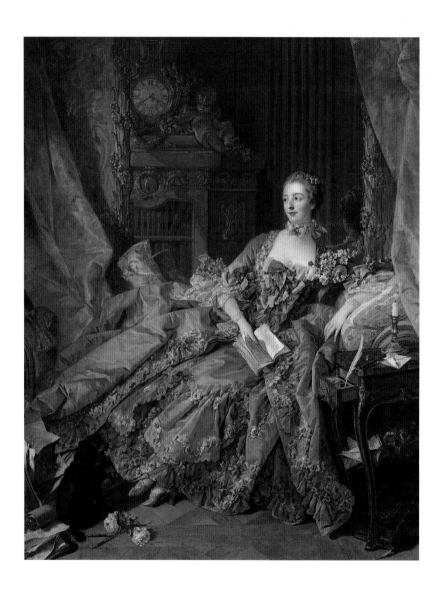

François Boucher's (1703–1770) portrait of Madame de Pompadour from 1756 is the epitome of Rococo style. Madame de Pompadour was the royal mistress of King Louis XV, an important art patron, and a woman of power in the French court. Around 1750, she commissioned a series of portraits of herself on the themes of fidelity and friendship to define her relationship with the king.

This portrait expresses her interests and patronage. Symbols abound: the book signifies her intellectual prowess; the sheet music and architectural drawings her artistic concerns; and the feather quill her patronage of Diderot, Voltaire, and other philosophers of the Age of Enlightenment. Fashion was an important part of this symbolism. Madame de Pompadour is dressed in a silk robe à la française with an explosion of pink silk trim, bows, fabric roses, and sleeve flounces of gathered lace. A ribbon choker encircles her neck, and four strands of pearls adorn each wrist, while flowers decorate her bodice and hair.

The Italian artist Francesco Vezzoli chose Nicki Minaj as his modern Pompadour because, as he explained, "In her performances, Minaj makes very explicit and challenging use of her beauty and her body." Minaj and Madame de Pompadour do, in fact, share much in common: international fame, stunning beauty, and the ability to forge their own identities.

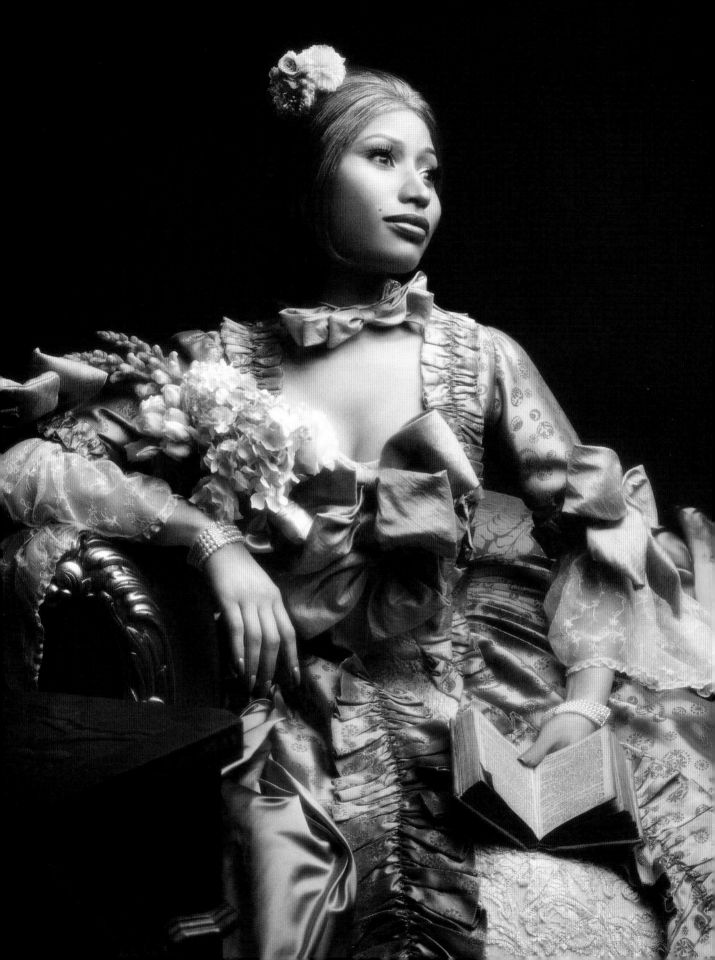

KATSUSHIKA HOKUSAI

Under the Wave Off Kanagawa,
or *The Great Wave*, circa 1830–1832

JOHN GALLIANO
FOR CHRISTIAN DIOR

Spring/Summer 2007
Haute Couture

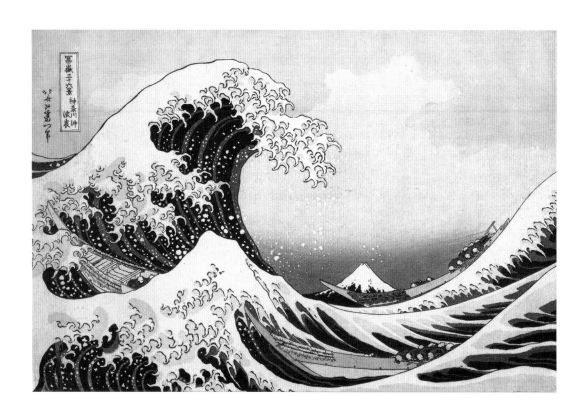

The Great Wave off Kanagawa (1830–1833) is a color woodblock from a series by Katsushika Hokusai (1760–1849) known as *Thirty-Six Views of Mount Fuji*. Mount Fuji is both an active volcano and a sacred mountain, attracting more than 200,000 pilgrimage climbers a year. Hokusai's image shows a wave—calculated to be 32 to 39 feet tall—about to engulf three fishing boats.

The appeal of Hokusai's print is enhanced by its use of a color termed Prussian or Berlin blue, first manufactured by a Guangzhou entrepreneur in the early 1800s. The pigment exploded in popularity in Asia, as it had earlier in Europe, and was used extensively in Hokusai's series, where its range and intense color made it ideal for rendering land and seascapes.

John Galliano's stunning haute couture coat references Japanese art in many ways. It takes on an instantly recognizable meaning through its use of *The Great Wave* and also its application of fabric in the traditional Japanese art form of origami folding.

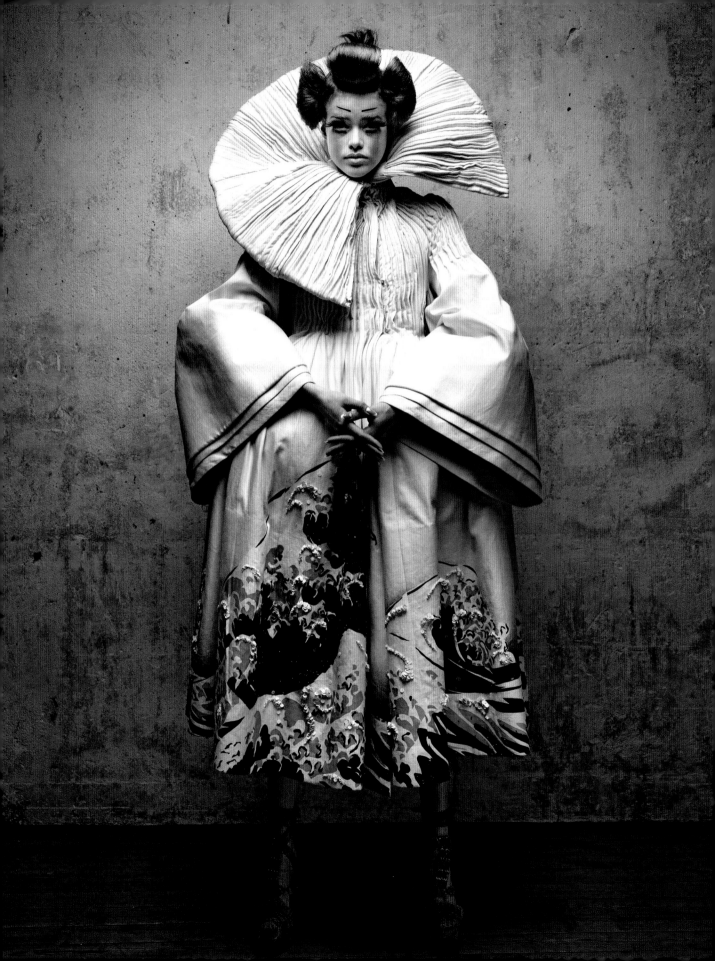

DRAGON CHASING THROUGH THE CLOUDS

After the Flaming Pearl of Wisdom
and Immortality, Nineteenth century

ANDRÉ KIM
Bali Fashion Week 2008

The Korean painting *Dragon Flying Through the Clouds* depicts the mythical beast who in Korean tradition brings good fortune and symbolizes ultimate power. The dragon, usually borne on a swirl of billowing clouds in pursuit of the pearl of wisdom, is an ever-present symbol in East Asian art.

The outfits at right are by André Kim, one of the most famous designers in Korea, who passed away in 2010. In 1962, Kim became the first male fashion designer in Korea when he founded his Salon André in Sogong-dong, Seoul. His self-made image—what we would today call branding—included wearing heavy makeup with penciled-in eyebrows, frequent use of such English words as "elegance" and "fantasy," and designing for himself a "futuristic" white suit, of which he had more than 100 copies (he changed two or three times a day).

Kim's garments reference the powerful, auspicious symbol of the dragon. In these robes, contours suggest the clouds upon which the fold-appliqué dragon writhes. The dynamic boldness of the outfits with their striking colors and materials perhaps is due to Kim's approach rather than reflecting the complex subtlety of the Korean aesthetic.

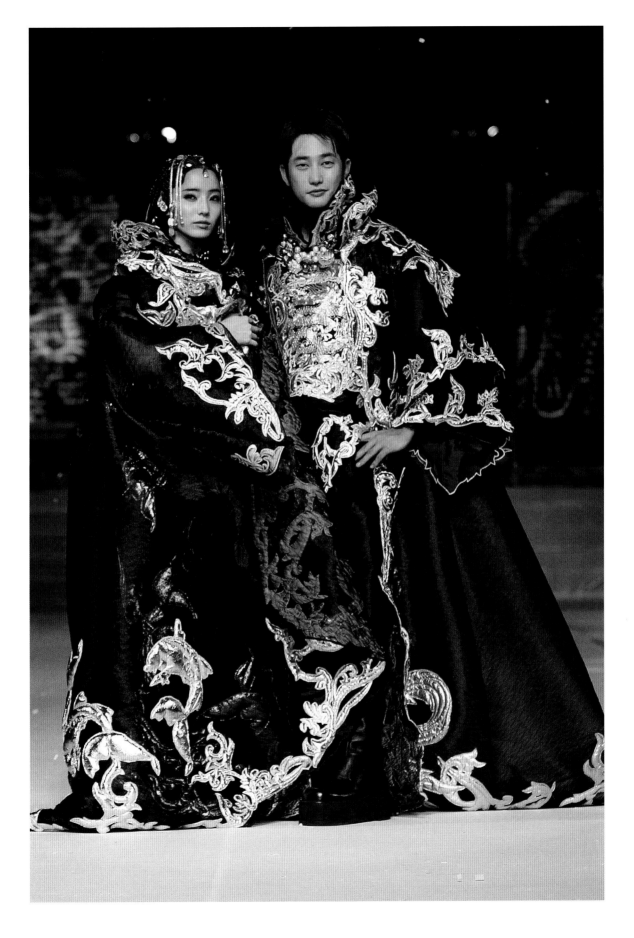

KONSTANTIN MAKOVSKY

Woman in a Russian Dress, circa 1880

JEAN PAUL GAULTIER

Fall 2005 Haute Couture

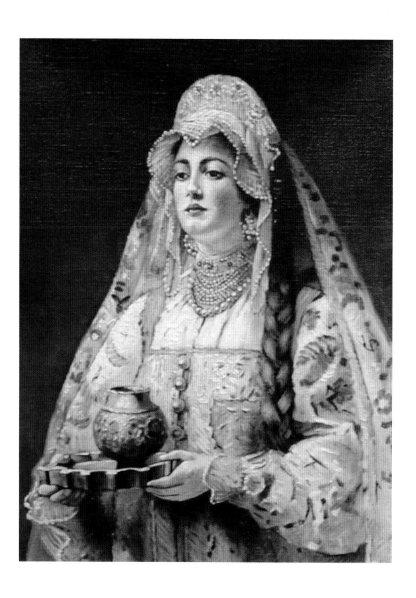

Konstantin Makovsky (1839–1915) was one of the best regarded and highest paid Russian artists of his time, well known for capturing the beauty of Russia's women. He was also renowned for painting the traditional Russian costume of an earlier era with its opulent details, rich coloring, and folkloric allusions. Makovsky was a member of Peredvizhniki (The Wanderers or Itinerants), a group of realist painters that existed from 1870 to 1923 and whose members drew their subject matter from everyday life, reflecting their egalitarian social and political views.

Jean Paul Gaultier's Fall 2005 couture collection was not the first to draw on Russian sources for inspiration. Yves Saint Laurent's 1976 Fall/Winter collection was inspired by his trip to Russia in 1959 when he was director of Dior. The collection caused a sensation at the time and again decades later when it was shown in an exhibition at the Fondation Pierre Bergé-Yves Saint Laurent in Paris in 2009, an outpouring of Russian-inspired items followed, including entire collections by Karl Lagerfeld and John Galliano and the Russian-inspired wedding dress from Christian Lacroix's Fall 2009 haute couture collection.

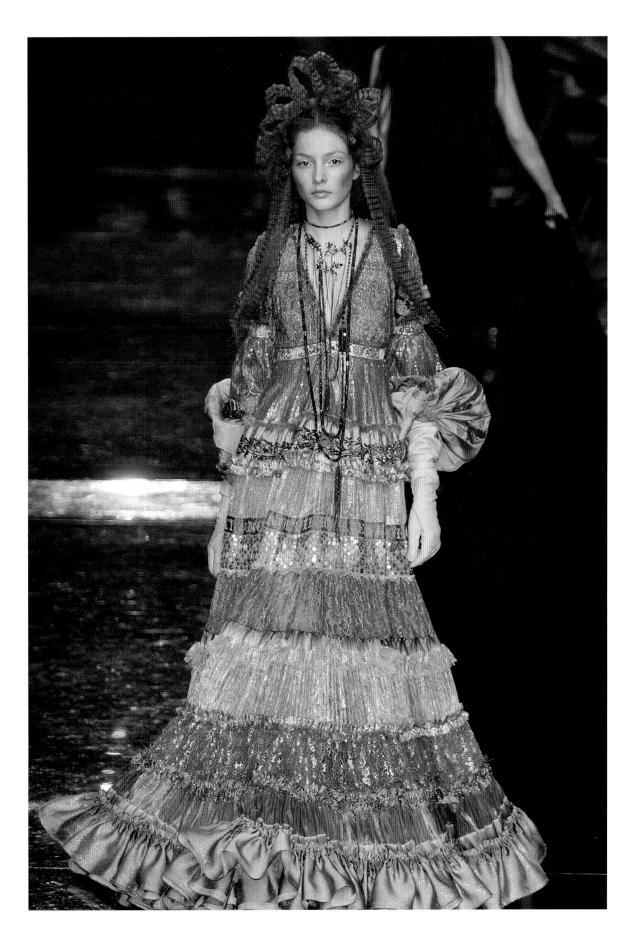

EDGAR DEGAS

Swaying Dancer (Dancer in Green), 1877–1879. Museo Naciona Thyssen-Bornemisza, Madrid

OSCAR DE LA RENTA

Misty Copeland as the Swaying Dancer, March 2016, photographed by Ken Browar and Deborah Ory

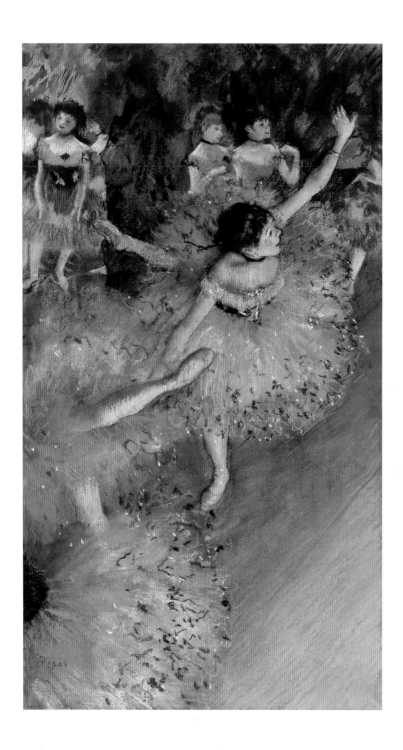

Edgar Degas (1834–1917), one of the greatest artists of the nineteenth century, was a leading member of the Impressionist movement. He shared with the other Impressionists a commitment to interpreting modern life but rejected their plein-air practice. Ballet, which provided Degas the compelling artistic challenge of capturing the human figure in motion, was his most important subject. Half of his mature work—comprising around 1,500 paintings, drawings, pastels, photographs, and sculptures—relates to the ballet. Degas was a brilliant draftsman whose line creates a sense of vibration and movement, perfectly suited to dance. To this he added a palette of high-key color, made possible in part by the 1856 discovery of synthetic aniline dyes added to artists' pastels.

Who better to depict Degas's dancers than ballet superstar Misty Copeland? In 2015, Copeland was appointed as principal dancer of American Ballet Theater, the first African-American woman ever promoted to the position in the company's seventy-five-year history. For the March 2016 issue of *Harper's Bazaar*, photographed by Deborah Ory and Ken Browar, Copeland posed to recreate works by Degas wearing fashions by Valentino, Carolina Herrera, Alexander McQueen, and other designers. Here, Copeland wears Oscar de la Renta as Degas's ethereal Swaying Dancer.

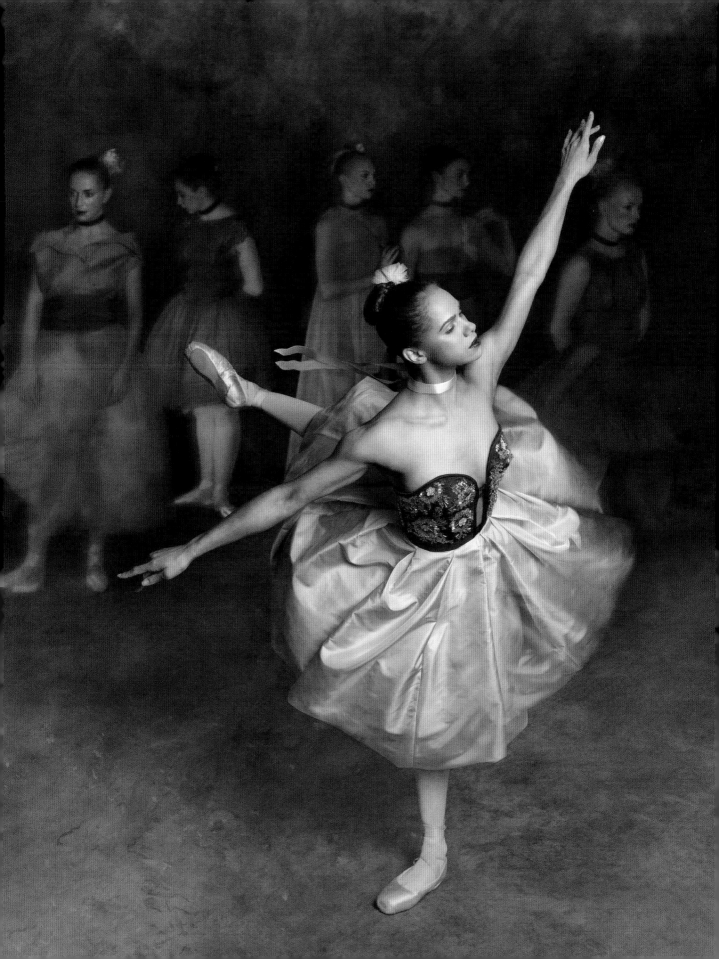

CLAUDE MONET

Nymphéas (Water Lilies), circa 1916–1919

DOLCE & GABBANA

Spring/Summer 2008 Ready-to-Wear

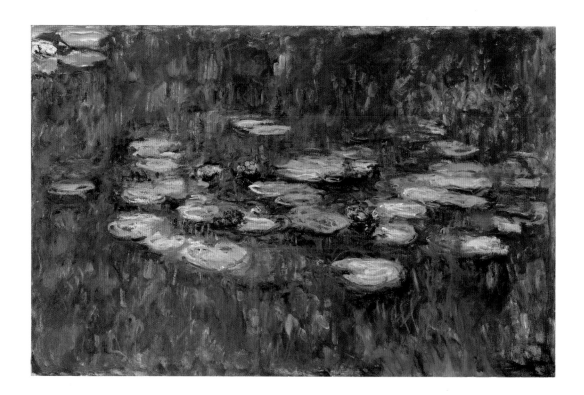

Claude Monet (1840–1926) is best known for the beautiful paintings of water lilies he executed en plein air in his fabled gardens. Monet created floral landscapes composed of irises, tulips, and Japanese peonies and ponds of waterlilies at the home he bought outside Giverny, now the Fondation Claude Monet Museum. The grounds were tended by a six-man team at the astonishing cost of 40,000 francs annually, forty times the annual salary of the average Parisian laborer.

Monet was obsessed with water lilies, which he had first seen at the 1889 Exposition Universelle. In *Mad Enchantment: Claude Monet and the Painting of the Water Lilies*, Ross King writes that water lilies for Monet "became a substitution or replacement for the hidden or absent woman ... serving as substitutes for the female models denied to Monet by the jealous Alice [his wife]." The lush beauty of Monet's waterlilies translated into Dolce & Gabbana's lavish gown, creating the effect that the model is floating in the painting.

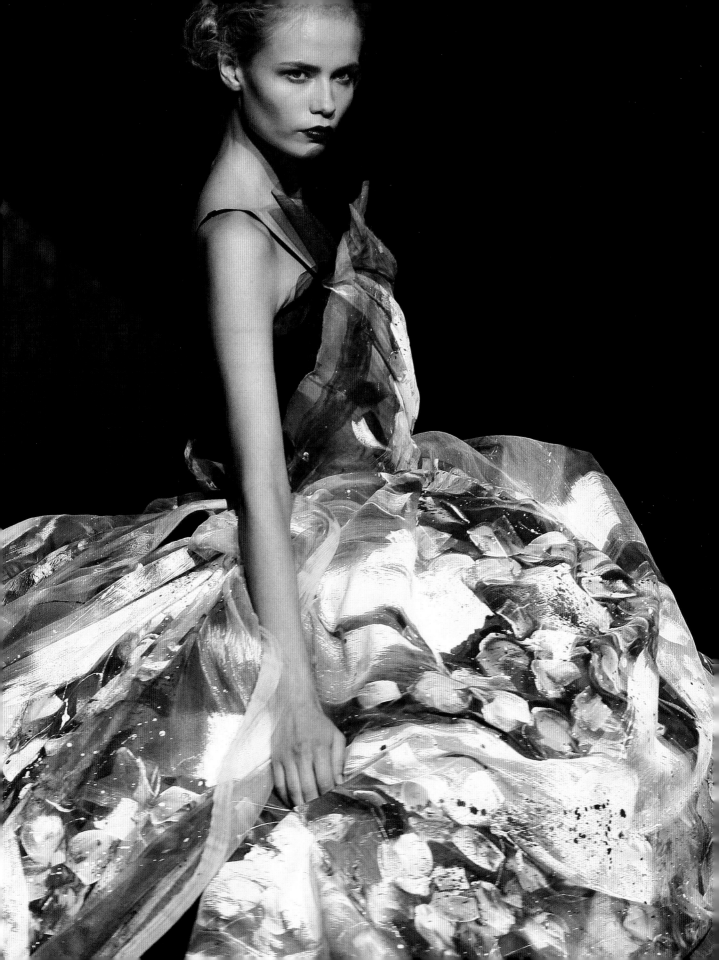

PAUL GAUGUIN

Te Arii Vahine (The Queen, the King's Wife), 1896. Pushkin Museum, Moscow

MAISON MARTIN MARGIELA

Spring/Summer 2014 Haute Couture

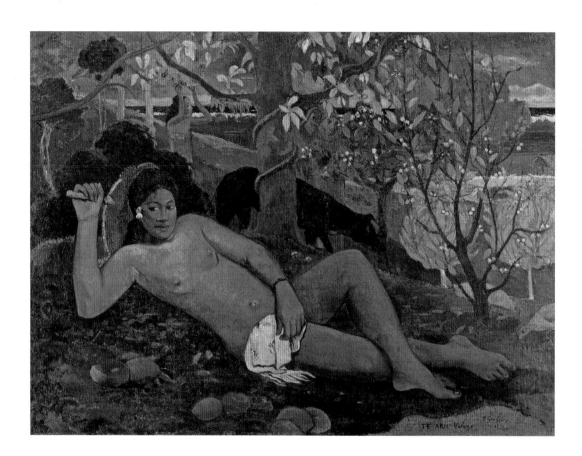

In 1891, Paul Gauguin (1848–1903) rejected his conventional life as a stockbroker and father of five to follow his fantasy of pursuing art in a tropical paradise. He produced painting, sculpture, ceramics, monotypes, and woodcuts in French Polynesia. On Gauguin's second trip to Tahiti, he painted *Te Arii Vahine (The Queen, the King's Wife),* showing a beautiful native woman (identified by specialists as the artist's Tahitian wife) in a lush tropical landscape. Her pose echoes

those depicted in Édouard Manet's *Olympia* and Titian's *Venus of Urbino,* and there are European religious references, including what appears to be a tree of knowledge.

Maison Margiela takes Gauguin's painting into the realm of fashion by repurposing a 1950 Aubusson tapestry of the painting into a peacoat. Margiela had an important precedent: the tradition of making paintings into tapestries in France goes back to the seventeenth century, when both Aubusson and Gobelin

became known for tapestries, including weavings of paintings by significant artists of the time, such as Charles Le Brun. Margiela cut his coat from a needle-woven wool tapestry showing Gauguin's *Te Arii Vahine,* produced by the Atelier Raymond Picaud Aubusson around 1950. There are thus many layers of repurposing: Gauguin's painting into a tapestry into Margiela's extraordinary coat.

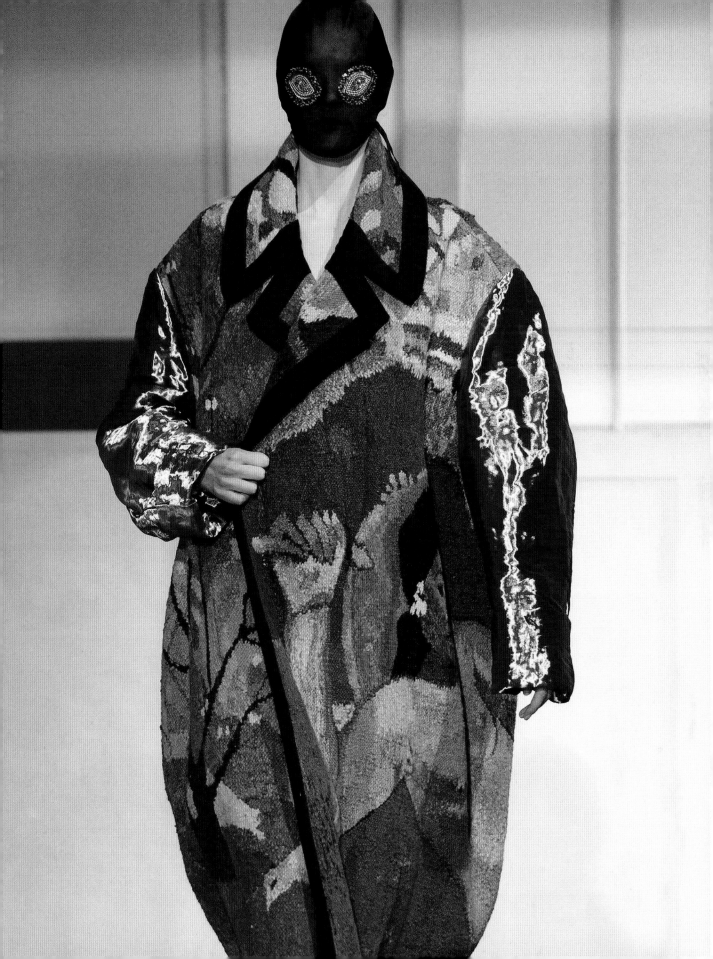

EDVARD MUNCH VIKTOR & ROLF

The Scream, 1893.
National Museum of Art, Oslo

Spring/Summer 2016, Haute Couture

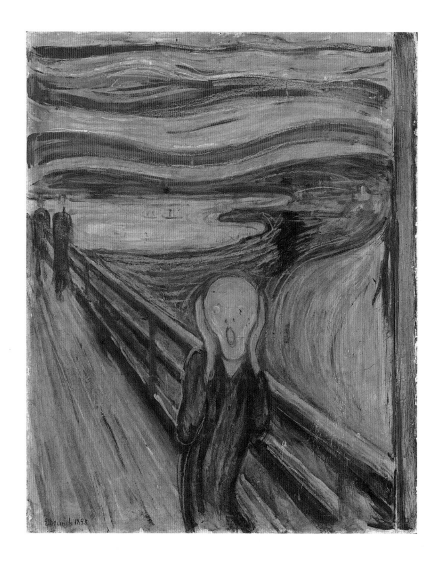

The Scream by Edvard Munch (1863–1944) is a distillation of existential anxiety, an image so powerful that it has become a symbol of emotional trauma for our times. It achieves its effect through piercingly vivid color, the landscape's throbbing Art Nouveau curves, acute foreshortening, and, especially, the figure's sunken eyes and horrified gesture.

"The head of this victim of what today we might call an anxiety attack," the eminent art historian Robert Rosenblum wrote, "becomes a skull before our eyes. Indeed, so close is this head to the bone below that even its sex remains indeterminate—a raw portrait of living terror that may well have been inspired … by a Peruvian mummy acquired about 1880 by Paris's ethnographic museum at the Trocadero." The Dutch fashion house Viktor & Rolf's white piqué dress offers Munch's *Scream* in a more approachable version. The *Scream*-inspired dress, though referencing a painting rather than a sculpture, was part of an all-white art-influenced collection titled The Performance of Sculptures, meant to suggest a likeness to plaster or marble. The figure's head, so terrifying in Munch's painting, is here topped by a jaunty bow, and the body is covered not in deathly black but in ruffled white.

GUSTAV KLIMT

Portrait of Adele Bloch-Bauer I, 1907.
Neue Galerie, New York

JOHN GALLIANO
FOR CHRISTIAN DIOR

Spring/Summer 2008 Haute couture

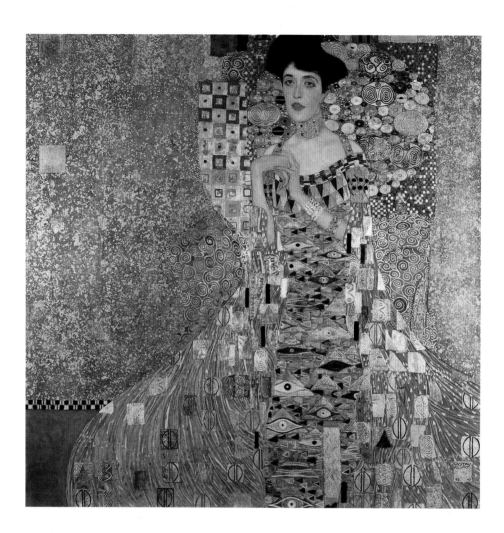

In 1904, Adele Bauer, daughter of the head of one of the largest banks in the Hapsburg Empire and a noted art patron, met Klimt (1862–1918), one of the leaders of the Vienna Secession. Despite her haute bourgeois upbringing, Bauer was a rebel—an independent thinker and atheist. Shockingly, Bauer, a single woman in her early twenties, agreed to pose for Klimt, a bohemian who had fathered fourteen children. Whether Bauer and Klimt were lovers remains uncertain, though he was clearly obsessed with her, having produced more than one hundred pencil sketches of her in addition to two portraits.

Klimt's influence on the tangerine-colored coat by John Galliano for Christian Dior, with its gold motifs, extends to the silhouette of the garment and the styling of the model's hair and makeup. Klimt had been impressed by the Byzantine mosaics in the Basilica of San Vitale in Ravenna, which he had seen on a trip in 1903, and was also influenced by Egyptian, Minoan, and Classical Greek sources and the Japanese Rinpa school, with its floral motifs and use of gold, silver, and pearl backgrounds. Galliano's coat for his Spring/Summer 2008 Haute couture collection came amid heightened interest in Klimt's work. Two years earlier, Ronald Lauder had spent a record-setting 135 million dollars to purchase *Portrait of Adele Bloch-Bauer 1 (The Lady in Gold)* for the Neue Galerie in New York, where it now resides.

ÉMILE ROBERT

Art Nouveau gate, 1902.
Musée de l'École, Nancy, France

CHARLES FREDERICK WORTH

Evening dress, 1898–1900

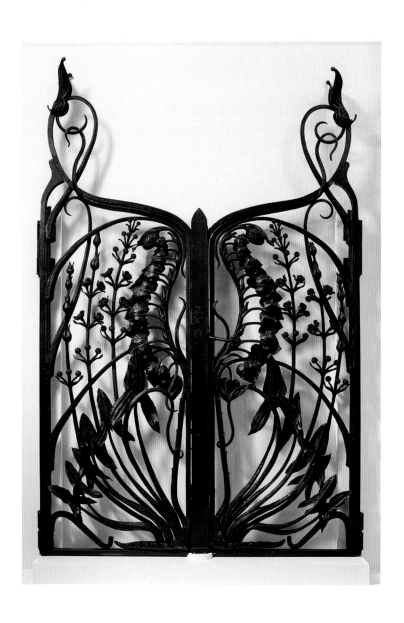

Both Émile Robert's ironwork gate and Charles Frederick Worth's evening dress are masterpieces of Art Nouveau, the international style popular from 1890 to 1910. Each displays the movement's signature sinuous forms inspired by flowers and other plants. The similarity of Worth's fabric decoration to Art Nouveau ironwork is noted in the Metropolitan Museum's description of the gown in its Costume Institute collection: "The striking graphic juxtaposition of the black velvet on an ivory satin ground creates the illusion of ironwork, with curving tendrils emphasizing the fashionable shape of the garment."

Applied and decorative arts, such as glass art, ceramics, and ironwork were an important part of the Art Nouveau movement, which sought to break down distinctions between fine and applied art. Émile Robert (1860–1924), who was honored with the French Chevalier de la Légion d'Honneur later in his career, was a master ironwork artist who worked with such distinguished names as Émile Gallé, Louis Majorelle, and Jean Daum. Charles Frederick Worth, the father of Parisian couture, employed references to art of the past to elevate the very idea of fashion, repositioning what had been seen as a frivolous industry with solely monetary goals (earlier in the nineteenth century) as a high artistic pursuit.

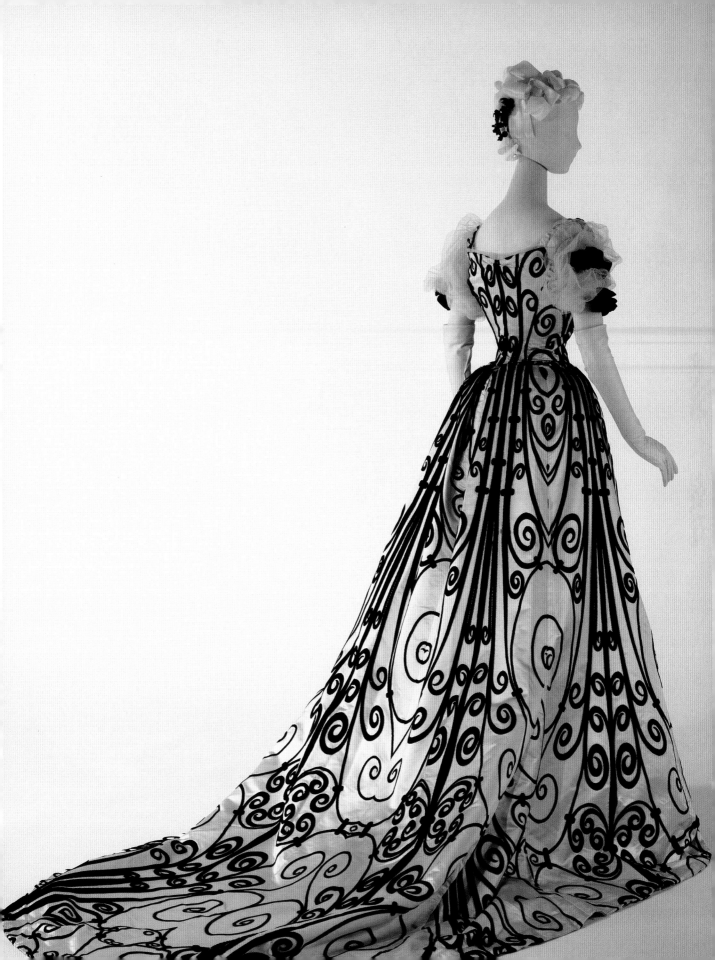

GEORGES BRAQUE

Two Birds, 1955. Tel Aviv Museum of Art

Rhum et guitare, 1918

YVES SAINT LAURENT

Photo by Irving Penn for *Vogue*, 1988

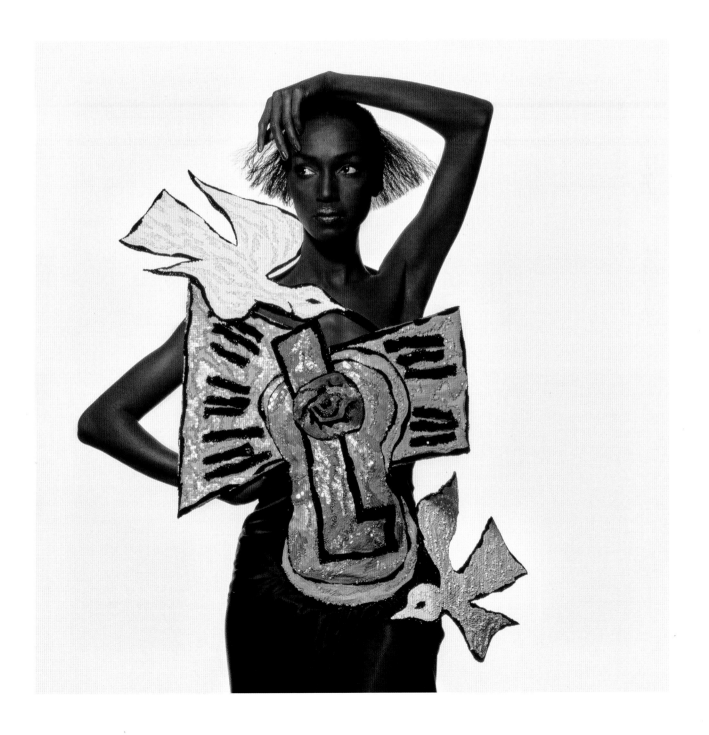

WASSILY KANDINSKY

Schwarz und Violett, 1923

JUNYA WATANABE

Spring/Summer 2015 Ready-to-Wear

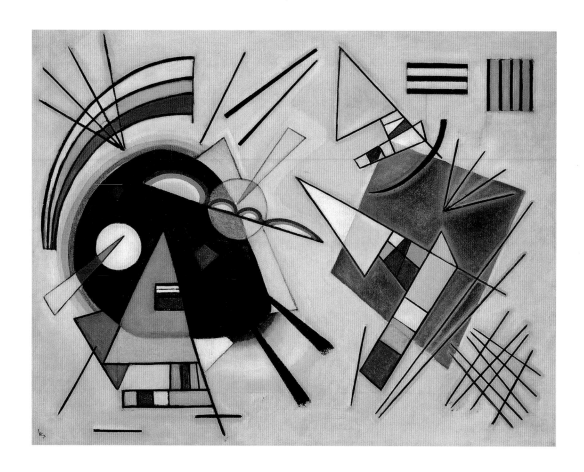

The Russian painter Wassily Kandinsky (1866–1944) was a pioneer of abstraction. A brilliant writer and art theorist, he developed his art based on his complex philosophical and pictorial ideas. He was influenced by theosophy, whose followers believe that creation is a geometrical progression, starting from a single point and expressed by a descending series of circles, triangles, and squares. Kandinsky aimed for color that caused "vibrations in the soul." His painting became increasingly abstract over the course of his career.

Innovative Japanese fashion designer Junya Watanabe was channeling Kandinsky for his Spring 2015 ready-to-wear collection.

Clear Constructivist-looking raingear, accented by futuristic headpieces, included flat purple, red, white, and black geometric shapes. Watanabe pioneered the use of synthetic textiles and fabrics, including simulating the look of cellophane by laminating polyurethane on nylon tricot fabric, for his Fall/Winter 1995 collection.

MARCEL DUCHAMP

Fountain, 1917. The Israel Museum, Jerusalem

PHILIP COLBERT

Urinal Dress

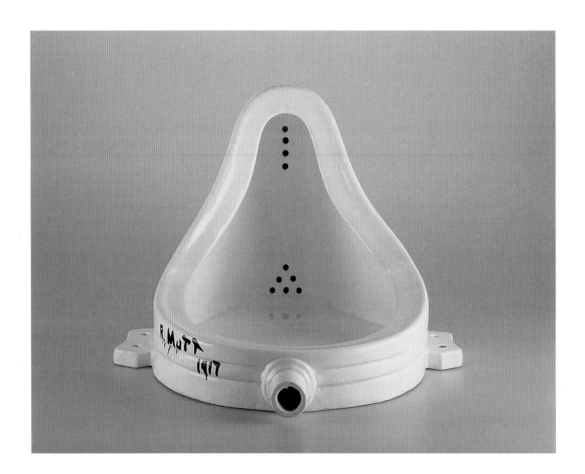

In 1917, avant-garde French artist Marcel Duchamp (1887–1968) submitted a urinal signed R. Mutt to the Society of Independent Artists exhibition. Though the piece was rejected, and Duchamp resigned in protest, the urinal—which vanished after being photographed by Alfred Stieglitz—opened a floodgate to fundamental questions about the meaning of art. The urinal was what Duchamp termed a "readymade," an ordinary manufactured object he had not made but selected and recontextualized as art.

The provocation and naughty humor of Duchamp's *Fountain* is at the heart of the Urinal Dress by Scottish designer Philip Colbert. It transfers Duchamp's questions to fashion: What constitutes fashion? What do we expect fashion to look like? Can fashion images be appropriated (chosen) too? Colbert has said that his work "walks a humorous line between fashion and art. I like the idea that my clothing is taken off the wall and worn ... I feel that fashion's greatest value is in fantasy and escapism. For me humor is a powerful tool to push understanding and encourage a thoughtful approach to clothing."

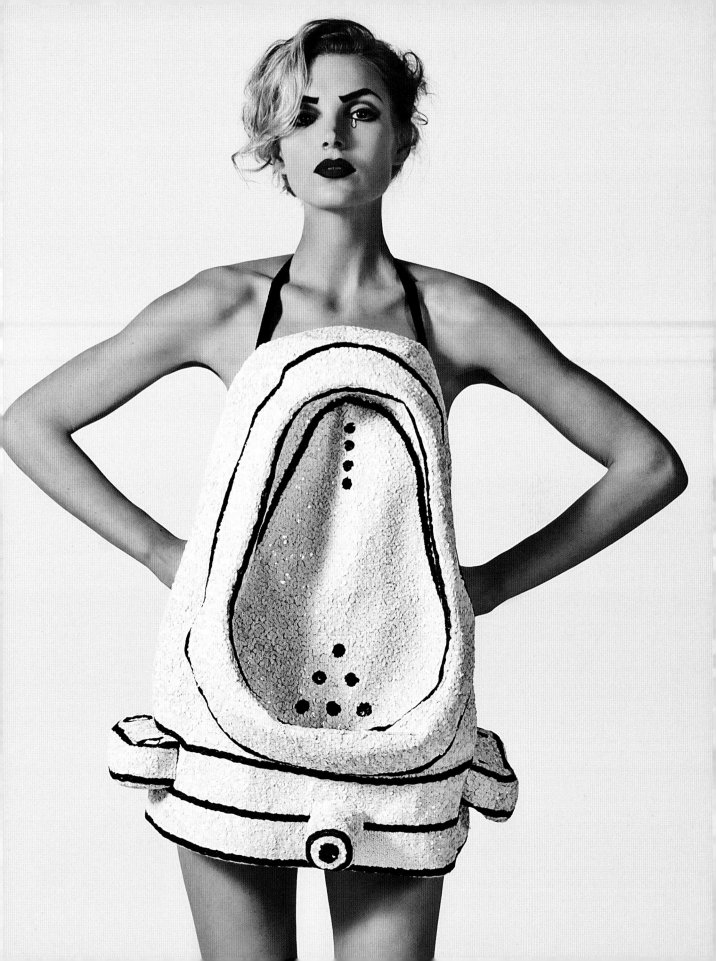

WILLIAM VAN ALEN

Elevator doors in the lobby
of the Chrysler Building,
ca. 1928-30, New York

EDWARD STEICHEN

Photo by Edward Steichen for *Vogue*,
June 1, 1925

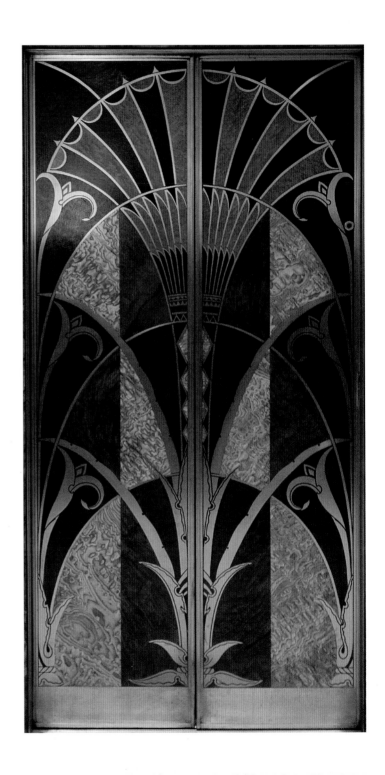

The elevator doors of New York's Chrysler Building, featuring metal and exotic wood marquetry in the shape of a papyrus plant, are a definitive example of Art Deco in America. Art Deco was a design language suited to the modern world, influenced by speed, streamlining, and industrial society. These doors include both the strong geometric forms and stylized floral patterns characteristic of the style.

Edward Steichen was the first and most important fashion photographer to produce work in the Art Deco style. This photograph was taken for *Vogue* in 1925—the year of the seminal Exposition Internationale des Arts Décoratifs et Industriels Modernes in Paris from which Art Deco derived its name. The fashion itself, an oversized silk scarf hand-painted in bold colors without any known designer, is the dominant Art Deco feature. Steichen often organized his sets and lighting to emphasize bold geometry, used backdrops hand-painted with Art Deco motifs, and chose models who conveyed the sleekness of the Deco style, such as the dancer Helen Tamiris, shown here.

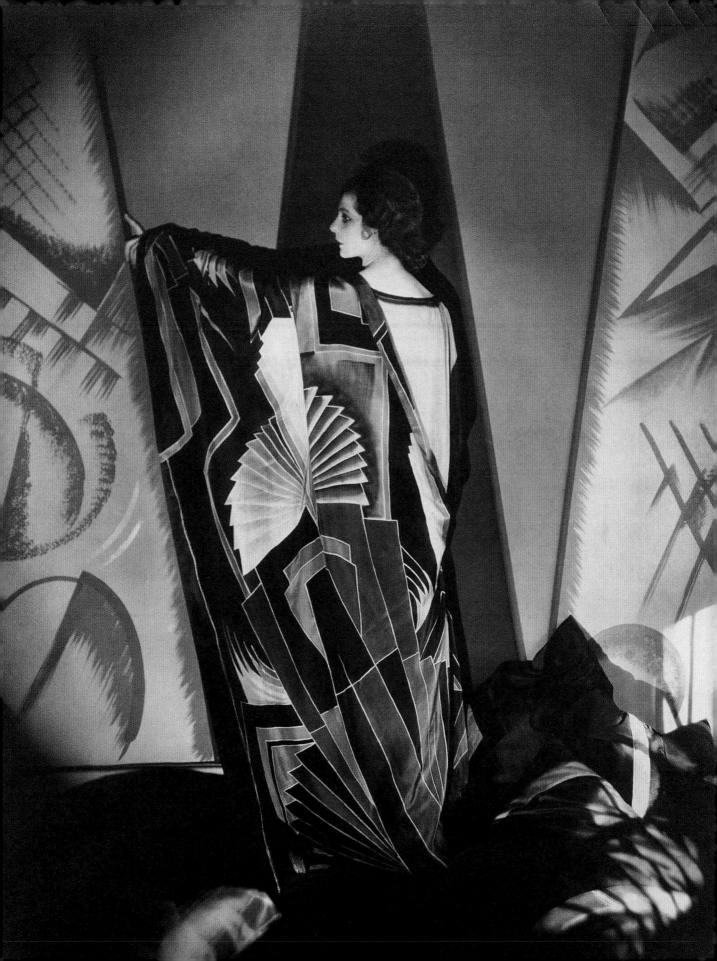

SONIA DELAUNAY

Detail, Rhythm, 1938

———

Models in Sonia Delaunay swimsuits,
ca. 1924-28

Sonia Delaunay (1885–1979) is the epitome of the art-fashion connection, as she moved effortlessly between the two disciplines. Born in Ukraine, raised in Saint Petersburg, and trained in Germany, she moved to Paris and married fellow artist Robert Delaunay in 1910. Together they founded Orphism, a Cubist-inspired form of abstraction built on planes of color. Both Sonia and Robert exhibited numerous Orphic works in the early years of the 1910s, but Orphism effectively ended before World War I. After Robert's death in 1941, Sonia created prints and paintings in gouache and oil.

In the years 1918 to 1935, when Sonia rarely painted, she became a fashion designer using Orphic forms and colors. For a 1918 London production of *Cléopâtre* by the Ballets Russes, Sonia designed the costumes and Robert designed the sets. By the mid-1920s, Sonia had opened Maison Delaunay, her studio for creating textiles and clothing, and fashionable Casa Sonia, the first edition of her design house.

She was successful, lecturing on the influence of painting on clothing design at the Sorbonne and designing for an affluent international clientele, including the movie star Gloria Swanson, for whom she designed an embroidered wool coat in geometric shapes of rich red, brown, and cream. She designed "simultaneous" dresses, as well as bathing costumes, driving caps for use in then-ultramodern motor cars, fur coats, and—in collaboration with Dada poet Tristan Tzara—"dress-poems" in color combinations inspired by his words. For more than forty years, Delaunay continued to design fabrics in partnership, producing more than 2,000 fabrics for the avant-garde Dutch emporium Metz & Co. Fashionable to the end, she chose to be buried in the dress Hubert de Givenchy had designed for her to wear to attend a reception for Queen Elizabeth.

PABLO PICASSO COCO CHANEL

Bathers, 1918.
Musée National Picasso, Paris

Coco Chanel bathing suits worn by dancers
in the Diaghilev Ballets Russes production
of *Le Train Bleu*, November 1924

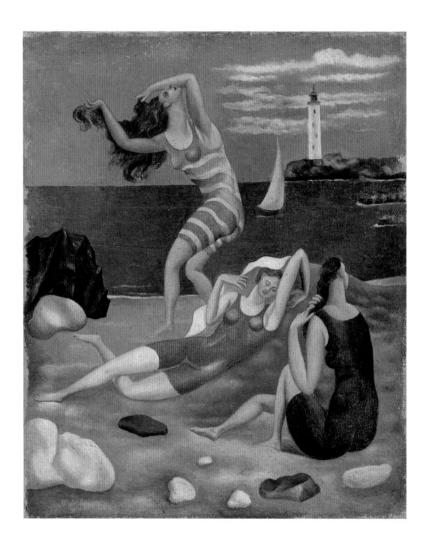

The iconic French fashion designer Coco Chanel changed the concept of leisurewear in the twentieth century. Her designs for beach-inspired casual wear, including the beach pajamas popularized in her 1922 collection, reflected the concept of the modern woman as active and athletic. An avid tennis player, Chanel believed that maintaining an exercise routine helped shape a beautiful body and that it was beneficial for women to tan at the beach. With what biographer Anne de Courcy described as "alluring looks—sensual, androgynous and chic—short hair and a slender figure," Chanel was the living expression of her fashion aesthetic.

This is one of the few examples of fashion influencing painting. Chanel's new approach to fashion—freeing the body from corseted constriction—inspired Picasso's painting *Bathers* of 1918. In the summer of that year, Picasso married Olga Khokhlova, a ballerina with Sergei Diaghilev's Ballets Russes troupe, and they spent their honeymoon near Biarritz in the villa of glamorous Chilean art patron Eugenia Errázuriz. "Fascinated by Chanel's revolutionary effect on the way women looked and behaved," the great Picasso biographer John Richardson wrote, "Picasso did a fine, small painting of three bathing-suited girls—each fiddling with her hair—on the beach below the Palace Hotel [in Biarritz]. This is the first of countless bather compositions in Picasso's work."

SALVADOR DALÍ

Atavistic Vestiges After the Rain,
circa 1934

VIKTOR & ROLF

Spring/Summer 2010 Ready-to-Wear

The Spanish Surrealist Salvador Dalí (1904–1989) was an artist of extraordinary technical virtuosity who was known for his eccentric personality and role as a provocateur. His work expressed themes of eroticism, death, and decay in a dream world filled with distorted figures.

In Atavistic Vestiges After the Rain, a hole in an amorphous object is a focal point. The object itself balances precariously on a rock and a spindly crutch. According to Dalí's writings, the hole is a result of erosion, but also of sexual conflict, which has led to speculation that the hole alludes to the female body and possibly to Dalí's lifelong phobia of female genitalia.

Since 1993, the Dutch duo Viktor & Rolf—Viktor Horsting and Rolf Snoeren—have created conceptual fashion designs. There is a concurrence of form—the large, amorphous shape with disturbing holes—between the Dalí painting and this Viktor & Rolf dress from their 2010 collection. At the time, Snoeren explained, "With the credit crunch and everybody cutting back, we decided to cut tulle ball gowns" with chainsaws rather than dressmaking shears, creating dramatic holes and shocking gashes in the pastel fabric.

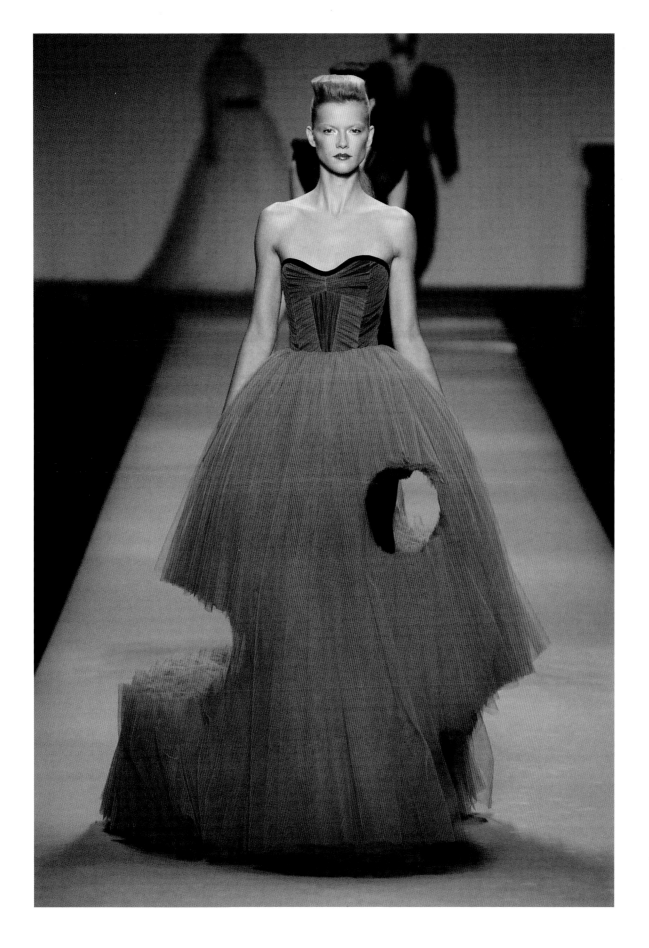

The Conversation, 1944

Fall/Winter 2011 Haute Couture

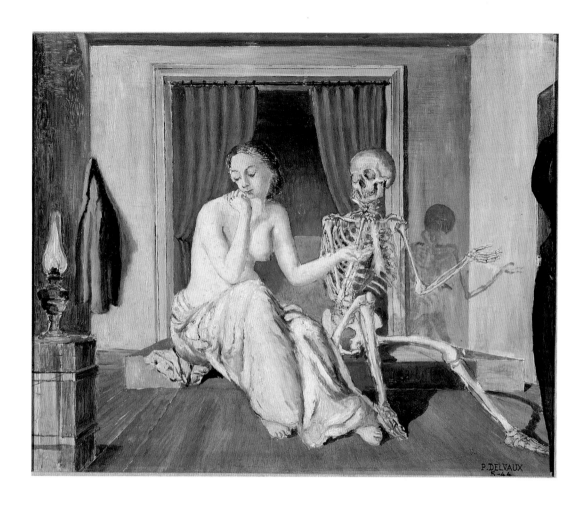

Belgian painter Paul Delvaux (1897–1994) was only briefly associated with the Belgian Surrealist group, yet his paintings share the incongruities of Surrealist work. In *The Conversation*, he juxtaposes male and female, nude and skeleton, and eroticism and death. Delvaux's childhood fascination with skeletons continued through his life, inspiring a series of skeleton paintings that he began in 1943.

Iris van Herpen, the Dutch fashion maverick, sees art as central to her design process. She collaborates with a diverse group of creatives, including the artist collective Studio Drift, photographer Nick Knight, musician Björk, choreographers and dancers Benjamin Millepied and Nanine Linning, and architects Philip Beesley and Rem Koolhaas.

Van Herpen defines her atelier as a "laboratory" for experimentation in materials and techniques, such as laser cutting, digital fabrication, and 3D printing. She has worked a type of silicone used by the military as body armor, metal lace, resin mixed with iron filings, white polyamide, and materials so new they don't yet have names. The result is a combination of couture craftsmanship with modern technologies.

Van Herpen told *Vogue* of her now-iconic Skeleton dress, "This dress visualizes the inside of the body outside ... it represents freedom and imperfection, and between those two is where beauty can be found."

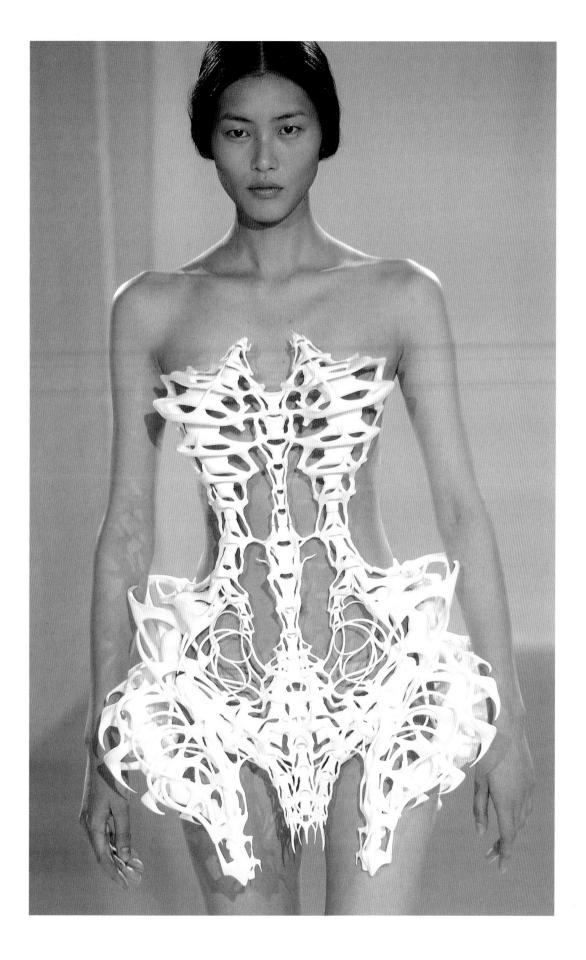

M. C. ESCHER

Liberation, 1955

ALEXANDER MCQUEEN

Fall 2009 Ready-to-Wear

In March 2009, designer Alexander McQueen presented his Fall/Winter collection titled The Horn of Plenty: Everything But the Kitchen Sink. It was a masterpiece of rebellion with the unlikely leitmotif of trash. The set design was a scrap heap of recycled debris from previous McQueen shows spray-painted black; it included tires, TVs, and a kitchen sink. The catwalk was made of shattered mirrors. The outfits were also outrageous, with some appearing to be made of trash bags or Bubble Wrap. Headgear consisted of aluminum cans wrapped in plastic, upturned umbrellas, and lampshades.

Among these provocative gowns was Alexander McQueen's red-and-black print dress, which took its cue from the extraordinary visual ambiguities in *Liberation* by the Dutch artist M. C. Escher (1898–1972). Birds appeared throughout McQueen's work and abounded in the Horn of Plenty collection. In addition to the Escher-inspired gown, there was a terrifying garment of duck feathers dyed black that looked like a giant raven, a Romantic symbol of death, as well as two outfits that transformed their wearers into white and black bird-women.

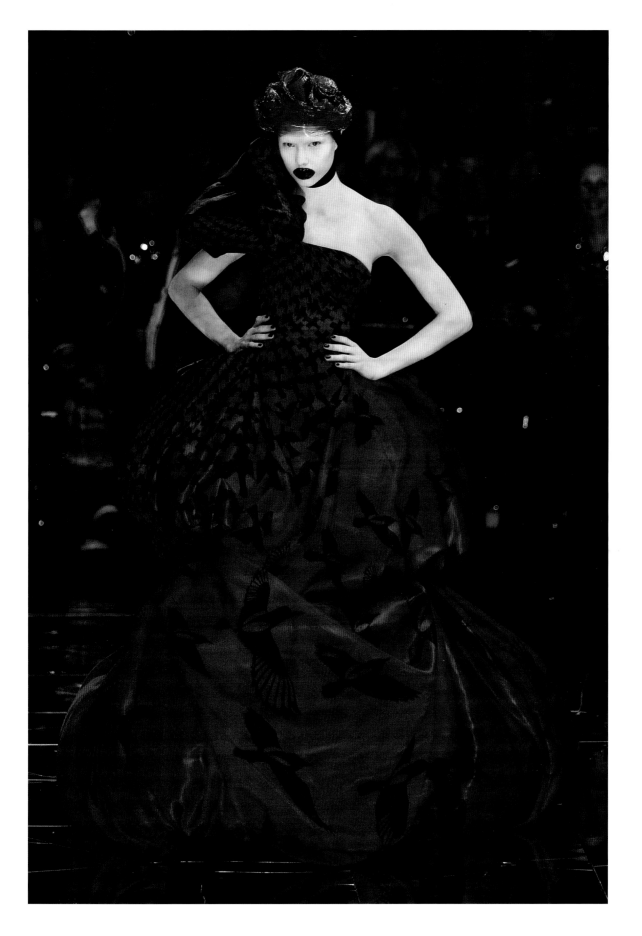

Untitled, 1957

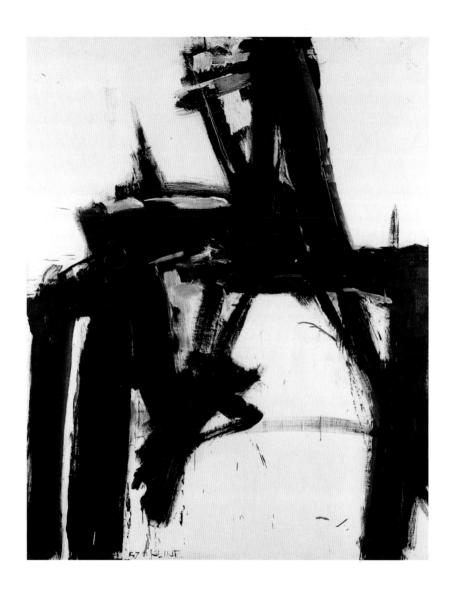

Though his thick enamel strokes slashed across white grounds were forms of gestural abstraction, Franz Kline's (1910–1962) paintings evoked the trains of Pennsylvania coal country, where he grew up, and the bridges and buildings of New York, where he lived.

The drama of Kline's images inspired Donna Karan's ready-to-wear Spring 2015 collection. Though the collection received favorable reviews, virtually no one seemed to recognize Kline as the source of what *Vogue* called "one of Karan's most vital collections in a while: vibrant, uncomplicated, desirable." Perhaps a clue to why Karan was drawn to Kline's paintings is provided in her words in her show notes for the collection: "New York is my palette, my passion, my fuel; a culture that empowers creativity."

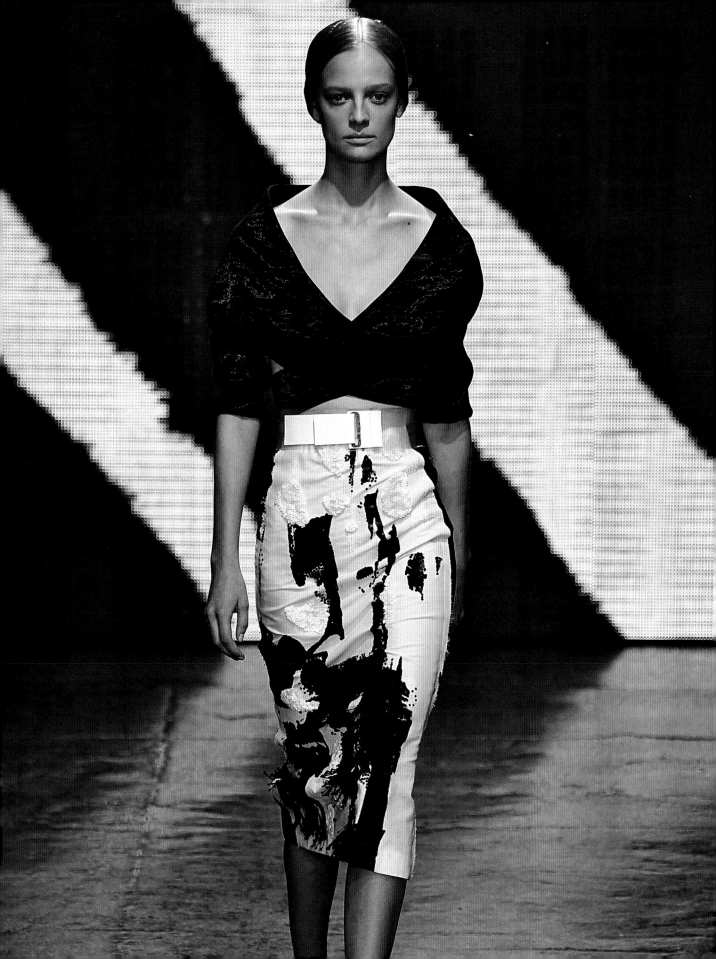

FRIDA KAHLO
Self Portrait, Dedicated to Dr Eloesser, 1940

JEAN PAUL GAULTIER
Spring/Summer 1998 Ready-to-Wear

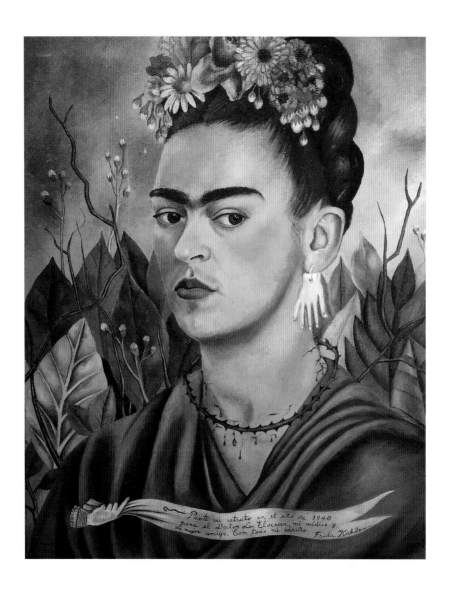

Mexican artist Frida Kahlo (1907–1954) is one of the most acclaimed artists of the twentieth century. A fashion and feminist icon, Kahlo developed an immediately recognizable style shaped by her ethnicity, disability, and politics.

Kahlo used self-portraiture extensively (55 of her 143 paintings were self-portraits) as an expression of her physical and emotional suffering. *Self Portrait Dedicated to Dr Eloesser*, a gift to a doctor who treated her

in San Francisco, illustrates how Kahlo used fashion as a means of expression. She was born to a German-Hungarian father and a Spanish-Tehuana mother, and she showcased her identity by wearing Tehuana dress from the matriarchal society located in the Isthmus of Tehuantepec in Oaxaca.

Kahlo crafted her style both to conceal her injuries (the full skirts hid her polio-induced limp and the long embroidered blouses her curved spine) and to express her beliefs as

a member of the Mexican Communist Party. The hand-shaped earrings in this self-portrait were a gift from Surrealist André Breton, a Marxist who had once been a Communist Party member. Designer Jean Paul Gaultier drew on Kahlo's status as a fashion icon for his Tribute to Frida Kahlo Spring/Summer 1998 collection. It featured diverse Kahlo-inspired fashion and dramatic allusions to Kahlo, including unibrows, tears of blood, thorn crowns, and elaborate flower headdresses.

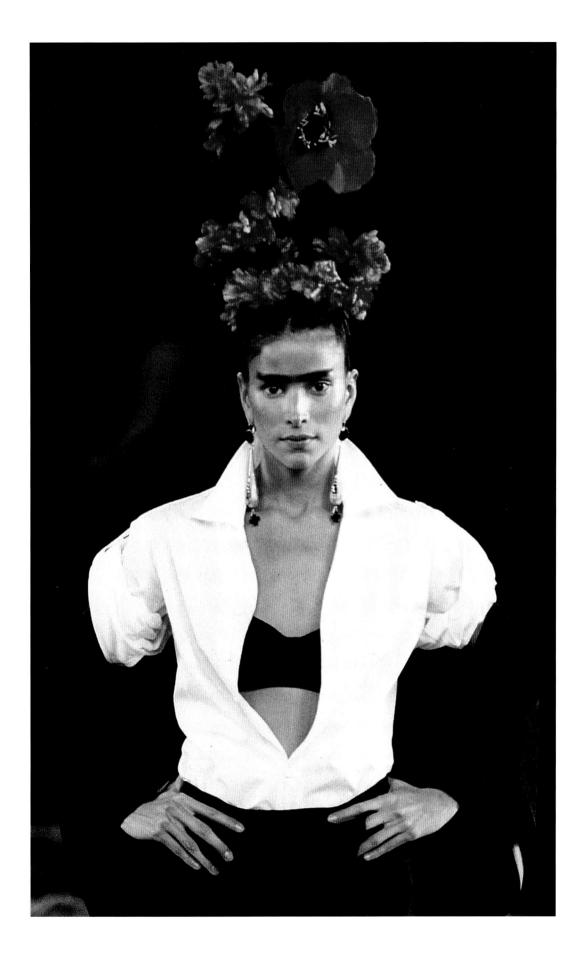

VICTOR VASARELY

JEAN PAUL GAULTIER

Vega 200, 1968

Fall/Winter 1995

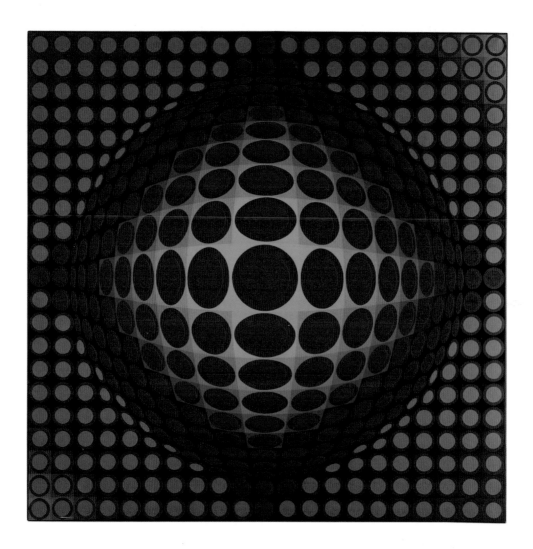

The French-Hungarian artist Victor Vasarely (1906–1997) is credited as the originator of the Op Art movement. His work was based on geometric form and precise color, creating near-hallucinatory optical vibration.

Vasarely defined himself as a humanist who felt that "art offered a way, through plastic equivalents, of making scientific models visually comprehensible." Though occasionally he

was dismissed as a poster artist, he received critical attention not only for the power of his kinetic images but also for the importance of his ideas, which formed the basis for bringing science and technology into art.

In the late twentieth century, the introduction of both personal computers and the Internet transformed culture, including fashion. In 1995 and 1996, Jean Paul Gaultier

turned to cyberspace for inspiration, producing an iconic spandex and mesh jumpsuit.

At the same time, computer-aided design (CAD) and computer-operated jacquard looms began to alter garment production. Gaultier's cyber clothing was revolutionary, and Vasarely's Op Art design—which inspired the garment's optical-illusion print—was perfect for Gaultier's innovation.

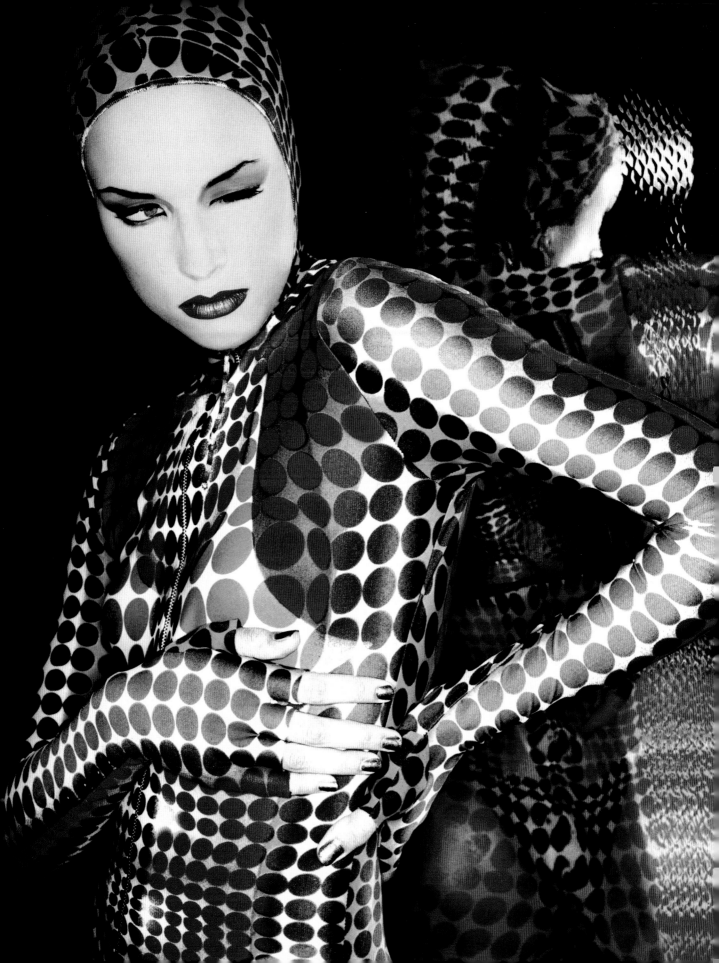

BRIDGET RILEY

Intake, 1964

F. C. GUNDLACH

Brigitte Bauer in Sinz bathing suit, 1966

Bridget Riley (b. 1931) was one of the leading artists of mid-1960s Op Art. According to critic Michael Kimmelman, when Riley was en route to the seminal 1965 group exhibition *The Responsive Eye* at the Museum of Modern Art, she saw dresses whose designs were lifted from her paintings in New York store windows. She was so horrified that she attempted to sue.

Her Op Art paintings used elementary geometric shapes to—in her own words—make "an extreme statement, of something violent, something that definitely did disturb," often triggering the sensations of vibration and movement.

F. C. Gundlach, one of Germany's most renowned fashion photographers, shot this one-piece by the bathing suit company Sinz.

Gundlach was known for capturing current trends in the visual arts in his fashion work and this shot, done at the height of the Op Art movement in 1966, was no exception. The optical sensation and graphic force of Gundlach's photograph clearly relates to Bridget Riley's painting.

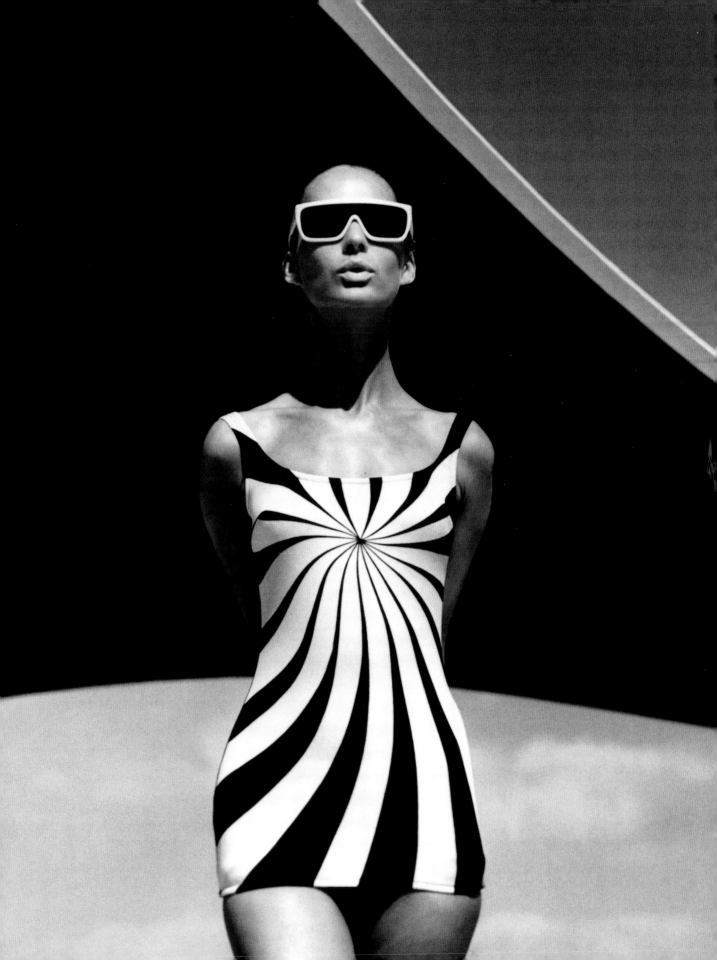

PIET MONDRIAN

Composition NºII, in Red, Blue and Yellow,
1930

YVES SAINT LAURENT

Fall/Winter 1965 Haute Couture

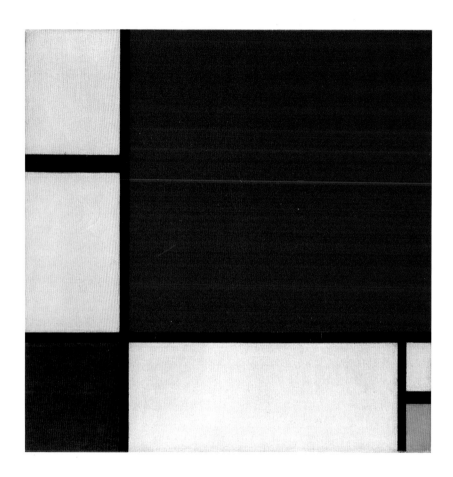

The importance of Yves Saint Laurent's 1965 dress, one of six in his 1965–66 Fall/Winter collection inspired by Piet Mondrian (1872–1944), cannot be underestimated. This color-blocked cocktail dress is iconic for multiple reasons: The first in a dialogue between fashion and art that would define the designer's career, a marker of fashion's turn toward modernity and youth, and the impetus for the first ready-to-wear line by a couturier. It spurred countless knockoffs and imitations,

and even the first pattern of a couturier garment available to home seamstresses.

Diana Vreeland raved, while *Women's Wear Daily* pronounced, "This is the Dress of Tomorrow." The dress appeared on the September 1965 cover of *Vogue Paris*, and was photographed by Irving Penn and Richard Avedon.

The seeming simplicity of the Mondrian dresses was misleading: there was technical intricacy to the way the pre-dyed fabric

squares were inlaid and combined by invisible seams. Years after Saint Laurent designed the Mondrian dresses, the designer and his partner, Pierre Bergé, acquired three abstract paintings by Mondrian. The impact of artists on his fashion continued throughout his life, as he designed clothing inspired by Pop artists, Matisse, Picasso, Jean Cocteau, Vincent van Gogh, and others.

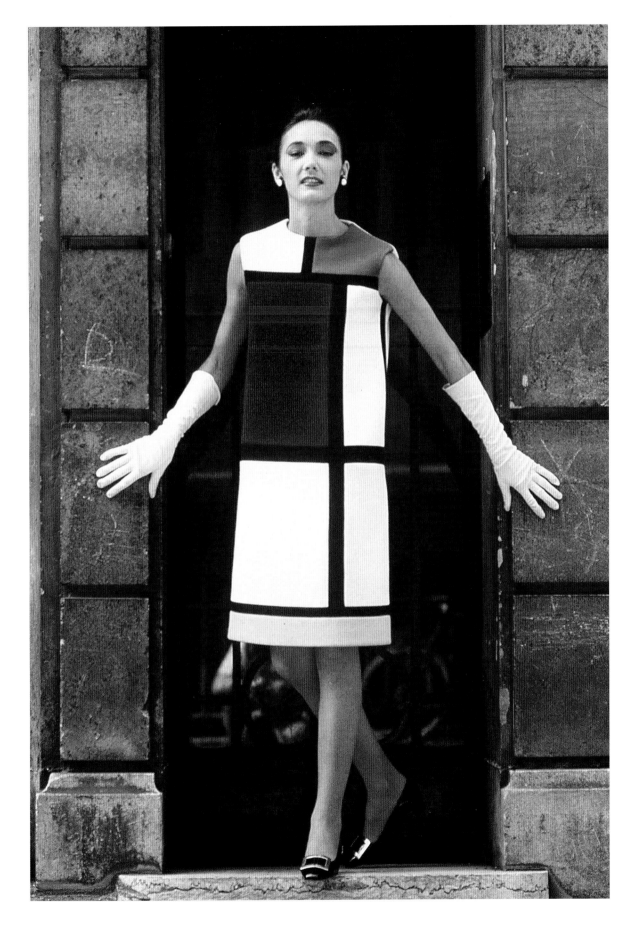

YVES KLEIN

Portrait Relief I: Arman, 1962.
Philadelphia Museum of Art

ROMAIN KREMER
FOR MUGLER

Fall/Winter 2013 Ready-to-Wear

86

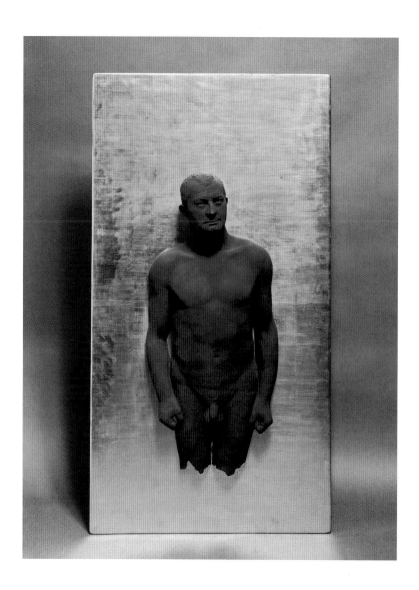

When Yves Klein (1928–1962) died at age thirty-four, the world lost "the last French artist of major international consequence," according to *New Yorker* art critic Peter Schjeldahl. Today, Klein's name is synonymous with International Klein Blue (IKB), the ultramarine color he developed and trademarked in which raw pigment is mixed with a synthetic gel called Rhodopas, which allows the color to retain its brilliance. This intense blue carried spiritual meaning for Klein, who created monochrome works to express the infinite.

In 1962, Klein produced a series of relief portraits of three of his artist friends, including Arman (Armand Fernandez). He made a life-sized plaster cast of his nude subject, which was then cast in bronze, painted with IKB, and attached to a plywood panel covered in gold leaf.

International Klein Blue has become a cult classic in fashion, appealing to numerous designers. In 2010, Nicola Formichetti became the artistic director of Thierry Mugler, changed the brand name to Mugler, and launched the revival of the brand's menswear collection in collaboration with Romain Kremer. This ultramarine colored suit was part of their Fall/Winter 2013–14 collection.

ALEXANDER CALDER

Untitled, circa 1942

© Alexander Calder

JEAN PAUL GAULTIER

Spring 2003 Ready-to-Wear

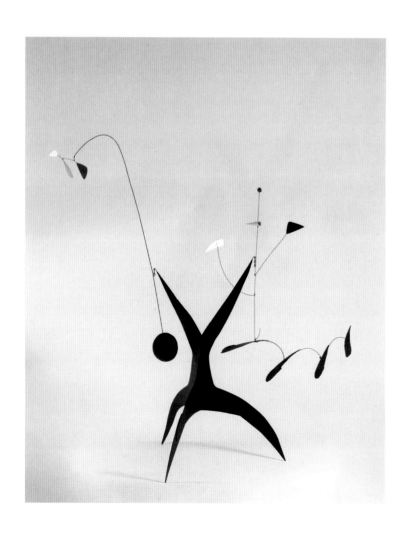

How can a designer possibly transform a moving, three-dimensional metal sculpture into a convincing piece of clothing? Jean Paul Gaultier "got carried away with the idea of Alexander Calder's mobile sculptures, a concept he worked into a frenzy of visual quips about strings and suspension," Sarah Mower wrote in *Vogue* in 2002. The sophisticated wit of Calder's work obviously appealed to Gaultier, who started his show with circus acrobats twirling on rings and swings, a reference to Calder's famous circus sculpture (1926–1931).

The garments most true to Calder's aesthetic were Gaultier's swimsuits of abstract shapes in Calder's palette of vivid-colors. The swimsuits were held together with black strings that imitated structural elements of Calder's work. Gaultier's clothing was put into motion as the models walked the catwalk, much as Calder's mobiles move in the wind.

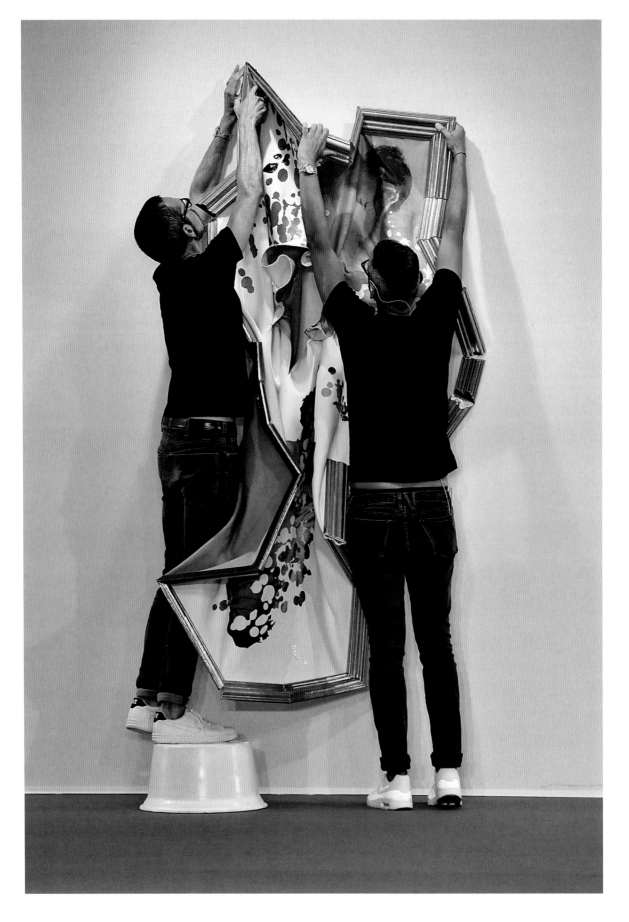

VIKTOR & ROLF

Fall/Winter 2015 Haute Couture

—

Fall/Winter 2015 Haute Couture

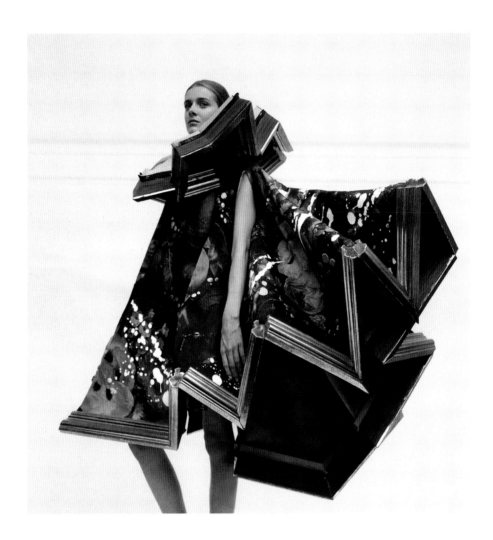

In 2015, Viktor & Rolf created the ultimate collision of art and fashion: a dress that both clothes the body and hangs on the wall in a frame. Through a system of hinged frames, the dress transformed from outfit into artwork. "Its crumpled, splattered, and suspended structure," wrote one journalist, "gave the impression of a masterpiece that had been rescued from a garbage compactor a few minutes too late."

Dutch designers Viktor Horsting and Rolf Snoeren are known for avant-garde luxury design that challenges conventional preconceptions of fashion. The designers were active participants in the runway presentation of the collection, titled Wearable Art.

They were busy removing this dress and other hinged items from models, converting them into paintings, and installing them on a large white wall. A white wall is where they will ultimately be seen, as the Dutch art collector Han Nefkens purchased the collection and donated it to the Museum Boijmans Van Beuningen in Rotterdam.

CONSTANTIN BRÂNCUȘI

Endless Column, Version I, 1918.
Museum of Modern Art, New York

JUNYA WATANABE

Spring/Summer 2010 Ready-to-Wear

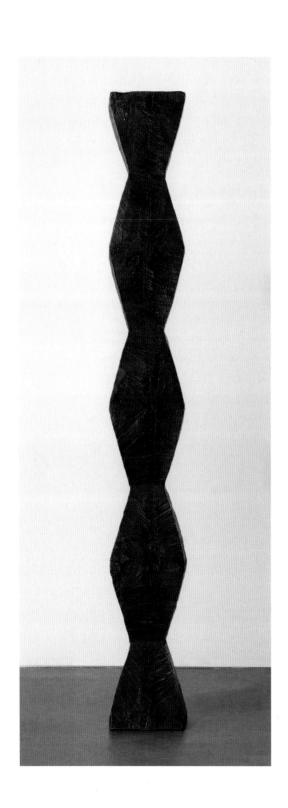

Endless Column by Romanian artist Constantin Brâncuși (1876–1957) was one part of a three-piece ensemble designed to commemorate a key event in Romania's history, the November 1916 battle of Târgu Jiu, where Romanians held off approaching German forces. One of several versions of *Endless Column* that Brâncuși executed in varying sizes and materials, the Romanian War Memorial in cast-iron ore is 98 feet high and is his only monumental outdoor sculpture. Both the war memorial and this version achieve their effect with a series of equal rhomboid units and characteristic half-units at either end that lead the eye into space to express the concept of the infinite.

Individualistic Japanese designer Junya Watanabe incorporated structural precision and geometric form into clothes that echo the force and clarity of Brâncuși's sculpture. The rhomboid outlines and silhouette of his Spring/Summer 2010 tailored trouser suit remind us of Brâncuși's *Endless Column*, especially the accompanying hat.

GERHARD RICHTER

Abstract Painting, 1995

GABRIELE COLANGELO

Spring 2012 Ready-to-Wear

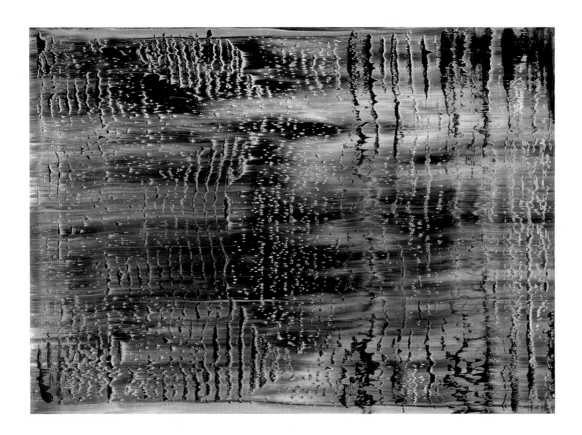

German artist Gerhard Richter—considered by some critics the most important painter of the twentieth century—has achieved eminence creating both abstract and figurative painting. He turned to abstraction after having risen to prominence in the late 1960s as a painter employing photographic imagery, a practice that he continued throughout his long career. In his abstract pictures, Richter builds cumulative layers by brushing big swathes of primary color onto his canvas, then rubbing and scraping the layers with a squeegee to expose variegations in prior layers and thus reveal surprising imagery.

It was Richter's paintings that inspired Gabriele Colangelo's fabric innovation for his Spring/Summer 2012 collection.

Colangelo experimented with creating new effects with jacquard, a textured fabric in which the design is woven rather than printed, dyed, or embroidered on top of the fabric. Colangelo works to create novel effects, such as the appearance of faux paint splotches on material that hasn't absorbed paint, or the look of water bubbles trapped in the design. Richter's paintings are obviously the perfect inspiration for this experiment.

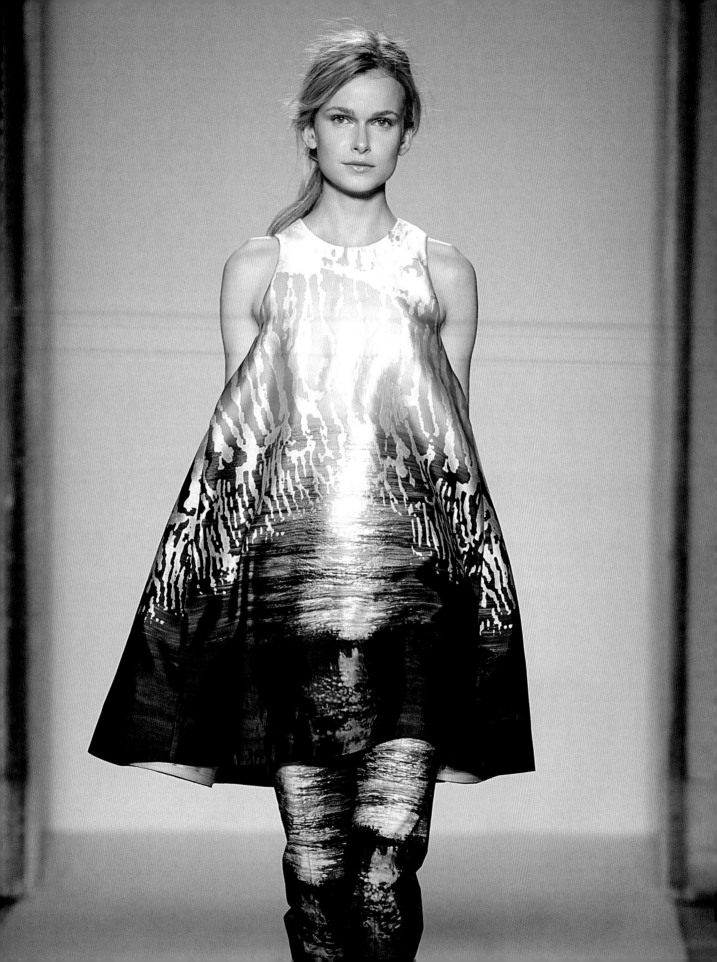

THEO ALTENBERG

Untitled Nº 8, 2009

JOHN GALLIANO

Fall/Winter 2010 Haute Couture

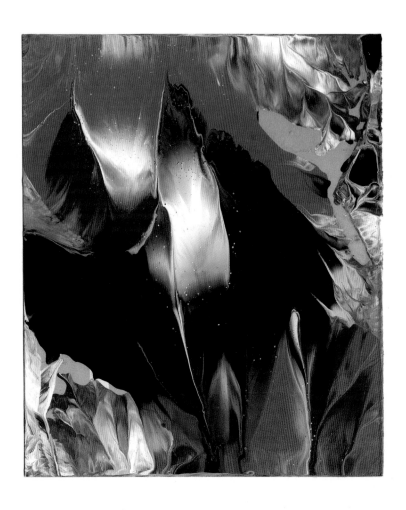

Though not a direct influence, the abstract painting of Theo Altenberg (b. 1952) strikes synchronicity with John Galliano's gown. Their palettes are nearly identical—a combination of soft lilacs and pinks, shimmering blues, and rose with black.

While there are countless collaborations between artists and designers, there are also more subtle signs of influence. Many designers keep mood boards of swatches and images, or they may assimilate an artist's palette or images, even indirectly. Inspiration comes from many angles.

MICKALENE THOMAS

Racquel Reclining Wearing Purple Jumpsuit, 2016

LOUIS VUITTON

Spring 2010 Ready-to-Wear

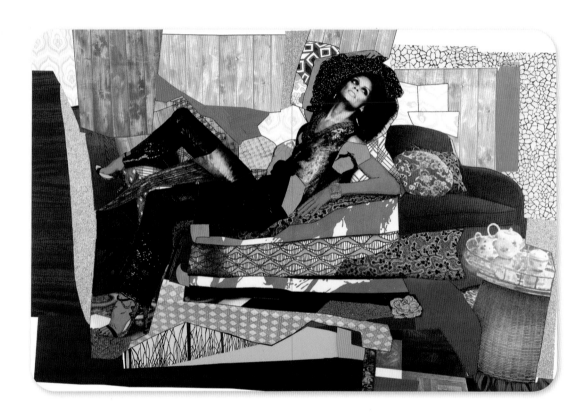

Mickalene Thomas centers her practice on female sexuality, beauty, and power. Thomas is an artist with an international reputation, but the starting point that defined her future course—what has been called "a defining touchstone of her practice"—was a 2002 series of photographs of her mother and herself. Her multi-textured, rhinestone-encrusted paintings of women in domestic settings often feature depictions of fashion and textiles.

Thomas felt fashion was always "in the back of my mind" as a source of inspiration, according to Anya Sacharow in her book *Brooklyn Street Style: The No-Rules Guide to Fashion*. The metallic jumpsuit in Thomas's painting *Racquel Reclining Wearing Purple Jumpsuit* could have come directly out of Marc Jacobs's Spring/Summer 2010 collection for Louis Vuitton, with its postpunk/hippie vibe. Jacobs's style mashups were individualistic; his combination of patterns, toggles, tassels, and fur tails seem straight out of Thomas's playbook.

BC (3733), 2012 Raf Simons × Sterling Ruby, Fall 2014

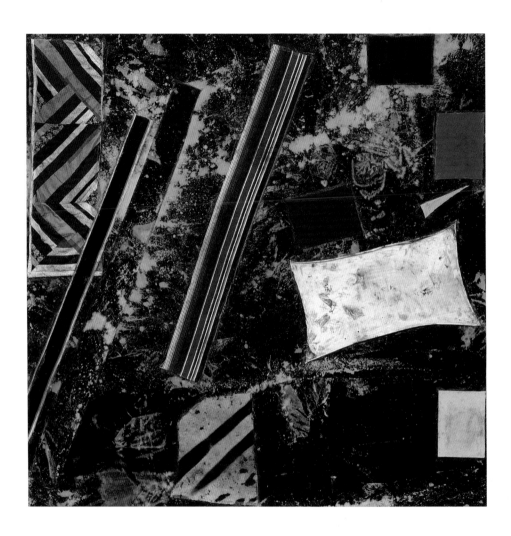

It was a meeting of the minds when Belgian fashion designer Raf Simons encountered American-born, Los Angeles–based artist Sterling Ruby (b. 1972). The duo discovered a shared love of punk and a deconstructed aesthetic. In 2008, Simons invited Ruby to design his Tokyo boutique. Using the store as a blank canvas, Ruby threw paint on the all-white walls and splashed bleach on the black plinths, producing what one fashion blogger called "something beautiful, simultaneously minimal, and chaotically expressive."

In 2009, the pair created a collection of jeans and jackets with denim bleached by Ruby. In 2012, Simons created satin fabric from Ruby's paintings and designed three dresses and a coat featuring these fabrics in his debut haute couture women's collection with Christian Dior. This men's coat with collaged fabrics was from the Fall 2014 capsule menswear collection presented during Paris Fashion Week, which *Vogue* called "a full-on, both-names-on-the-label mind-meld."

After Simons moved from Dior to Calvin Klein in 2016, more collaborations followed: art installations for the CK Fall 2017 and Spring 2018 runway shows, as well as the redesign of the New York showroom, the Paris headquarters, and the interior of the Madison Avenue flagship store.

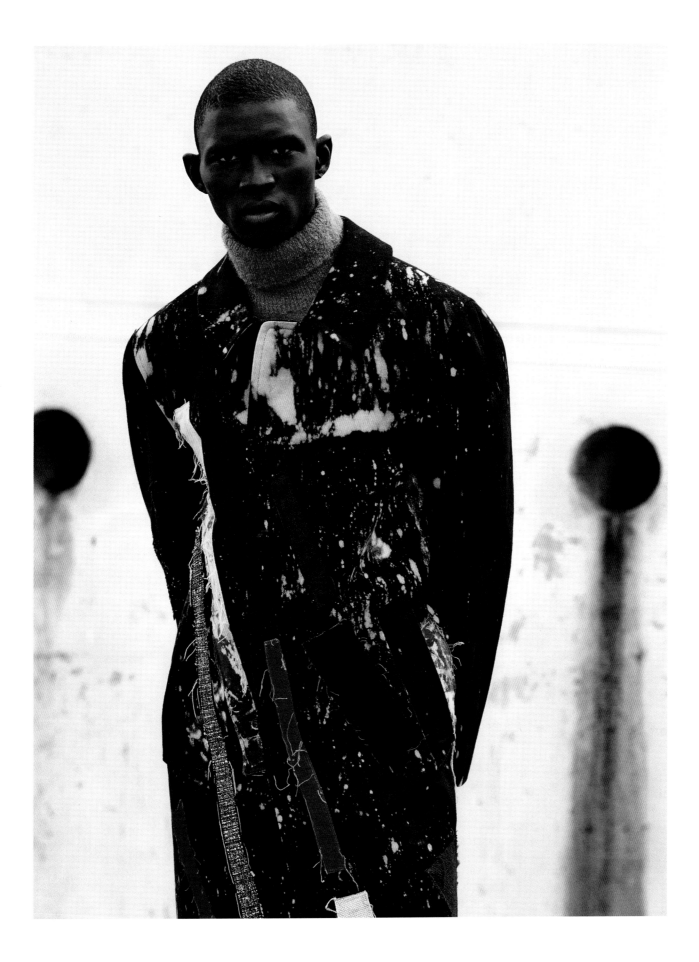

JEAN PAUL GAULTIER

Spring 1994 Ready-to-Wear

Tattoos have for thousands of years served as "amulets, status symbols, declarations of love, signs of religious beliefs, adornments and even forms of punishment." Tattoos appear on Egyptian figurines of c. 4000–3500 B.C.E., tomb scenes dating to c. 1200 B.C.E., and mummies from c. 2000 B.C.E. African cultures (Nubian, Libyan, Algerian, Nigerian), Scythian and Thracian cultures, Mongolians, the ancient pre-Columbian cultures of Peru and Chile, Polynesians, Native Americans, and Inuit, Chinese, and other cultures have all adopted tattoos.

Full-body tattoos, known as bodysuits, often incorporate designs reflecting a person's status, ancestry, and abilities—a true expression of identity. Bodysuits were the ultimate expression of Japanese tattooing, known as *irezumi*, which was inspired by woodblock printing. Popularized during the Edo period (1603–1838), Japanese bodysuits (*soushinbori*) were traditionally a male art form but are currently popular with women as well.

The most famous example of tattoos on the runway was Jean Paul Gaultier's Spring/Summer 1994 runway show, Les Tatouages, selected by *Vogue* as one of twenty-five most unforgettable shows of the 1990s. Walking in that show, supermodel Christy Turlington sported an imitation nose ring and piercings, as well as Gaultier's tattoo bodystocking inspired by tattoo bodysuits.

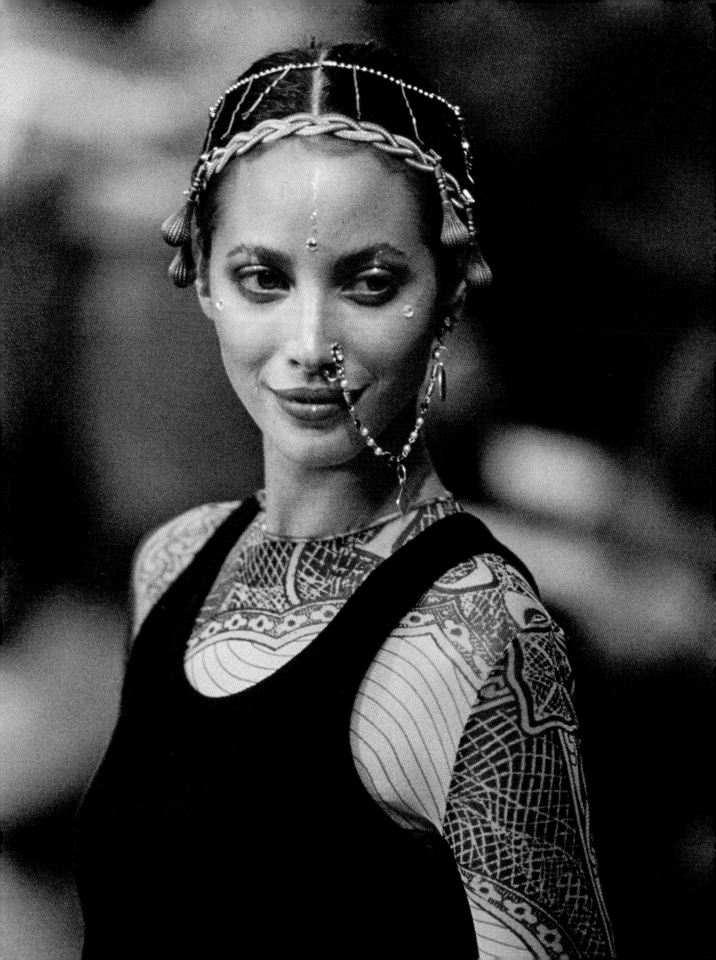

ARTISTS
COLLABO
IN

ORATING

FASHION

GUSTAV KLIMT

Fritza Riedler, 1906. The Belvedere, Vienna

———

Emilie Flöge in a reform dress designed by
Eduard Josef Wimmer-Wisgrill, 1909

VALENTINO

Fall/Winter 2015 Ready-to-Wear

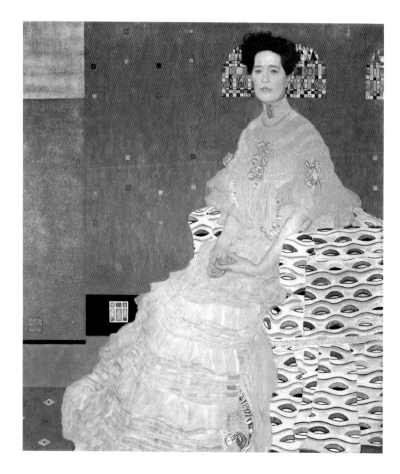

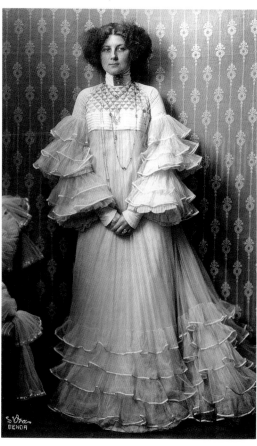

Gustav Klimt (1862–1918), known for ravishingly beautiful paintings accented with gold leaf, was also involved with reform fashion. Reform clothing—loose and comfortable—rejected the heavy ornamentation and tight corsets of the Edwardian era as harmful to one's health and a source of women's political and economic oppression. Considered avant-garde, the style was espoused by Klimt and Emilie Flöge (1874–1952), the Viennese couturier and Klimt's lifetime companion.

In 1895 Emilie's eldest sister, Pauline, opened a school for dressmakers, where Emilie learned her craft as a seamstress. In 1903, the Flöge sisters opened Schwestern Flöge, their fashion boutique in Vienna. The salon, designed in the Jugendstil style by architect Josef Hoffmann, presented clothing in the style of the Wiener Werkstätte. Klimt made clothing labels for the business and also drew some of its garments.

In both Klimt's 1906 portrait of Fritza Riedler and the 1909 photograph of Emilie in a reform dress, the subjects wear loose-fitting garments accessorized with Wiener Werkstätte jewelry. Valentino designers Maria Grazia Chiuri and Pierpaolo Piccioli, inspired by reform fashion and Flöge's design, produced a beautiful update of the earlier dresses—shorter, less fussy and entirely modern—for their Fall 2015 ready-to-wear collection.

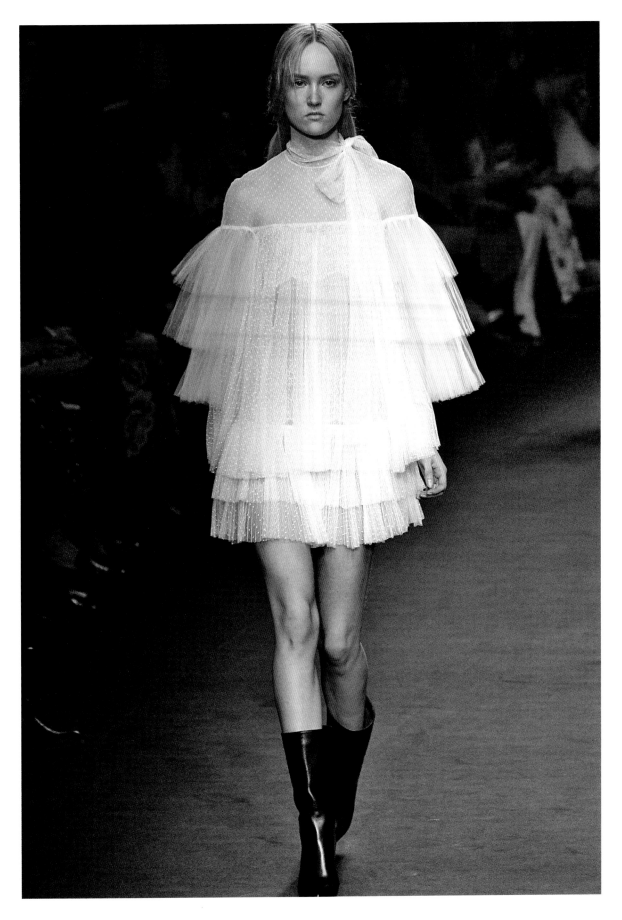

Maison et Jardin, 1915

La Perse coat in textile
designed by Raoul Dufy, 1911.
Metropolitan Museum of Art, New York

Raoul Dufy (1877–1953), who studied at the prestigious École des Beaux-Arts in Paris, was a painter of pursuit-of-pleasure scenes, including views of the French Riviera, yachting scenes, and chic parties. He was also a designer of textiles, theatrical sets, tapestries, ceramics, and prints, all informed by the same style as his paintings.

In 1911, Dufy broke into textile design under the guidance of French designer Paul Poiret, who founded a short-lived woodblock printing factory. The following year, Dufy left to join the textile firm Maison Bianchini-Férier, but he maintained a long collaboration with Poiret, designing the fabric for some of his most important fashions. Among these was the bold, woodblock-printed design for Poiret's coat La Perse, a pattern that was also used as a wall treatment for Poiret's avenue d'Antin salon.

The Orientalism that inspired the coat had been a cultural influence since the late nineteenth century but peaked with the first appearance of the Ballets Russes in Paris in 1909. Around this time, Poiret began using Eastern motifs in his designs, including harem pants, kimono coats, and details such as the silk lining of the La Perse coat in the blue-green color of Persian tiles.

FORTUNATO DEPERO

Ciclista attraverso la città, 1945.
Museo di Arte Moderna e Contemporanea
di Trento e Rovereto

———

Fortunato Depero and Filippo Tommaso
Marinetti in Futurist waistcoats, 1924

———

© Fortunato Depero

Italian poet, editor, and promoter of art Filippo Tommaso Marinetti (1876–1944) coined the term Futurism to describe an art movement that rejected traditional forms to embrace technology. The speed and sensations of modern life were given visual form, and the car, the airplane, and the industrialized city were symbols of the philosophy. By 1918, the most vital phase of the movement had ended, though aspects of Futurism survived through the 1920s and 1930s.

Fortunato Depero met Marinetti in 1915 in Depero's studio in Rome. In 1923 and 1924, they designed Futurist garments, presumably in response to the "Futurist Manifesto of Men's Clothing" by Giacomo Balla, which stated, "For quite some time now we have been convinced that today's clothes ... are still atrociously passéist. WE MUST DESTROY ALL PASSÉIST CLOTHES, and everything about them which is tight-fitting, colorless, funereal, decadent, boring, and unhygienic. As far as materials are concerned, we must abolish: wishy-washy, pretty-pretty, gloomy, and neutral colors, along with patterns composed of lines, checks and spots."

Depero's design and modeling of a Futurist vest was not his only flirtation with fashion. After moving to New York in 1928, he designed covers for various magazines, including *Vogue*.

GEORGE PLATT LYNES

Salvador Dalí, 1939. Metropolitan Museum of Art, New York

ELSA SCHIAPARELLI

Woman's dinner dress designed in collaboration with Salvador Dalí, 1937. Philadelphia Museum of Art

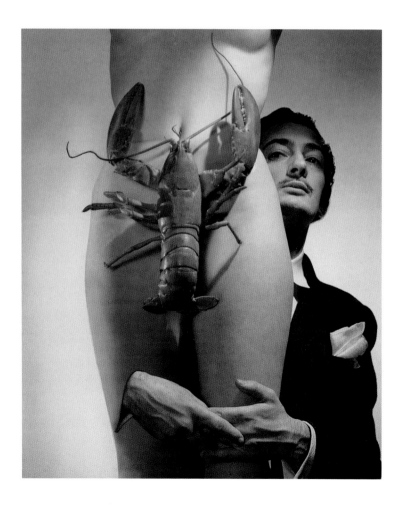

Salvador Dalí (1904–1989) created costumes, hats, and jewelry throughout his career. In the mid-1930s, he collaborated with avant-garde designer Elsa Schiaparelli on a series of notable outfits, including the Lobster Dress created in February 1937. Fashioned of cream-colored silk that included synthetic horsehair by master silk maker Sache, it featured a coral waist-piece and a lobster hand-painted by Dalí. A year earlier, Dalí created Lobster Telephone, marking the beginning of his obsession with the lobster as a symbol of castration in his personal iconography.

The lobster motif had a fascinating history. The eccentric British poet Edward James supposedly tossed a lobster shell, which landed atop his telephone. Dalí's Lobster Telephone was the result. The lobster motif appeared again in Dalí's work when he designed the Dream of Venus Pavilion for the 1939 New York World's Fair, and he incorporated a lobster into his pose when he had his portrait taken by George Platt Lynes, a fashion photographer.

Elsa Schiaparelli was born to an aristocratic Roman family in 1890. On a transatlantic ocean crossing to America in 1916, she met Gabrièle Buffet-Picabia, wife of the Dadist painter Francis Picabia, sparking her interest in Dada and Surrealist art and a New York artistic circle that included Man Ray, Alfred Stieglitz, and Marcel Duchamp.

Schiaparelli's numerous collaborations, many with Dada and Surrealist artists, produced some of the most renowned fashion of the twentieth century. In addition to the Lobster Dress, Dalí and Schiaparelli collaborated on the 1938 Tears Dress, the Skeleton Dress, and the famous Shoe Hat. In 1937, Schiaparelli collaborated with French avant-garde poet Jean Cocteau on an evening coat featuring Cocteau's trompe l'oeil faces.

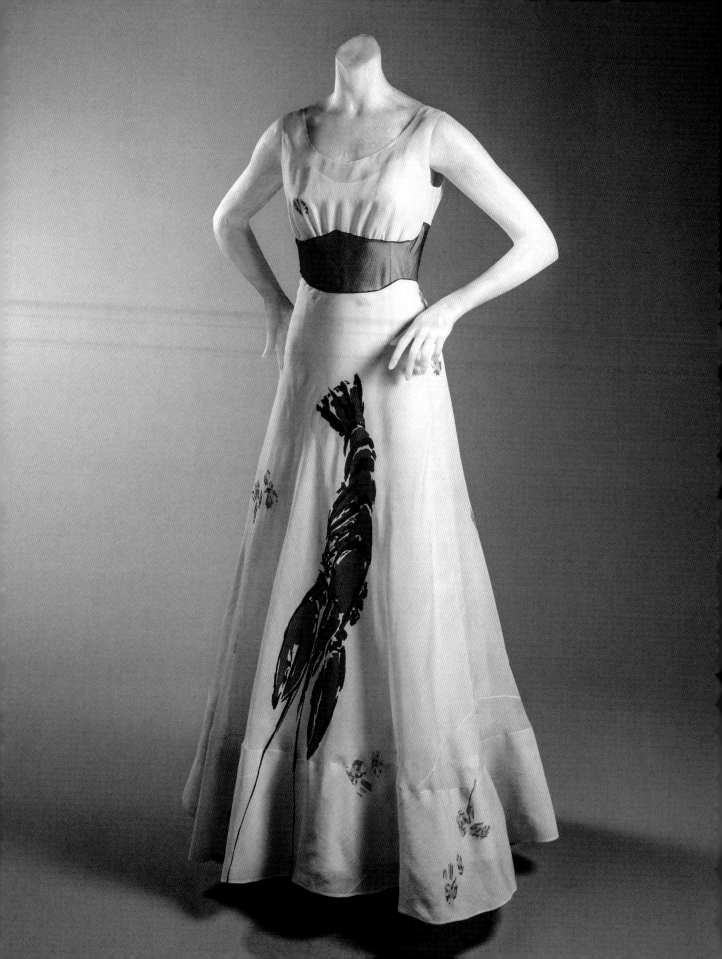

ANDY WARHOL

Portfolio of Marilyn Monroe, 1962-1967
———
© Andy Warhol

GIANNI VERSACE

Spring/Summer 1991,
photographed by Irving Penn

114

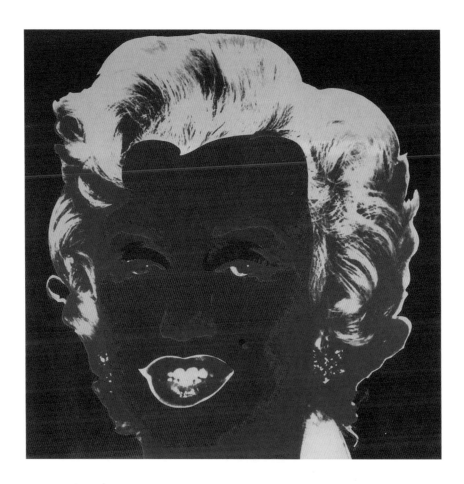

Artist Andy Warhol (1928–1987), a self-styled Pop icon, fashioned images of American consumer and celebrity culture—Brillo boxes, Campbell's soup cans, Marilyn Monroe, Liz Taylor, Elvis Presley, and many others—into the most recognizable art of our time. His icons represented popular dreams and desires. Marilyn Monroe, for example, was the personification of sexuality. When Monroe died of a presumed overdose in August 1962, the world was shocked. Between her death and January of the following year, Warhol created a total of twenty silkscreen paintings from the same image of the star.

Italian fashion designer Gianni Versace compounded the public's interest in Warhol's Monroe by creating a jewel-encrusted Marilyn gown and a bevy of glittering accessories based on the image (interspersed with the occasional image of James Dean). According to the Metropolitan Museum of Art Costume Institute (which now owns the gown), Versace had a passion for Warhol, whom he considered a soulmate. The dress was worn by supermodel Linda Evangelista for a 1991 Irving Penn photograph.

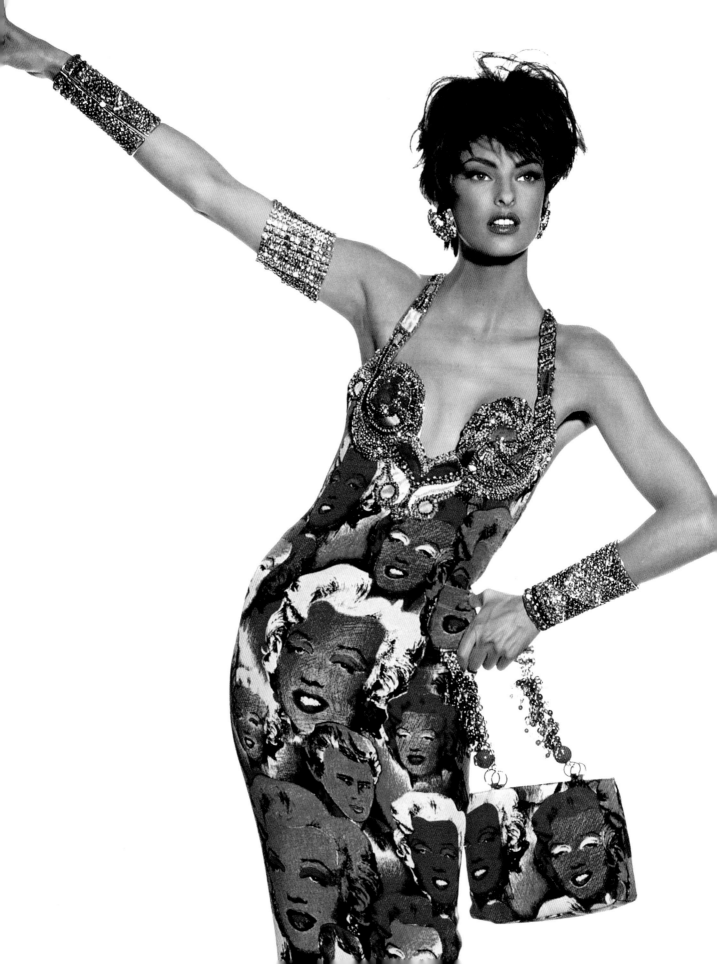

YAYOI KUSAMA

I Who Have Arrived in Heaven,
David Zwirner, 2013

———

Kusama store window,
Louis Vuitton, New York

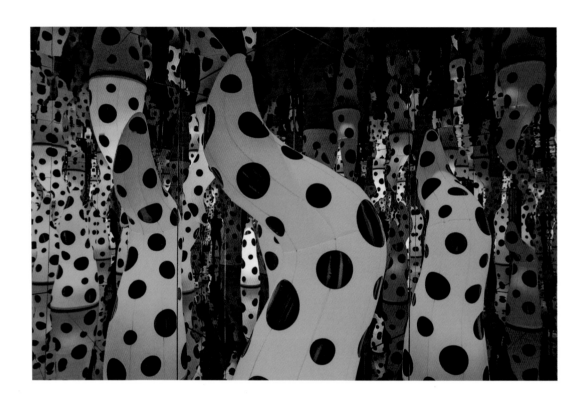

Yayoi Kusama is a worldwide art and fashion sensation. Born in 1929, Kusama was a central figure of the New York avant-garde scene in the 1960s, where she organized weekly happenings that involved participants painted with polka dots at venues such as Washington Square Park, the Brooklyn Bridge, and the Museum of Modern Art sculpture garden.

Kusama actively participated in fashion throughout her career. Her unique style was reflected in the clothing she designed for herself—from the macaroni-encrusted dresses of the 1960s, to the bespoke fabric outfits with patterns taken from her paintings, to her signature polka-dot dresses. In 1969 she founded Kusama Enterprises, a fashion label selling her clothing and textiles from her own boutique on Sixth Avenue in New York. She subsequently staged numerous fashion shows throughout Europe and Asia.

Kusama collaborated with several designers, including Stephen Sprouse and Takashi Murakami, Her most extensive collaboration in 2012 with Louis Vuitton included a vast capsule collection of bags, shoes, jewelry, clothing, and accessories covered with Kusama's dots. It also involved seven dedicated pop-up shops in Hong Kong, Tokyo, Singapore, London, and Paris, as well as the largest single brand take-over ever staged by Selfridges in London. Kusama-designed window displays appeared in 460 Louis Vuitton stores in 64 countries, each with a wax mannequin of Kusama carrying a Vuitton bag, as shown here.

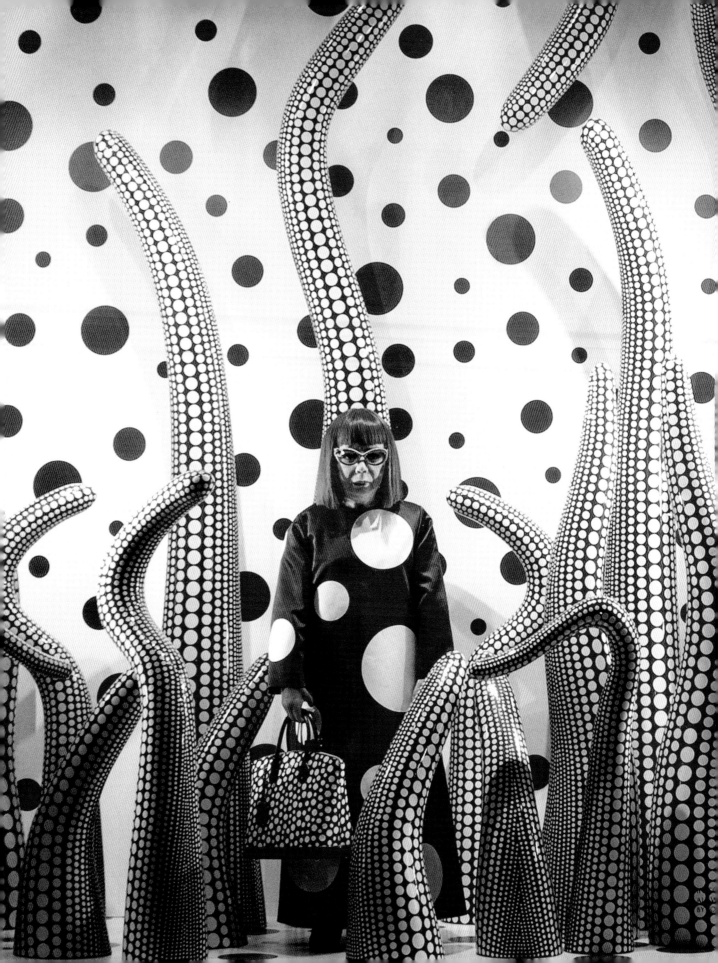

CINDY SHERMAN

Untitled, #458, 2007–2008

———

Advertisement for
Comme des Garçon, 1994

———

© Cindy Sherman

No one exemplifies the collision of art and fashion better than Cindy Sherman (b. 1954), an artist whose photography-based work addresses the identity of women and stereotypes about them, as well as issues of what constitutes feminine beauty, desirability, and authenticity. More than any other artist, Sherman has hit these significant issues head on and in the process has redefined the fashion photograph, fashion representation and fashion advertising. In her oeuvre, Sherman transforms herself through clothes, wigs, makeup, and prosthetics to portray a variety of feminine identities, from the ingénue to the aging party girl.

Fashion has played an integral and consistent role in Sherman's creative output throughout her career. Starting with her earliest collaboration with the New York store Dianne B. Benson in 1983, Sherman has produced campaigns and collaborations with numerous high fashion brands from Marc Jacobs to Louis Vuitton, Undercover and Supreme. In 1994 Sherman was given free rein to create advertising for Rei Kawakubo's Comme des Garçons, where she subverted the traditional perfection of fashion photography. She has produced fashion editorials for *Harper's Bazaar* and in 2008 was invited to produce six large-scale photographs of subjects wearing Balenciaga clothing, an assignment she used to call into question attitudes toward attractiveness and female aging. For *Garage* magazine she shot garments from the Chanel archive with photoshopped backdrops of locations including the apocalyptic volcanic eruption of 2010 in Iceland.

WILLIAM WEGMAN

Sunday Best, 1994

———

Flo and Topper modeling Chanel,
Paris Vogue, 2017

———

© William Wegman

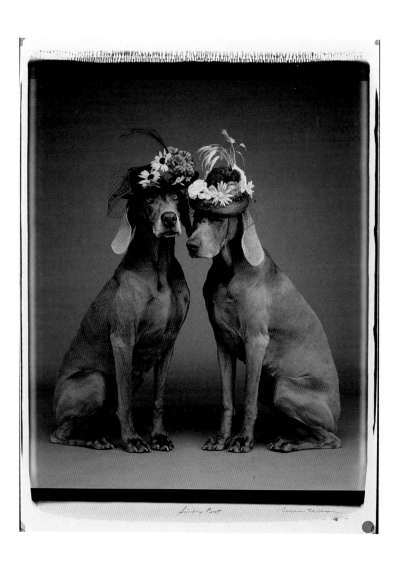

William Wegman (b. 1943) has a delicious sense of humor. At the heart of his art is an irreverent desire to turn the ordinary inside-out. A key figure of West Coast conceptual and video art, Wegman in 1970 hit upon using his beloved Weimaraner Man Ray as the lead model for his Polaroid portraits. The collaboration continued with another Weimaraner Wegman wittily named Fay Ray, in a nod to her predecessor, and in reference to the actress best known for her work in the original 1933 *King Kong* film.

Wegman's work for *Vogue Paris* humorously critiques the very medium of fashion photography, substituting his dogs Flo and Topper for high-fashion models. Wegman has noted that Weimaraners have a "cool, blank" gaze like that of many human models. It is the absurdity of Wegman's elegant canine-supermodel substitution that makes this translation of his work into fashion so funny and appealing.

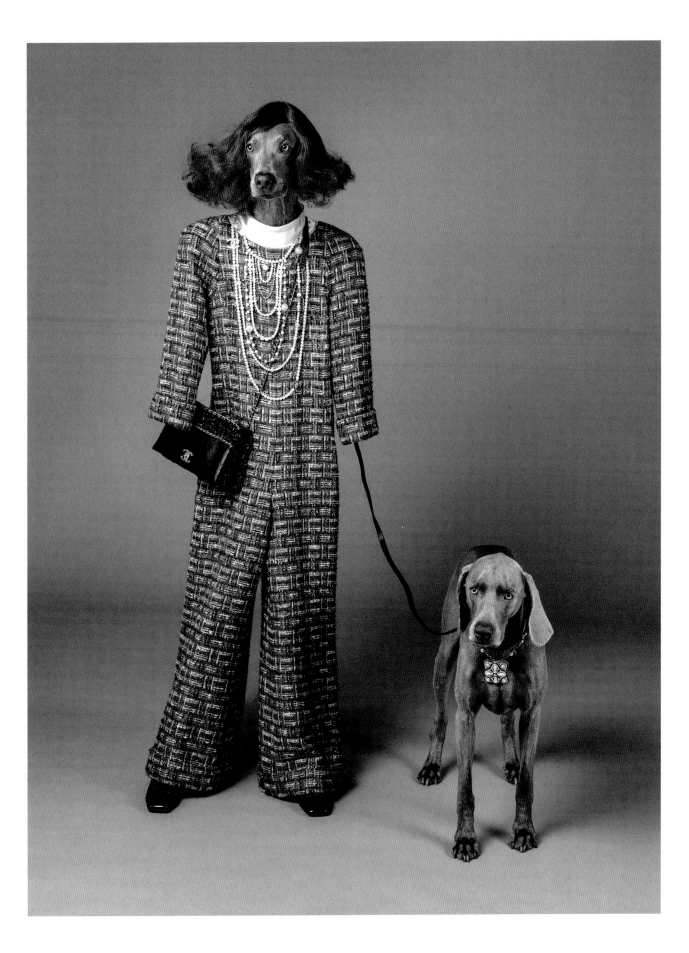

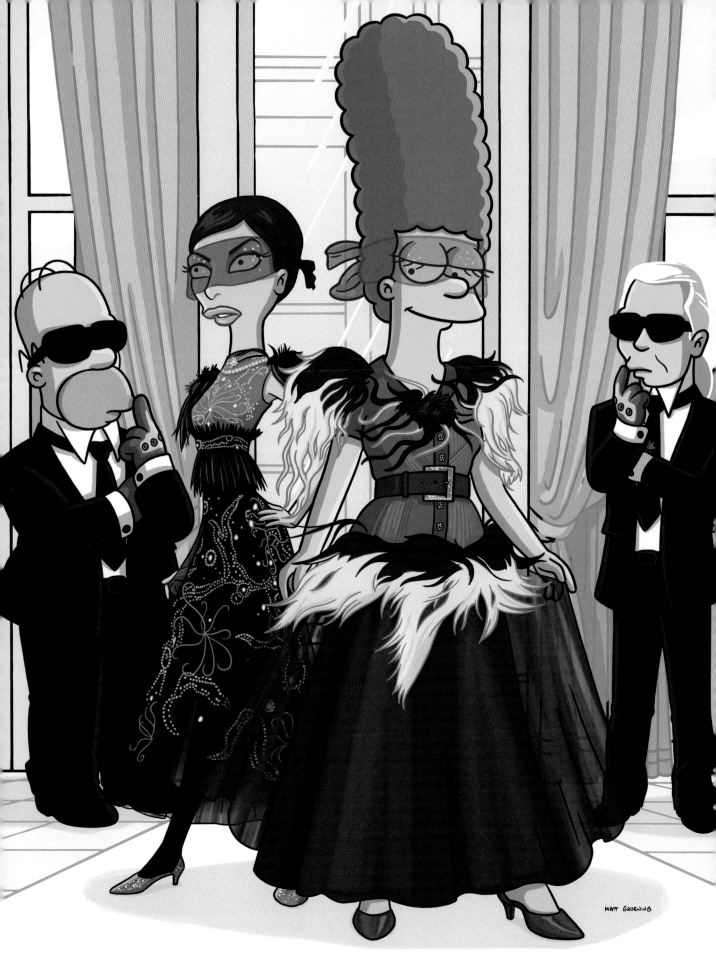

MATT GROENING

"The Simpsons Go to Paris with Linda Evangelista," *Harper's Bazaar*, August 2007.

CHANEL BY KARL LAGERFELD

Spring 2007 Haute Couture

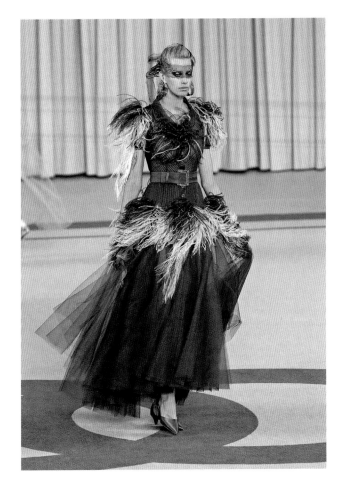

Matt Groening (b. 1954) is a formidable force in popular culture. Best known as the creator of *The Simpsons*, he is an American cartoonist, writer, producer, animator, and voice actor. Groening's genius was to create recognizable characters in a tongue-in-cheek storyline with its finger on the pulse of popular culture.

Groening and Julius Preite imagined the collision of America's favorite working-class family with the world of Parisian haute couture for a *Harper's Bazaar* article titled "The Simpsons Go to Paris with Linda Evangelista." Homer Simpson mimics the Chanel designer Karl Lagerfeld's signature

mode of dress—the tuxedo, wing-collared shirt, and gray gloves—as well as his gestures and aloof attitude. Both Homer and Lagerfeld watch as Homer's wife, Marge, joins Groening's cartoon version of supermodel Linda Evangelista in displaying their beaded and feather-adorned Chanel outfits.

RTP BALDESSARI. 10

JOHN BALDESSARI

Nose/Silhouette: Red, 2010

YVES SAINT LAURENT

John Baldessari with Mario Sorrenti,
W magazine project, 2007,
dress by Yves Saint Laurent

Conceptual artist John Baldessari (1931–2020) once predicted he would be best remembered as "the guy who puts dots over people's faces." Initially, he used price stickers as the dots on appropriated photographs, and then he began both hand-painting and overlaying colored body parts, as well as color-blocking parts of the images. The resulting images could be interpreted by the viewer in multiple ways.

Throughout his career, Baldessari explored the expressive possibilities of isolated body parts, especially noses and ears, and elbows and legs. For the series *Nose/Silhouette,* the artist created an image in which the entire head is color-blocked, leaving only the nose. He used much the same approach for the man's face and hand in an Yves Saint Laurent advertisement, but only somewhat covered the female model's face and leg.

TIM BURTON

Untitled, 1990

TIM WALKER & TIM BURTON

Evelina Mambetova & Sophie Srej,
Fashion: Salvatore Ferragamo & Rodarte,
Photographed in Colchester, Essex, 2009

Internationally acclaimed film director Tim Burton, is also a world-class illustrator trained at the famed CalArts. His unique visual imagination and Goth-inspired style make his work instantly recognizable. His iconic characters include Edward Scissorhands, who, with razor-sharp fingers that render him incapable of touching others directly, is the personification of social isolation and psychological dysfunction. "I felt very tortured as a teenager," Burton has said. "That's where Edward Scissorhands came from. I was probably clinically depressed and didn't know it." Yet Scissorhands—despite his skeletal emaciation, severed hands, and sinister bondage gear—is a figure of soulful appeal and considerable wit.

Tim Walker, a British fashion photographer who once worked as photographic assistant to Richard Avedon, is celebrated for his highly imaginative and fantastical photographs. Walker creates lavish tableaux with elaborate sets and props for his narrative-driven shots. In 2009, Burton and Walker teamed up for a *Harper's Bazaar* editorial destined to become a contemporary classic. It was a match made in heaven. The Goth tenor of Burton's style—evident here in the mangled hair, sunken eyes, the choice of black leather clothing, and the signature scissorhands—combines perfectly with Walker's more whimsical, fantasy-based approach.

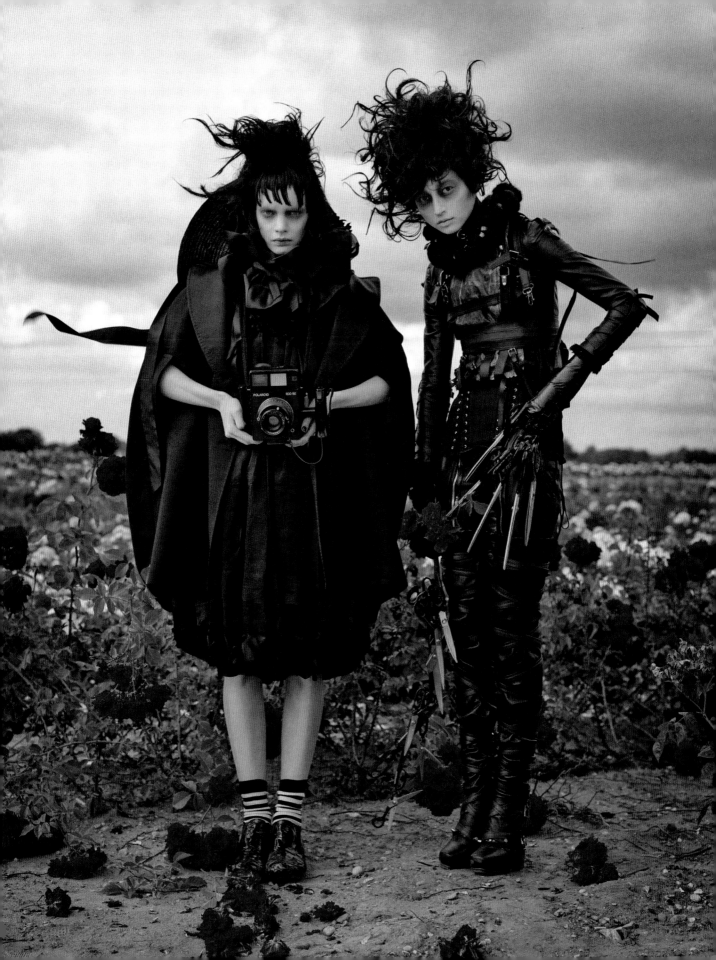

BENJAMIN SHINE

(Dreamer, Flow No. 1) from the Flow series,
made from a single length of uncut tulle,
Canberra, Australia, 2015

JOHN GALLIANO
FOR MAISON MARGIELA

Spring/Summer 2017 Haute Couture

Tulle! This fabric—a fine mesh net with an elegant shimmer and sparkle—is the unlikely primary medium of British artist Benjamin Shine (b. 1978), who has been called today's "foremost fabric sculptor." In a practice that he describes as "painting with fabric," Shine developed his amazing signature technique using an ordinary household iron to crimp tulle into haunting portraits. It is a demanding process requiring 100 to 300 hours per portrait.

In 2017, Shine and designer John Galliano, creative director of fashion house Maison Margiela, collaborated on this trench coat. "I wanted to see if the face could become completely transparent, like smoke engulfing the body with the coat still visible and moving beneath it," Shine explained at the time. "I particularly loved the idea of the tulle flowing from its functional role as the lining of the coat, into the ethereal image."

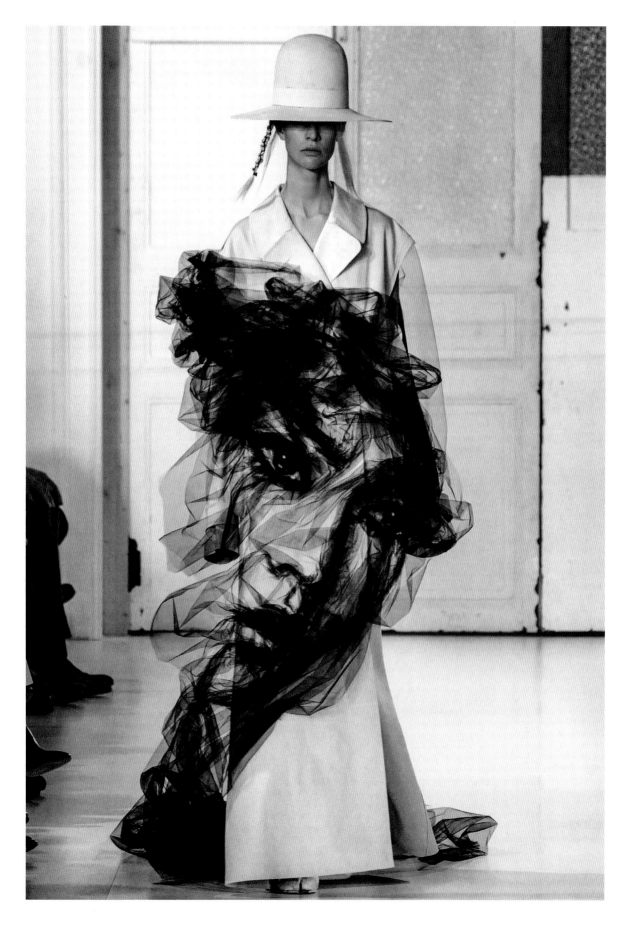

JOHN CHAMBERLAIN

Twilight Twinkle, 1998

MARY KATRANTZOU

Spring/Summer 2012 Ready-to-Wear

Fashion designer Mary Katrantzou's Spring/Summer 2012 collection was inspired by sculptor John Chamberlain (1927–2011). Katrantzou is a master of color, just as Chamberlain was. Here, she chose the same color palette he used—turquoise, cherry red, canary yellow—though Chamberlain's colors were dictated by the hues of the fenders, hoods, doors, and bumpers of the 1960s cars from which

he made his best-known sculptures. In a 1962 review of Chamberlain's work, sculptor Donald Judd wrote, "The hard, sweet, pastel enamels, frequently roses and ceruleans, of Detroit's imitation elegance for the poor [result in a palette] as particular, complex, and structural as any good painter's."

Both Katrantzou and Chamberlain used curling, ribbonlike forms, albeit in different

materials. Katrantzou's innovative digital prints are inspired by a range of sources, including perfume bottles, Fabergé eggs, Qianlong Dynasty China, vintage stamps, and tribal symbolism. Chamberlain's plasticity, exploration of color and surface, and boundary-exploding ideas inspired one of Katrantzou's best collections.

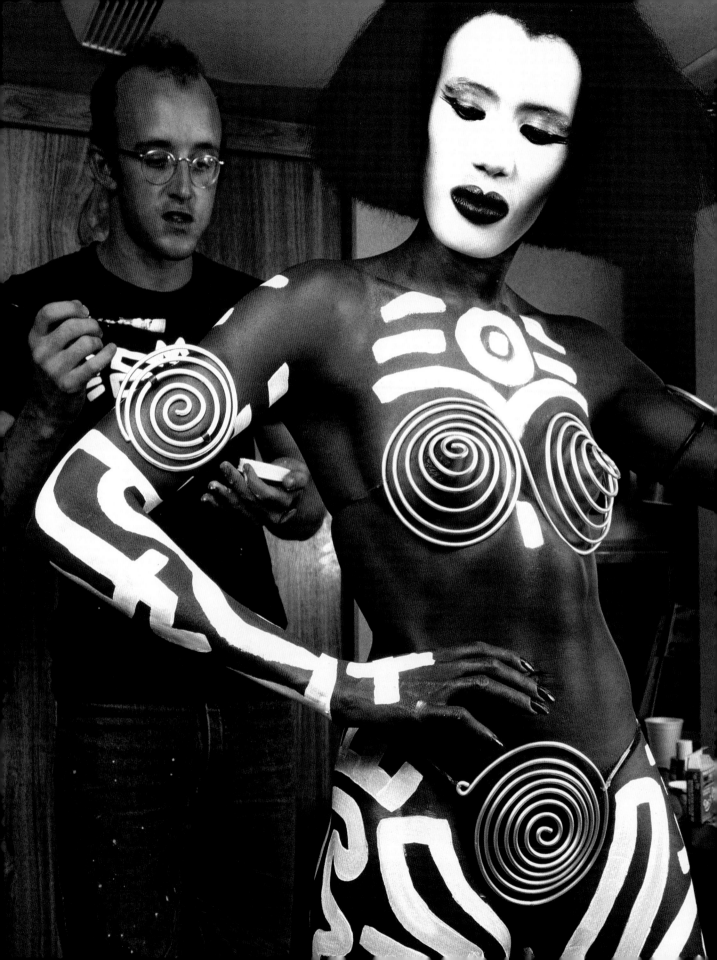

KEITH HARING

Keith Haring body-painting
Grace Jones as Katrina the vampire for
the 1986 comedy-horror film *Vamp*

———

Grace Jones wearing 30' skirt hand-
painted by Keith Haring at the New Year's
Eve concert at Roseland Ballroom,
New York, 1987

It was a moment when the stars aligned: in 1984, three of the most important artists of the late twentieth century—model and musician Grace Jones, artist Keith Haring (1958–1990), and photographer Robert Mapplethorpe (1946–1989)—participated in an eighteen-hour marathon session in which Haring painted Grace Jones with his signature graffiti, which Mapplethorpe then photographed. The three had been brought together by Andy Warhol for his magazine, *Interview*. This was the first of several times Haring painted Jones, as here for her transformation into Katrina the vampire for the 1986 comedy-horror film *Vamp*.

"Keith Me" read a headline in the *Vogue Paris* November 2009 issue dedicated to Haring's graffiti-inspired images. The cover and eleven pages, a tribute to Haring's work with Jones, showed a model body-painted by makeup artist Lucia Pieroni and styled with high-fashion clothes and accessories.

KEITH HARING
Untitled (from Pop Shop IV), 1989

JEAN-CHARLES DE CASTELBAJAC
Fall/Winter 2002 Ready-to-Wear

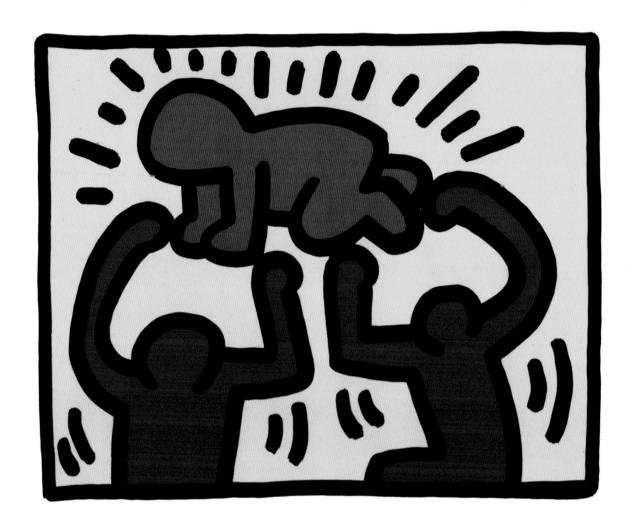

Jean-Charles de Castelbajac is wildly imaginative and uniquely innovative. He creates coats out of teddy bears and Muppet heads, paints on garments, experiments with unusual materials such as tennis ball fabric, and uses imagery from *South Park*, Disney, Snoopy, Legos, advertising logos, and other fragments of popular culture.

Castelbajac is involved with artists and collects French, German, and American art and photography. He became friends with Keith Haring in the mid-1980s, and just days after Haring's death in 1990, the designer received a drawing from his friend in the mail. Castelbajac later used the image on an invitation for a show. More than a decade later, Castelbajac returned to his friend's work (at right), to produce this dress referencing Haring's iconic radiant baby.

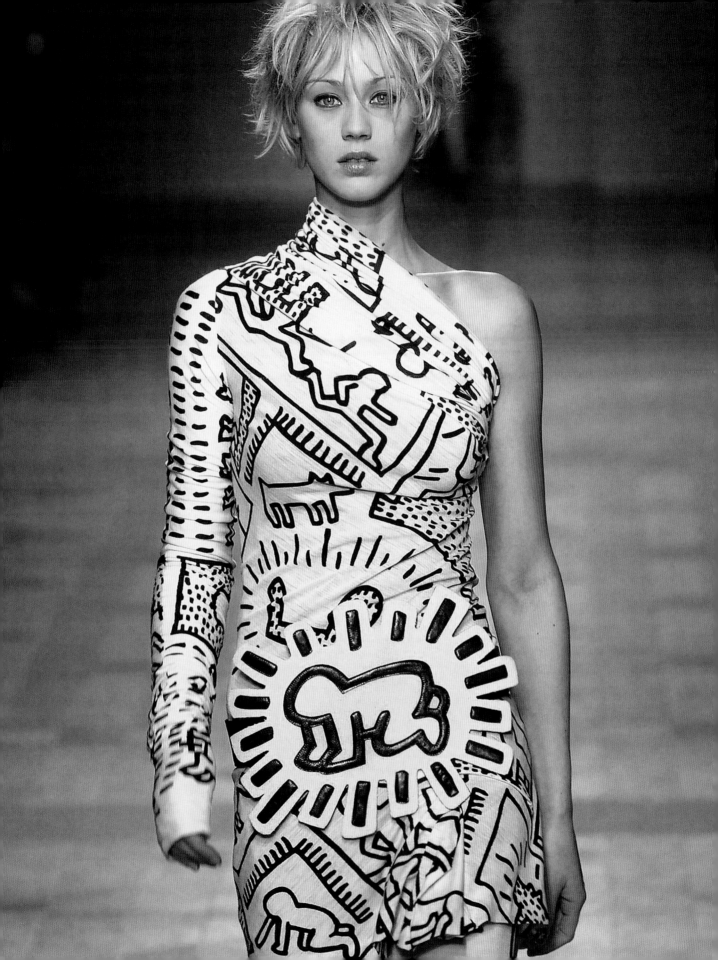

MELISSA KITTY JARRAM

How We Love 3, 2019

BETHANY WILLIAMS

Fall/Winter 2020

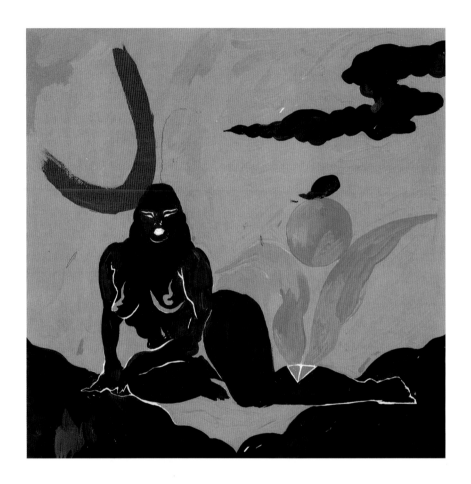

Bethany Williams infuses fashion with social consciousness and environmental responsibility. A London-based menswear designer with a background in art, Williams uses her brand to help society's most vulnerable. Williams, motivated by her concern with waste in the fashion industry, uses only materials that are responsibly sourced, repurposed, and recycled. She has redesigned tents as utility-wear, made coats from recycled blankets, and trained women at Downview prison in garment manufacturing to produce jersey fabric, as well as to teach the inmates a new professional skill. In her collection titled Breadline, Williams used waste materials and recycled cardboard from the Vauxhall Foodbank to create oversized knitwear, jackets, and jeans.

In 2020, Williams enlisted South East London-based illustrator Melissa Kitty Jarram in her collaboration with the Magpie Project, an organization in Newham, in London, that helps mothers who have "no recourse to public funds"—often abbreviated as NRPF—because of their immigration status. In a series of meetings, Jarram listened to the previously untold stories of these "Magpie mums" and drew images representing the important bond between mothers and children. The images Jarram produced, along with drawings by the mothers themselves, were incorporated into Williams' Fall/Winter 2020 collection.

KAWS

Untitled (Calvin Klein), 1999
Acrylic on existing advertising poster

———

KAWS and Mario Sorrenti
Interior spread from *Vogue Paris*,
November 2009

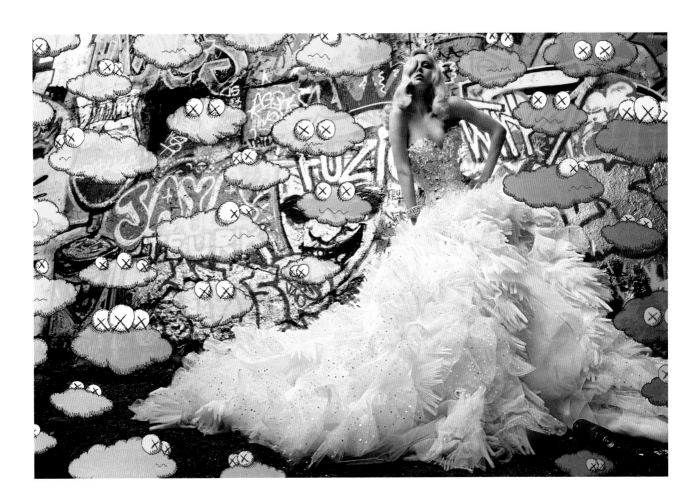

Brooklyn-based artist Brian Donnelly, a.k.a. KAWS, has created a vast body of work that ranges from graffiti writings and street art to industrial and product design, as well as limited editions and fashion. Influenced from the age of twelve by skateboarding, Donnelly adopted the name "KAWS," a purely visual composition with no specific meaning, to garner anonymity.

KAWS's billboard interventions are an important part of his work: existing fashion advertisements are taken from bus shelter display cases, painted over in KAWS's studio, then reinstalled. KAWS developed a signature image—a soft, inflated skull with crossbones and crossed-out eyes—that playfully subverted the marketing purpose of the fashion images. Subsequently, photographer Mario Sorrenti invited KAWS

to collaborate on the cover for the November 2009 issue of *Vogue Paris* and contribute an editorial portfolio. KAWS has intersected frequently with the fashion world throughout his career, starting with the launch of his own fashion label, Original Fake, in the early 2000s, as well as collaborations with fashion brands A Bathing Ape and Comme des Garçons.

DERRICK ADAMS

Floater 83, 2019

KERBY JEAN-RAYMOND
FOR PYER MOSS

Spring/Summer 2019 Ready-to-Wear

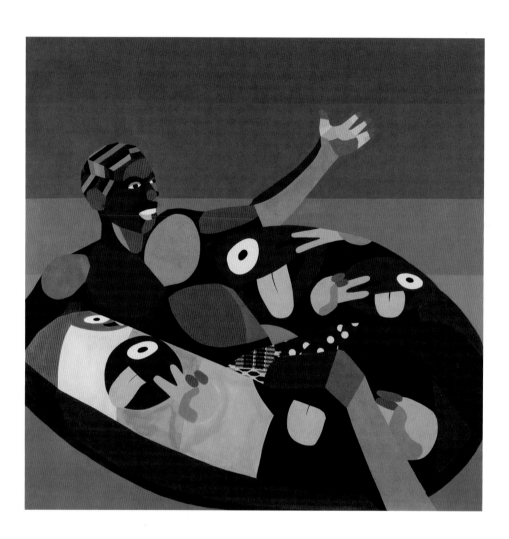

Kerby Jean-Raymond describes the brand he founded in 2013 as an "art project" and each collection as an installation that presents a thesis. He thinks of his clothing as individual works that people collect, like pieces of art. This Haitian-American designer mines American social issues for his fashion design and presents these themes in the most unlikely of places: the runway.

In 2015, the theme of Jean-Raymond's show was police brutality, leading to threats on his life. His runway presentations often featured a live choir named the Pyer Moss Tabernacle Drip Choir Drenched in the Blood that performed a combination of traditional gospel and pop hits. The live choir is now a much-copied fashion-show fixture.

The work of multidisciplinary artist Derrick Adams (b. 1970), including collage, drawing, sculpture, performance, and video, deals with Black identity and American culture. Placing the image of a Black father holding his baby on a Swarovski crystal–covered casual dress—an Adams work on clothing by Jean-Raymond—results in an amalgam of social issues, fashion, and American values.

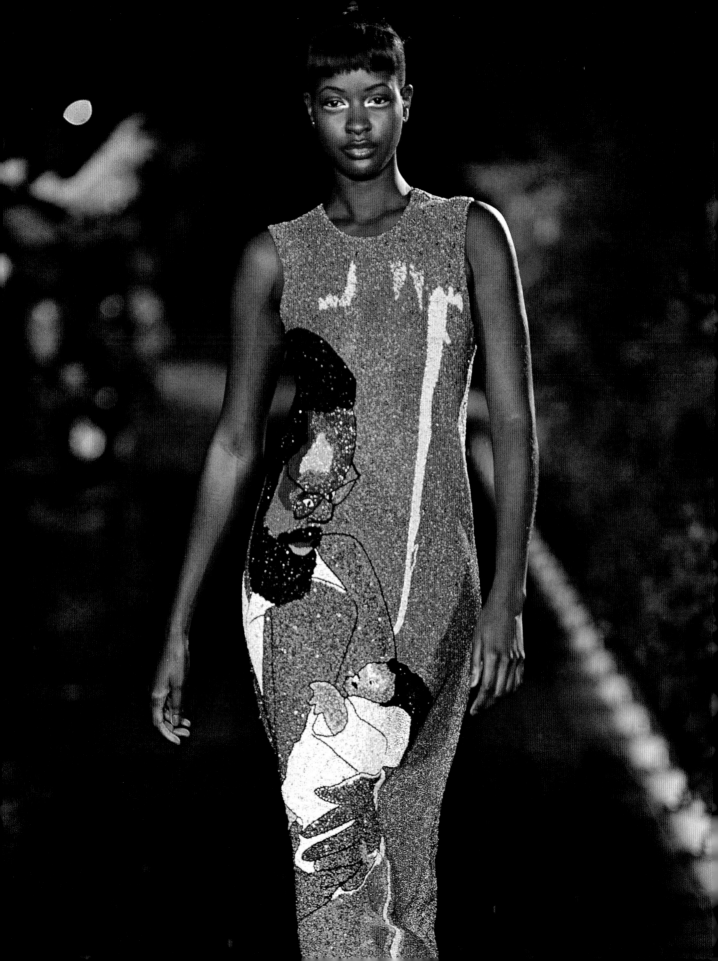

JOE BRAINARD

Flower Painting IV, 1967

LOEWE

Fall/Winter 2021

Joe Brainard (1942–1994) was an American artist, poet, and writer whose "real genius lay in illustration and collage," according to Constance Lewallen, an expert on his work. Brainard's initial ambition at age eight was to design women's fashion, and he did that for his mother. She made and wore his designs, but this idea eventually faded. In 1961, Brainard arrived in New York and began creating collages. Two years later, lacking funds for paint and canvas, he began collecting street detritus and buying trinkets out of which he made three-dimensional assemblages.

In the mid- to late 1970s, Brainard obsessively devoted himself to creating thousands of collages and small paintings on paper, 1,500 of which were exhibited at the Fischbach Gallery in 1975. Among his collages are many of flowers. He created these by painting individually all kinds of flowers that in reality would never be in bloom together and assembling them in an allover pattern, "some say like Jackson Pollock," according to Lewallen.

In 2021, Joe Brainard's artwork and writing inspired the entire men's and women's collections of Loewe, the Spanish luxury design house. Loewe creative director Jonathan Anderson reportedly felt that Brainard's "ability to create things out of the everyday" was the perfect perspective for today's world. He used Brainard's collage as a starting point for the juxtaposition of unexpected visual combinations and startlingly original methods of wrapping, tying, and draping of garments. Brainard's bright overall fields of flowers, including his signature pansies, appeared on Loewe garments and accessories.

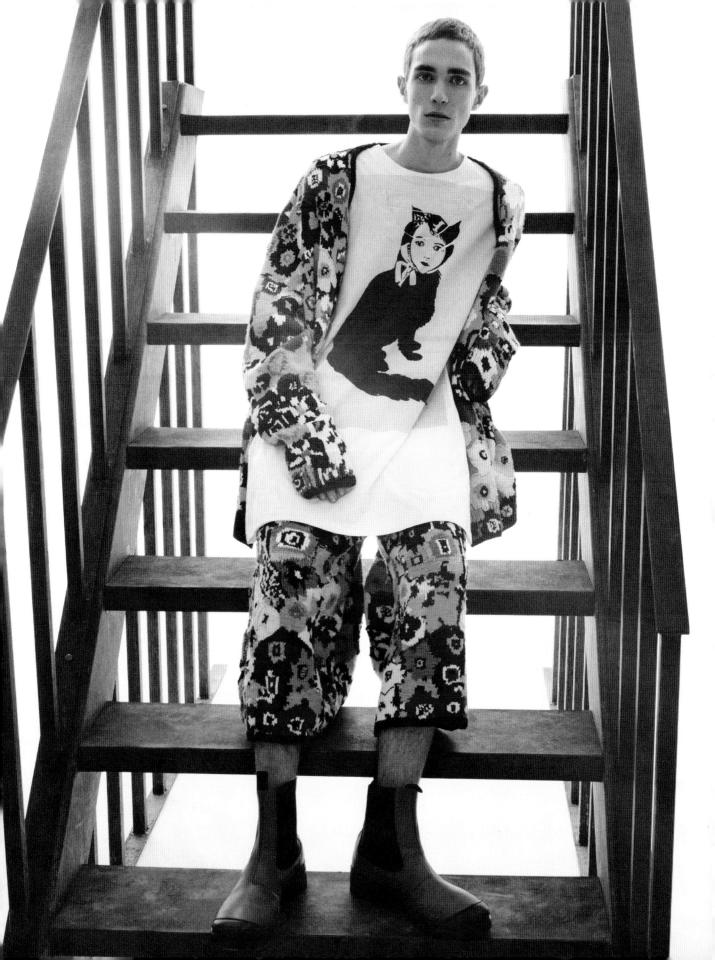

ARTIST-
DESIGNE

ACCESSO

FASHION
RIES

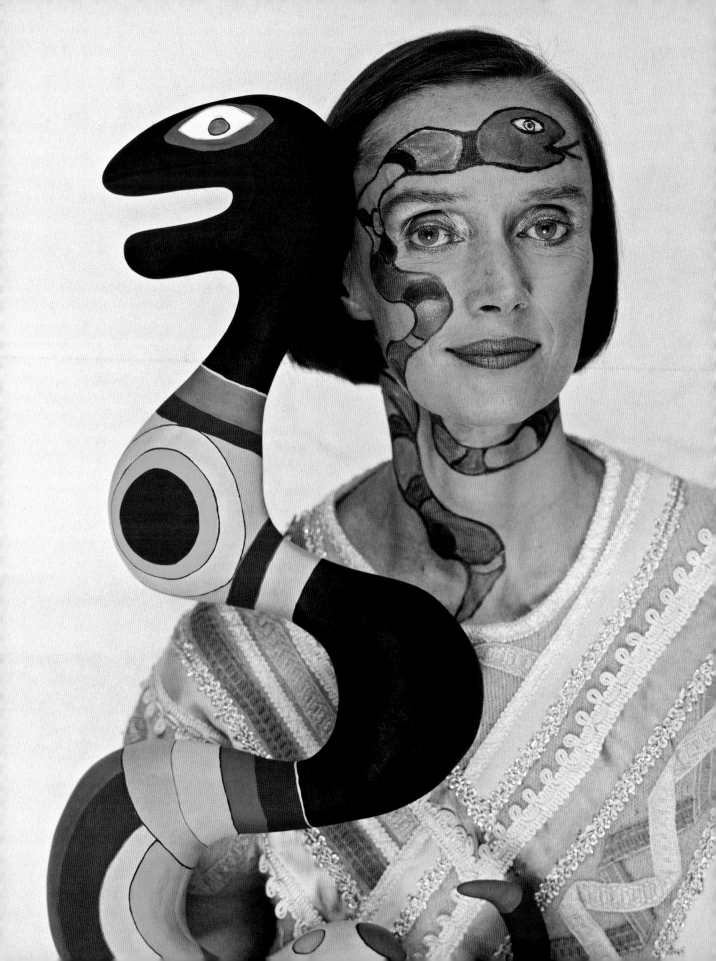

NIKI
DE SAINT PHALLE

Artist with one of her pieces, 1983

———

Double Serpent, 1989

The joyous, colorful art of Niki de Saint Phalle (1930–2002), best known for her sculptural female figures known as *Nanas*, belies a traumatic childhood. The self-taught Saint Phalle, born into an aristocratic family in France and raised mainly in America, became instrumental in France's avant-garde through her violent assemblages, created by shooting packets of paint with firearms. Eventually, she would transition to working on two major motifs: fantastical animals, including serpents, and her voluptuous, goddess-like *Nanas*.

Saint Phalle worked in a variety of media as a sculptor, painter, filmmaker, performance artist, and creator of hand-illustrated books. Perhaps influenced by a short-lived but successful modeling career in the 1970s, she began producing colorful enameled jewelry with GianCarlo Montebello, founder of the Milan-based Gem Montebello. Montebello, who also collaborated on jewelry with Man Ray, made finely crafted items. One of these is Saint Phalle's pin of intertwined snakes, a motif of celebration of the female spirit and sexuality directly influenced by her art.

RENÉ MAGRITTE

The False Mirror, 1929. Museum of Modern
Art, New York

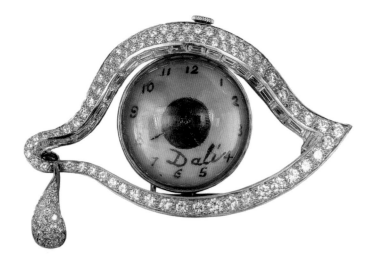

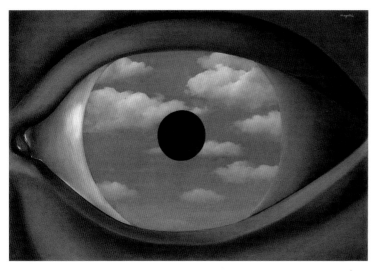

Belgian artist René Magritte (1898–1967) painted objects of our "real" world, taken out of their normal contexts and changed in scale and shape. *The False Mirror* (1929) creates new relationships by showing an eye—a frequent subject in Surrealism—whose interior is an expanse of blue sky. It is, indeed, a false mirror of reality.

Salvador Dalí produced many jewelry designs throughout his career, including six unique jewels he made with influential Italian jeweler Duke Fulco di Verdura. Dalí was obsessed with the passage of time, represented most notably in the melting watches of his most famous painting, *The Persistence of Memory* (1931). With *The Eye of Time* (1949), the artist combined the frequent Surrealist image of the eye—executed in diamonds, platinum, and enamel—with a functional watch.

This photograph by Irving Penn of a pair of earrings by Jean Paul Gaultier, also featuring eyes, showcases Penn's elegance and masterful use of color. The central pictorial idea is derived from Picasso: Penn reorganizes the "reality" of the face by positioning the two enormous eye of Jean Paul Gaultier's earrings on one side of a face in profile.

Penn's picture also illustrates the thought he put into relationships between colors. Every aspect is orchestrated—from the brilliant pink applied to the ear to balance the lime green and vivid yellow of the earrings, to the addition of white above one eye, to the ombré coloration of the slicked-back hair.

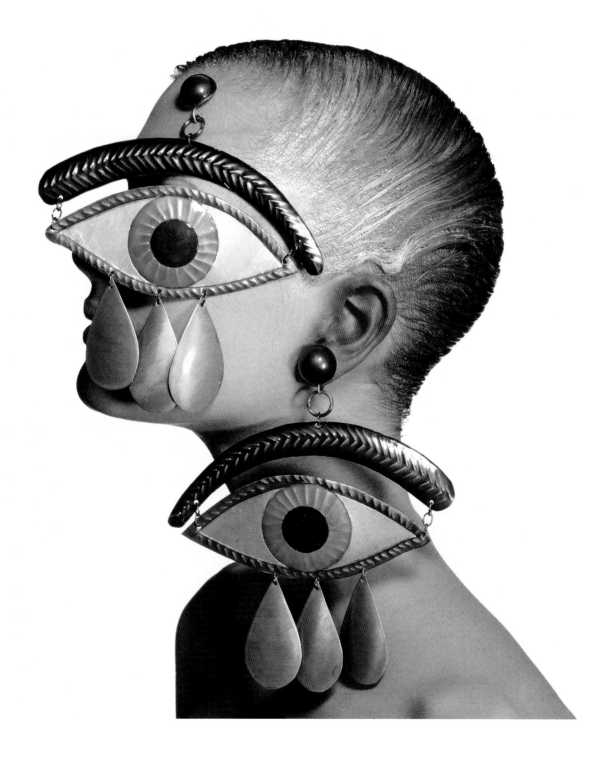

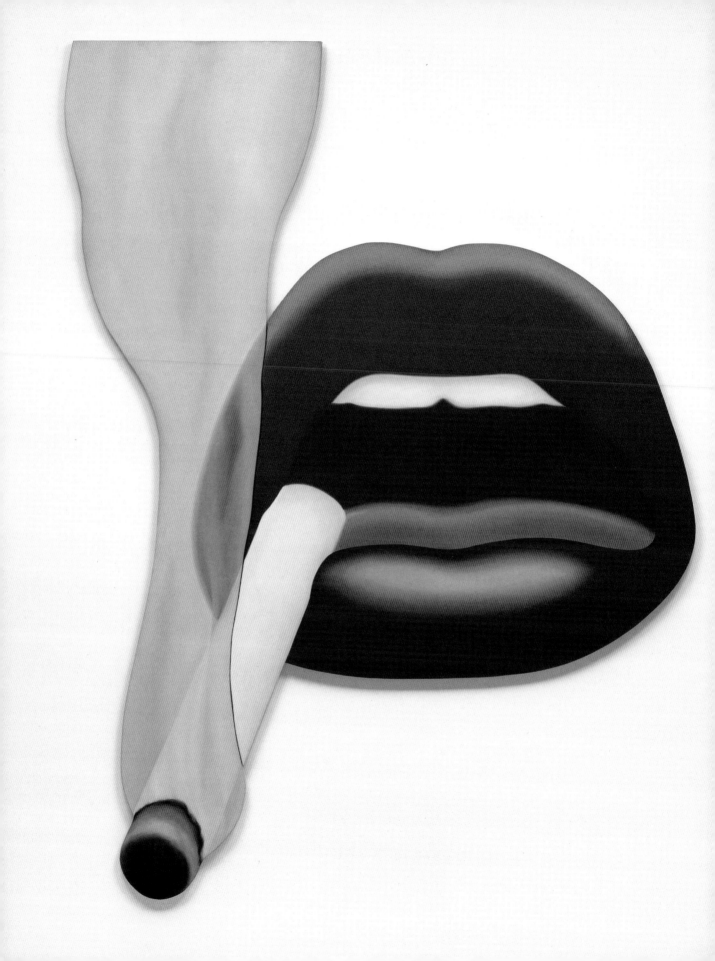

TOM WESSELMANN

Smoker, 1 (Mouth, 12), 1967.
Museum of Modern Art, New York

SALVADOR DALÍ

Ruby Lips, 1949

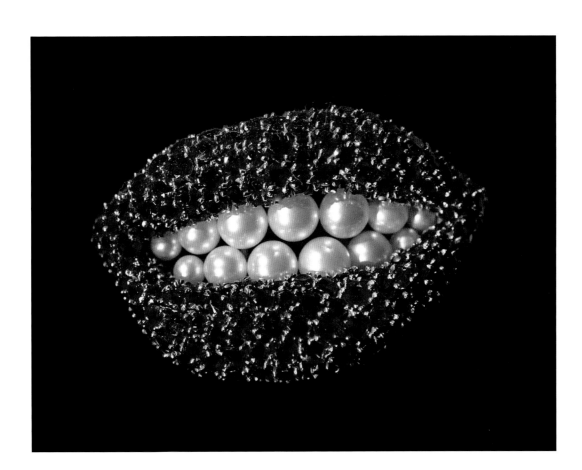

Lips—symbol of eroticism and love—are everywhere in art and fashion. In 1934, Man Ray, jilted lover of Lee Miller, immortalized her disembodied lips in an 8-foot-wide painting. Lips—specifically the lips of American bombshell Mae West—repeatedly appeared in the work of Spanish Surrealist Salvador Dalí.

In 1938, he designed the Mae West lips sofa, commissioned by British poet and Surrealist patron Edward James for his country home. Mae West's lips reappeared in 1949 in one of Dalí's most iconic objects, a sexy brooch with lips made of rubies and teeth of pearls.

Lips became a sign of eroticism in the Pop Art of Tom Wesselmann (1931–2004), particularly in the *Smoker* series, where he combined red-hot lips with a post-coital cigarette. Lips also carried quite a different meaning: one of love.

LOUISE
NEVELSON

Cascade, 1964. San Francisco Museum
of Modern Art

———

Painted wood and metal ring and brooch

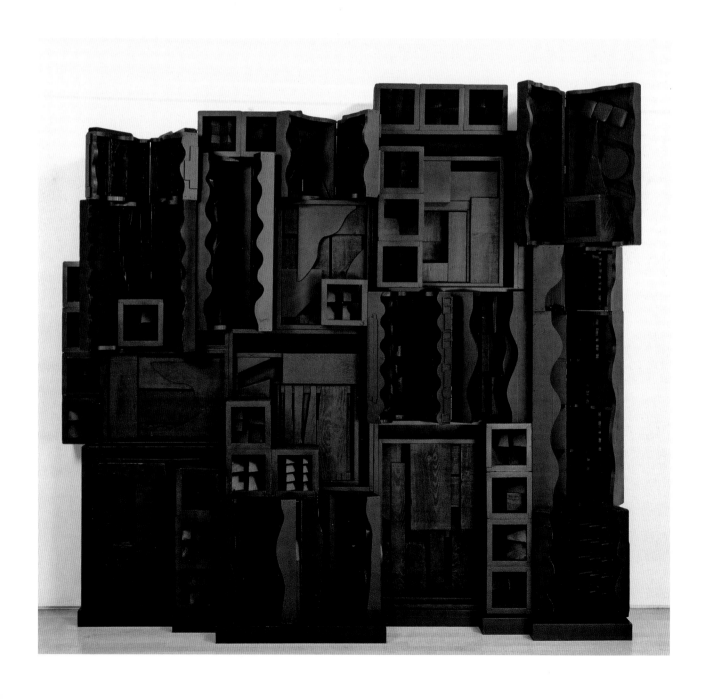

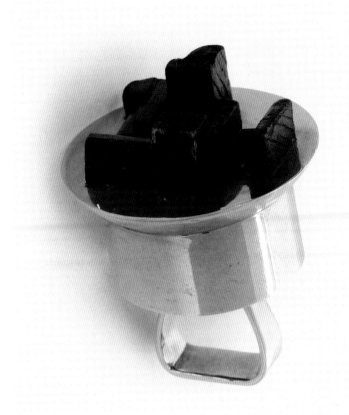

Nevelson used scavenged wood—items such as baseball bat shards, croquet mallet heads, chair backs, banister spindles, sections of crates, and lumberyard detritus—to create sculptures that ranged in size from small reliefs to walls of black boxes that eventually grew to monumental scale. Nevelson pioneered a form of sculpture that was entirely new by combining the concept of junk assemblage explored by Picasso with an insistence on the picture plane that she learned from her teacher, the painter Hans Hofmann. Her found objects were unified, "disguised with a surfeit of paint—all black, all white, or all gold—to foster an elegant uniformity" according to art historian Brooke Kamin Rapaport.

Louise Nevelson made about 200 pieces of her own jewelry—small versions of her assemblages originally executed in wood scraps. In the 1960s and 1970s, Nevelson worked with a metal jeweler to add yellow or white gold to the pieces, and later in the 1980s again to add brass and silver. Gold, which Nevelson had combined with black in her sculptures, was especially provocative to her. "The minute you have gold it takes you over," she once said. "It's splendor. And an abundance. And that abundance is really materialistic."

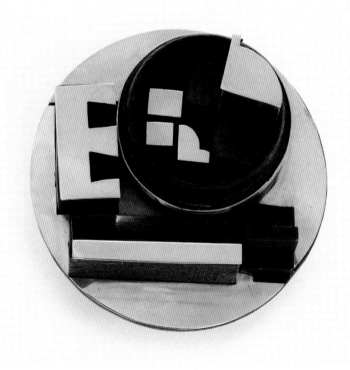

FRANK STELLA

k.304 (full-size)[detail], 2013

———

Untitled (ring), 2010

Frank Stella (b. 1936) burst onto the art scene in 1959 with his *Black Paintings*, minimalist bands of black paint separated by pinstripes of unpainted canvas. The paintings were a shocking turn from Abstract Expressionism, and started the Minimalist movement. Stella moved from innovation to innovation, turning to color and shaped canvases, then to relief, collage, and mixed-media work, and eventually to three-dimensional sculpture. In 2006, he began a series of 3D printed sculptures that mimic the visual rhythm and movement of the harpsichord sonatas of eighteenth-century Italian composer Domenico Scarlatti.

This jewelry by Stella is more than a ring: like the giant entries in the *Scarlatti Sonata* series, it is a complex sculpture. Large for a ring at nearly three inches across, it features coils, lattices, and positive and negative space. The piece consists of twenty-eight separate parts welded together, and took six months to develop. Stella had never designed jewelry until Diane Venet, curator of the 2011 exhibition *Picasso to Koons: Artist as Jeweler* at New York's Museum of Art and Design, asked Stella to make a piece for her collection. He refused, then decided to give Venet an enormous 11-inch-wide necklace of his design, which led to the development of this limited-edition ring, produced in collaboration with Ernest Mourmans and Marc Benda.

PABLO PICASSO

Maquette for Guitar, 1912.
Museum of Modern Art, New York

STEPHEN JONES

John Galliano Spring 2001 Ready-to-Wear

In 1914, Pablo Picasso (1881–1973) made *Guitar*, a radical object that turned sculptural traditions inside out and forged a new direction for the medium. *Guitar* was made of ordinary materials—the sculpture of industrial sheet metal and its maquette of paperboard, paper, string, and wire. It was neither carved nor modeled, nor was it on a pedestal. Instead, it hung high on the wall. In

the words of sculpture expert Joan Pachner, "*Guitar* marks the end of the monolithic tradition, as it forged a new sculptural path in which artists assemble compositions from an array of given shapes."

Stephen Jones's peek-a-boo boater from John Galliano's Picasso collection is a witty recasting of Picasso's *Guitar* into a fashion idiom. The sound hole of the guitar in

Picasso's work is a projecting cylinder that likely derived from an African Grebo mask Picasso had acquired in August 1912, only months before making the *Guitar* maquette. Jones made the sound hole into an opening through which to peer. The brown ribbons recall the guitar's fretboard, and the hat pin supplies further suggestion of the guitar.

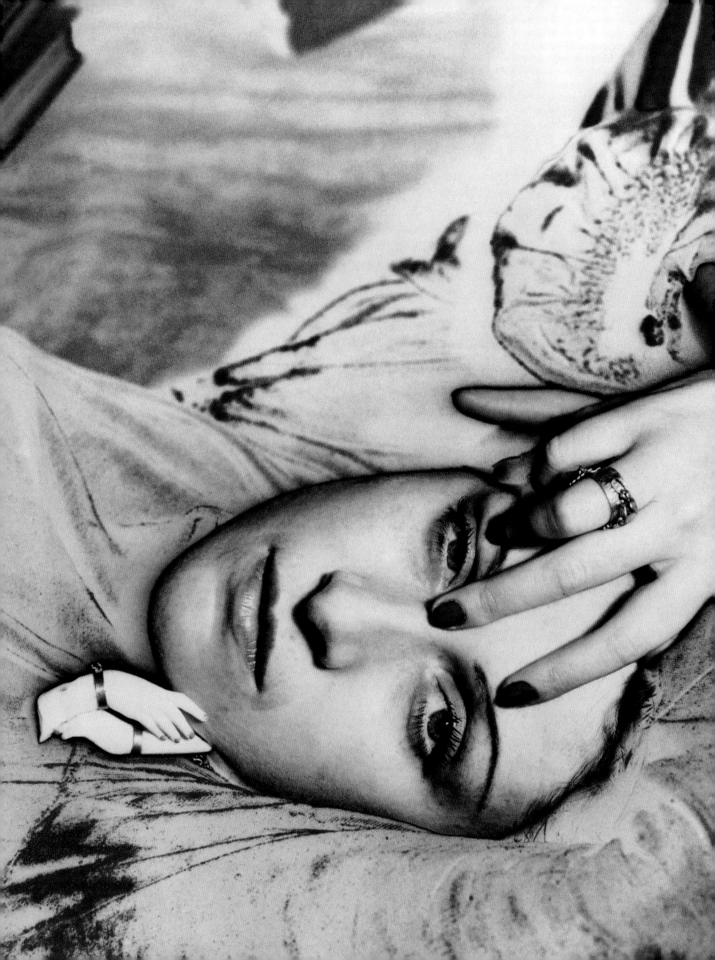

Dora Maar, 1936

JEAN BARTHET
OF PARIS

Hands of Fate hat

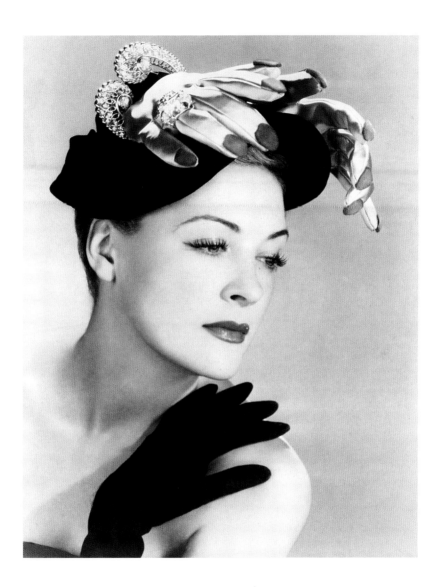

The portrait Man Ray (1890–1976) made of Dora Maar is one of the most evocative Surrealist images. Man Ray—who earned his living in Paris in the 1930s as a fashion and portrait photographer—solarized the photograph, a technique of tone reversal yielding luscious blacks and creating a disembodied head and mysterious background. Maar was a successful fashion, portrait, and documentary photographer in the 1930s. Here,

her long, tapering fingers juxtaposed with a set of tiny white hands create a Surrealist jolt. The photograph was so mesmerizing that on seeing it in Man Ray's studio, Picasso begged Man Ray to trade the photograph for one of his own etchings.

Surrealism was a strong influence on fashion and its photography throughout the 1930s and 1940s. An example is the photograph of the Hands of Fate hat by Jean

Barthet of Paris, also called the Existentialist hat. Barthet became a leading milliner in French haute couture and Hollywood and a favorite of Sophia Loren, Brigitte Bardot, and Audrey Hepburn. This black velvet calotte features two rose satin hands, the hovering hands of fate, accented by a diamond bracelet and an enormous diamond ring, both by the French luxury jeweler Boucheron.

VINTAGE CHINESE CORK LANDSCAPE

Vintage Chinese ornament silhouette made by cork and plastic

PHILIP TREACY
FOR ALEXANDER MCQUEEN

Isabella Blow in 'Chinese Garden' hat, Spring/Summer 2005

Isabella "Izzie" Blow has been called many things: a style icon, a promoter of fledgling designers, an influential stylist, and a true English eccentric. She was all of that and more.

In 1989, Izzie met milliner Philip Treacy and asked him to design an elaborate medieval headdress for her upcoming wedding to Detmar Blow. Their resulting artist-muse collaboration proved to be lasting. Blow would go on to commission and collect Treacy's most avant-garde designs.

Treacy became a leading milliner for haute couture and the British royal family's milliner of choice. His trademark hats are outlandish creations, involving such follies as a head full of butterflies, a lobster, a dead seagull, an elaborate replica sailing ship, and the Japanese temple seen here. In 2002, an exhibition titled *When Philip Met Isabella* opened at the Design Museum in London and subsequently had a traveling schedule that drew a worldwide audience of more than 400,000.

Isabella Blow's suicide was devastating in the fashion world. Alexander McQueen dedicated his Spring 2008 collection, La Dame Bleue, to Blow, and Treacy designed hats for the bird-themed collection. Fashion maverick and heiress Daphne Guinness established a foundation in Blow's name to support emerging talent, and a biopic of Blow has been optioned by Maven Pictures.

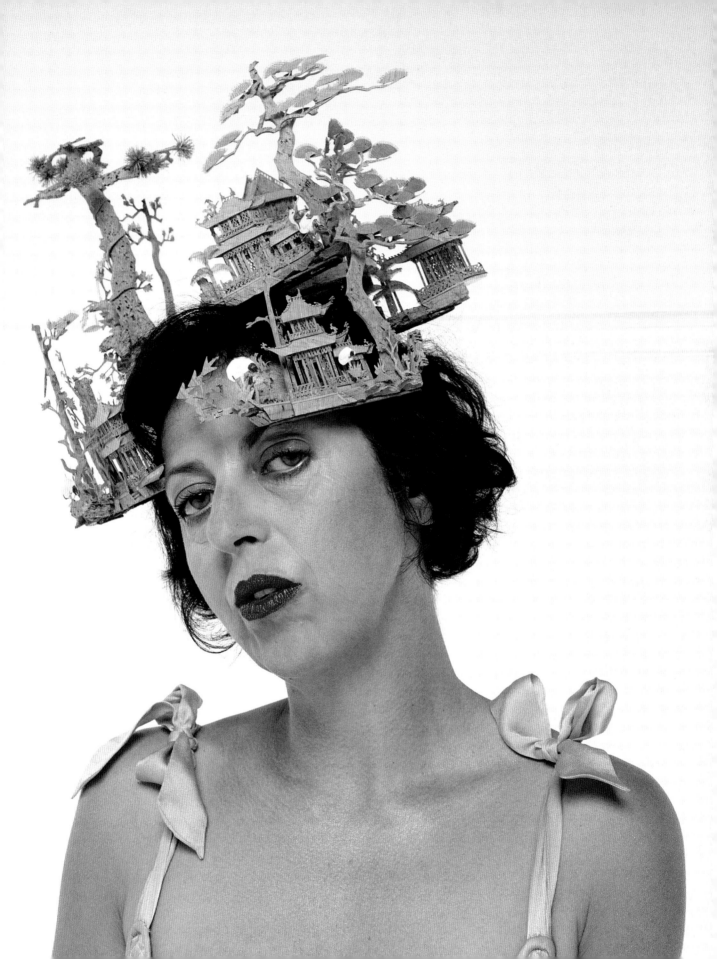

RENÉ MAGRITTE

Le modèle rouge (The Red Model), 1935.
Musée National d'Art Moderne/Centre
Georges Pompidou, Paris

PIERRE CARDIN

Men's Shoes, 1986, France. Gift of Richard
Martin

© Pierre Cardin

René Magritte's (1898–1967) thought-provoking images challenge our idea of what constitutes reality. The Belgian Surrealist depicted ordinary objects changed by unusual contexts: A rose is the size of a room, a still-life is made of stone, and clouds are French baguettes. The viewer relates to the everyday objects yet is surprised by the power of the artist's simple changes.

In Magritte's world, what is interior can be exterior, day can be night, and human feet can transmute into the shoes they usually wear, as in *The Red Model* seen here.

In 1945, Magritte's *The Red Model* was featured on the cover of the second edition of André Breton's *Le Surréalisme et la Peinture* and used in a window display, created by Marcel Duchamp and American

Surrealist Enrico Donati, to promote the book at Brentano's, the New York bookstore. The boots, with toes painted red by Donati, were reproduced. Forty-one years later, French designer Pierre Cardin created leather shoes with articulated toes. Since then, various designers, including Comme des Garçons and Martin Margiela, have produced shoes influenced by Magritte's idea.

JEAN-HONORÉ FRAGONARD

Girl with a Dog, circa 1770.
Alte Pinakothek, Munich

JEFF KOONS ✕ LOUIS VUITTON

Masters Collection handbag, 2017

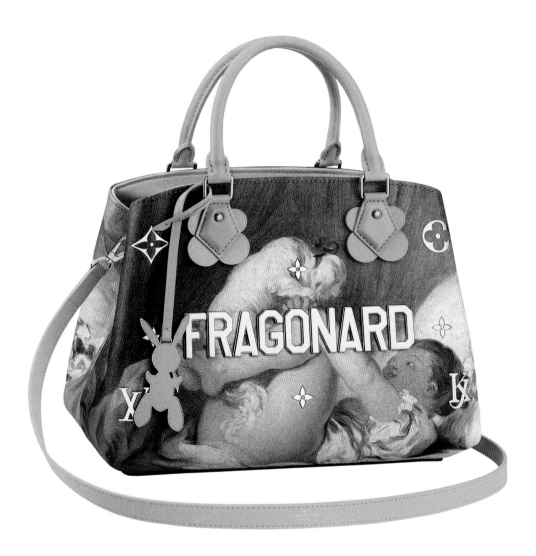

In 1770, French artist Jean-Honoré Fragonard (1732–1806) created the image of a young woman playing with her dog, her bare legs and bottom erotically exposed—the painting chosen by Jeff Koons (b. 1955) for a Louis Vuitton handbag. The choice was pure Koons: a painting by a well-known artist (the artist's name spelled out in large gold letters the width of the bag) used by Koons in the service of commercialism. The eroticism was also typical of Koons, who in 1991 married the porn star Cicciolina and made a series of explicit artworks called *Made in Heaven* that depicted the couple having sex in different positions and outfits.

The dog is a favorite Koons subject. He has made a career using the dog in numerous versions of his stainless steel *Balloon Dog,* as well as a 40-foot-high construction covered in bedding plants called *Puppy,* one version of which is now at the Guggenheim Museum Bilbao.

TAKASHI MURAKAMI

The World of Sphere, (Diptych), 2003

———

Takashi Murakami in collaboration
with Louis Vuitton,
Monogram Panda handbag, 2003
from the Character Bag collection

———

© Takashi Murakami

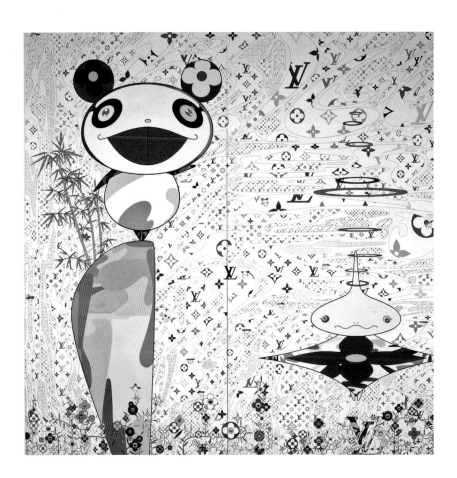

Takashi Murakami (b. 1962) creates art based on principles of two-dimensional imagery in Japanese manga (comics), anime, and Ukiyo-e prints, for which Murakami coined the term "superflat." The word also comments on how issues of social class and popular taste in Japanese society have flattened distinctions between high and low.

In 2002, Murakami, at the invitation of Marc Jacobs, collaborated with Louis Vuitton, reworking the company's monogram and adding his characters to a series of handbags. This collaboration fit neatly into Murakami's superflat concept, blurring the distinction between high art and commercial branding.

Murakami's panda character, drawing on Japanese *kawaii* (cute) culture, mixed with a Pop aesthetic, is the ultimate expression of superflat. The artist used the panda in multiple formats: in paintings such as *The World of Sphere (Diptych)*, the Louis Vuitton Monogram Panda handbag from the Character collection, a short film titled *Superflat Monogram*, and a limited-edition fiberglass *Panda* sculpture, featuring patterns Murakami designed for the LV campaign, that stands on an antique Louis Vuitton trunk.

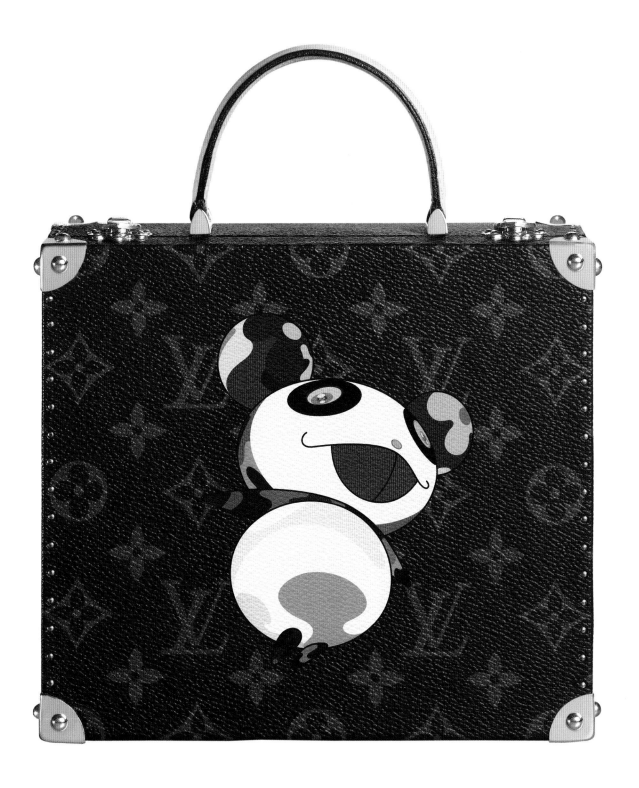

NANCY HALL-DUNCAN

Nancy Hall-Duncan has enjoyed a distinguished career curating and writing on 20th and 21st century art, photography and fashion. She has published extensively in these fields, writing nearly thirty books and catalogs that have been published in four languages. Her groundbreaking 1978 book *The History of Fashion Photography*, winner of the Grand Prix from the Musée Français de la Photographie, was the first full-scale attempt to place fashion in its true relation to art history as a whole.

Hall-Duncan is an art historian trained at the NYU Institute of Fine Arts. As Senior Curator of Art at the Bruce Museum and Associate Curator at the International Museum of Photography at the George Eastman House, she has curated over seventy exhibitions on a broad range of topics in art—from surrealism, the American avant-garde, and fakes and forgeries to cutting-edge art and numerous topics in photography.

Hall-Duncan has appeared on National Public Radio, Radio Free Europe and other TV and radio venues, including an internationally televised CNN gallery tour. She is an engaging and popular lecturer as well as a symposium founder and moderator. She established and currently hosts the Art Talk Table at New York's famed Lotos Club, whose membership includes pre-eminent journalists, scholars, musicians, artists and historians. She has received numerous awards for her work, including grants from the National Endowment for the Arts, the Smithsonian Institution, the Dedalus Foundation and the Cleveland Foundation.

VALERIE STEELE

Valerie Steele is director and chief curator of The Museum at the Fashion Institute of Technology, where she has organized more than two dozen exhibitions since 1997, including *The Corset: Fashioning the Body; Gothic: Dark Glamour; A Queer History of Fashion: From the Closet to the Catwalk; Pink: The History of a Punk, Pretty, Powerful Color;* and *Paris, Capital of Fashion.*

She is also the author or editor of more than 25 books, including *Paris Fashion, Women of Fashion, Fetish: Fashion, Sex and Power, The Corset, The Berg Companion to Fashion*, and. *Fashion Designers A-Z: The Collection of The Museum at FIT.* Her books have been translated into Chinese, French, German, Italian, Portuguese, Russian, and Spanish. In addition, she is founder and editor in chief of *Fashion Theory: The Journal of Dress, Body & Culture*, the first scholarly journal in Fashion Studies.

Steele combines serious scholarship (and a Yale PhD) with the rare ability to communicate with general audiences. As author, curator, editor, and public intellectual, Valerie Steele has been instrumental in creating the modern field of fashion studies and in raising awareness of the cultural significance of fashion. She has appeared on many television programs, including *The Oprah Winfrey Show* and *Undressed: The Story of Fashion.* Described in *The Washington Post* as one of "fashion's brainiest women" and by Suzy Menkes as "The Freud of Fashion," she was listed as one of "The People Shaping the Global Fashion Industry" in the *Business of Fashion 500:* (2014 to the present).

GENERAL

Belcove, Julie. "The Bazaar World of Dalí." *Harper's Bazaar*, December 19, 2012. https://www.harpersbazaar.com/culture/features/g2436/salvador-dali-profile-1212/.

Blanks, Tim. "Raf Simons Fall 2014 Menswear." *Vogue*, January 14, 2014. https://www.vogue.com/fashion-shows/fall-2014-menswear/raf-simons.

Breward, Chris. "Shock of the Frock." *The Guardian*, October 17, 2003. https://www.theguardian.com/artanddesign/2003/oct/18/art.museums.

Cohn, Hana. "The 50 Best Artist Collaborations in Fashion." *Complex*, April 4, 2013. https://www.complex.com/style/2013/04/the-50-best-artist-collaborations-in-fashion/.

Cox, Caroline. *The World Atlas of Street Fashion*. New Haven, CT: Yale University Press, 2017.

Cutler, E. P., and Julien Tomasello. *Art + Fashion: Collaborations and Connections Between Icons*. San Francisco: Chronicle Books, 2015.

Dawson, Dyanna, and J. T. Tran. *Street Fashion Photography: Taking Stylish Pictures on the Concrete Runway*. San Francisco: Chronicle Books, 2013.

Fashion History Timeline. "Fashion History Timeline." Accessed January 1, 2022. https://fashionhistory.fitnyc.edu/.

Fashion Mayann. "Fashion Mayann." Accessed January 1, 2022. https://fashionmayann.wordpress.com/.

French, Jade. "THE ART/FASHION DIVIDE," *kids of dada*, accessed January 2, 2022. https://www.kidsofdada.com/blogs/magazine/15959989-the-art-fashion-divide.

Geczy, Adam, and Vicki Karaminas, eds. *Fashion and Art*. London/New York: Bloomsbury, 2013.

Hall-Duncan, Nancy. *The History of Fashion Photography*. New York: Alpine Book Co., 1979.

Hall-Duncan, Nancy, Joan Pachner, and Bruce Museum. *Innovations in the Third Dimension: Sculpture of Our Time*. Greenwich, CT: Bruce Museum, 2009.

Harrison, Martin. *Appearances: Fashion Photography Since 1945*. New York: Rizzoli, 1991.

The Hepworth Wakefield. "Disobedient Bodies: JW Anderson Curates The Hepworth Wakefield." Accessed January 1, 2022. https://hepworthwakefield.org/whats-on/disobedient-bodies-jw-anderson-curates-the-hepworth-wakefield/.

Jones, Terry, and James Anderson, eds. *Fashion Now*. Cologne: Taschen, 2012.

Kandinsky, Wassily, Vivian Endicott Barnett, and Armin Zweite. *Kandinsky: Watercolors and Drawings*. Munich/New York: Prestel, 1992.

Koda, Harold. *Extreme Beauty: The Body Transformed*. New York: Metropolitan Museum of Art, 2001.

Margolles Garrote, Jorge, ed. *Contemporary Portraits of Fashion, Photography & Jewellery*. Amsterdam: Pepin Press, 2011.

Martin, Richard. *Fashion and Surrealism*. New York: Rizzoli, 1987.

Martin, Richard, and Harold Koda. *Haute Couture*. New York: Metropolitan Museum of Art, 1995.

Martineau, Paul, and J. Paul Getty Museum, eds. *Icons of Style: A Century of Fashion Photography*. Los Angeles: J. Paul Getty Museum, 2018.

Milbank, Caroline Rennolds. *Couture: The Great Designers*. New York: Stewart, Tabori & Chang, 1985.

Oakley Smith, Mitchell, and Alison Kubler. *Art/Fashion in the 21st Century*. New York: Thames & Hudson, 2013.

Rayner, Geoffrey, Richard Chamberlain, and Annamarie Stapleton. *Pop! Design, Culture, Fashion 1955–1976*. Woodbridge, UK: ACC Art Books, 2012.

Sanchez, Serge. *Man Ray*. Paris: Gallimard, 2014.

Sargent, Antwaun. *The New Black Vanguard: Photography Between Art and Fashion*. New York: Aperture, 2019.

Sherman, Cindy. *Cindy Sherman: The Complete Untitled Film Stills*. New York: Museum of Modern Art, 2003.

Skov, Lise, ed. *Berg Encyclopedia of World Dress and Fashion*. New York: Berg, 2010.

Sloman, Paul, ed. *New Fashion Photography*. London/New York: Prestel, 2013.

Tamagni, Daniele, Rosario Dawson, and Abrima Erwiah. *Fashion Tribes: Global Street Style*. New York: Abrams, 2015.

Tonchi, Stefano, Christopher Bagley, and Joseph Logan, eds. *W: The First Forty Years*. New York: Abrams, 2012.

Vogue, ed. *Vogue: Fantasy & Fashion*. New York: Abrams, 2020.

Watt, Judith, ed. *The Penguin Book of Twentieth-Century Fashion Writing*. New York: Viking, 1999.

INDIVIDUAL ARTISTS & DESIGNERS

Giuseppe Arcimboldo
The Art Story.
"Giuseppe Arcimboldo."
Accessed January 26, 2022.
https://www.theartstory.org/
artist/arcimboldo-giuseppe/.

Kaufmann, Thomas DaCosta.
*Arcimboldo: Visual Jokes,
Natural History, and Still-Life
Painting*. Chicago: University
of Chicago Press, 2009.

John Baldessari
Baldessari, John, interview by
Christopher Knight, April 4–5,
1992, Archives of American
Art, Smithsonian Institution,
Washington, D.C.

Baldessari, John, Jessica
Morgan, Leslie Jones, and
Marie de Brugerolle.
John Baldessari: Pure Beauty.
Los Angeles: Los Angeles
County Museum of Art, 2009.

Isabella Blow
Cooke, Rachel. "Blow by Blow:
The Story of Isabella Blow by
Detmar Blow." *The Guardian*,
October 2, 2010.
https://www.theguardian.com/
lifeandstyle/2010/oct/03/
isabella-blow-fashion-
hats-biography.

Dunbar, Polly. "They Blamed
Me for Her Suicide: Style Icon
Isabella Blow's Husband Tells
How He Was Snubbed at Her
Funeral after She Poisoned
Herself with Weedkiller—
Even Though She Had Tried
to Kill Herself Seven Times."

Daily Mail, June 16, 2012.
https://www.dailymail.co.uk/
femail/article-2160304/
Style-icon-Isabella-Blows-
husband-tells-snubbed-
funeral-poisoned-weedkiller--
tried-kill-seven-times.html.

Kellaway, Kate. "Philip Treacy:
'I Like Hats That Make the
Heart Beat Faster.'"
The Guardian, July 9, 2011.
https://www.theguardian.
com/lifeandstyle/2011/jul/10/
philip-treacy-milliner-interview.

Georges Braque
Braque, Georges, Brigitte Léal,
Gary Tinterow, and Alison
de Lima Greene.
Georges Braque, 1882–1963.
Paris: Réunion des musées
nationaux-Grand Palais, 2013.

Wilkin, Karen, and Georges
Braque. *Georges Braque*.
New York: Abbeville Press,
1991.

Constantin Brâncuşi
Georgescu-Gorjan, Sorana,
Ernest Beck, Constantin
Brâncuşi, and World
Monuments Fund,
eds. *Brâncuşi's Endless
Column Ensemble:
Târgu Jiu, Romania*. New York:
World Monuments Fund, 2007.

Tim Burton
Burton, Tim, Ronald
S. Magliozzi, and Jenny He.
Tim Burton. New York:
Museum of Modern Art, 2009.

Alexander Calder
Hall-Duncan, Nancy, and Sam
Hunter. *The Mobile, the Stabile,
the Animal: Wit in the Art
of Alexander Calder*.
Greenwich, CT:
Bruce Museum, 1995.

John Chamberlain
Judd, Donald, "In the Galleries."
In *Donald Judd: Complete
Writings 1959–1975*. New York:
Judd Foundation, 2015.

Coco Chanel
Nicolau, Amalia. "Chanel
& Sports." Esta boca es
mía, November 9, 2014.
https://estabocaesmia.
net/2014/11/09/chanel-sports/.

Misty Copeland
Mooallem, Stephen.
"Misty Copeland and Degas:
Art of Dance." *Harper's Bazaar*,
February 10, 2016.
https://www.harpersbazaar.
com/culture/art-books-music/
a14055/misty-copeland-
degas-0316/

Salvador Dalí
Fashion History Timeline.
"1930–1939." Accessed
January 1, 2022.
https://fashionhistory.fitnyc.
edu/1930-1939/.

Frazier, Nancy. "Salvador Dalí's
Lobsters: Feast, Phobia, and
Freudian Slip."
Gastronomica 9, Nº 4
(November 2009): 16–20.
https://doi.org/10.1525/
gfc.2009.9.4.16.

Edgar Degas
Gordon, Robert, Andrew Forge,
and Edgar Degas. *Degas*.
New York: Abrams, 1988.

Kendall, Richard, and Jill
Devonyar. *Degas and the
Ballet: Picturing Movement*.
London: Royal Academy
of Arts, 2011.

Schneider, Karen. "Degas
and Pastels, Part I." Phillips
Collection, December 20, 2011.
https://blog.phillipscollection.
org/2011/12/20/degas-and-
pastels-part-i/.

Schneider, Karen. "Degas
and Pastels, Part II." Phillips
Collection, December 21, 2011.
https://blog.phillipscollection.
org/2011/12/21/degas-and-
pastels-part-ii/.

Sonia Delaunay
Jamie, Kathleen. "Sonia
Delaunay: The Avant-garde
Queen of Loud, Wearable Art."
The Guardian, March 27, 2015.
https://www.theguardian.com/
artanddesign/2015/mar/27/sonia-
delaunay-avant-garde-queen-
art-fashion-vibrant-tate-modern.

Nathan, Emily. "Sonia
DeLaunay (1885–1979):
Reaping What She Sews."
Hazel Home Art and
Antiques, July 14, 2015.
http://hazelhomeartandantiques.
blogspot.com/2015/07/
sonia-delaunay-1885-1979
reaping-what.html.

Fortunato Depero
Braun, Emily. "Futurist Fashion: Three Manifestoes." *Art Journal* 54, Nº 1 (March 1995): 34–41. https://doi.org/10.1080/00043 249.1995.10791674.

Christian Dior
Charlesworth, Harry. "Dior And Impressionism: A Love affair." impressionistaa, October 26, 2014. https:// impressionistaa.tumblr.com/ post/101055865206/dior-and-impressionism-a-love-affair.

Martin, Richard, and Harold Koda. *Christian Dior*. New York: Metropolitan Museum of Art, 1996.

Dolce & Gabbana
Casadio, Mariuccia. *Dolce & Gabbana: Fashion Album*. Milan: Skira, 2006.

Leitch, Luke, and Ben Evans. *Vogue on Dolce & Gabbana*. London: Quadrille Publishing, 2017.

Marcel Duchamp
Grovier, Kelly. "The Urinal That Changed How We Think." BBC, April 11, 2017. https://www.bbc.com/culture/ article/20170410-the-urinal-that-changed-how-we-think.

Emilie Flöge
Bahr, Caitlin J. Perkins. "Women and the Wiener Werkstätte: The Centrality of Women and the Applied Arts in Early Twentieth-Century Vienna." MA thesis, Brigham Young University, 2013.

"Before Coco Chanel There Was Emilie Flöge: A Designer the Fashion Industry Forgot." *Harper's Bazaar*, September 20, 2017. https://harpersbazaar. my/lifestyle/culture/coco-chanel-emilie-floge-designer-fashion-industry-forgot/.

John Galliano
Sischy, Ingrid. "Galliano in the Wilderness," *Vanity Fair*, July 2013. https://archive.vanityfair.com/ article/2013/7/galliano-in-the-wilderness.

Jean Paul Gaultier
Loriot, Thierry-Maxime, and Montreal Museum of Fine Arts, eds. *The Fashion World of Jean Paul Gaultier: From the Sidewalk to the Catwalk*. Montreal: Museum of Fine Arts, 2011.

Mower, Sarah. "Jean Paul Gaultier Spring 2003 Ready-to-Wear." *Vogue*, October 4, 2002. https://www.vogue.com/ fashion-shows/spring-2003-ready-to-wear/ jean-paul-gaultier.

Matt Groening
Sheff, David. "Matt Groening." *Playboy*, June 2007. https://web.archive.org/ web/20071013165626/ http://playboy.com/arts-entertainment/features/ matt-groening/matt-groening-01.html.

Keith Haring
Phillips, Natalie E. "The Radiant (Christ) Child: Keith Haring and the Jesus Movement." *American Art* 21, Nº 3 (Fall 2007): 54–73. https://doi.org/10.1086/526480.

Vogue Paris, "Keith Me." November 2009, cover and pp. 130-141.

Katsushika Hokusai
Lane, Richard. *Hokusai: Life and Work*. London: Barrie & Jenkins, 1989.

Grace Jones
Sawyer, Miranda. "State of Grace." *The Guardian*, October 10, 2008. https://www. theguardian.com/music/2008/ oct/12/grace-jones-hurricane.

Stephen Jones
Jones, Stephen. *Dior Hats: From Christian Dior to Stephen Jones*. New York: Rizzoli, 2020.

Sporn, Stephanie. "How Dior and Stephen Jones Perfected the Art of the Hat." *Galerie*, August 31, 2020. https://galeriemagazine.com/ dior-stephen-jones-art-of-the-hat-book/.

Frida Kahlo
Martínez Vidal, Susana. *Frida Kahlo: Fashion as the Art of Being*. New York: Assouline, 2016.

McConnell, Kyra. "The Importance of Frida Kahlo's Clothes." *CR Fashion Book*, July 6, 2020. https://www.crfashionbook. com/culture/a33087827/ frida-kahlo-fashion-mexican-identity/.

Wassily Kandinsky
Solomon R. Guggenheim Museum and HIlla von Rebay Foundation, eds. *Kandinsky Watercolors*. New York: Solomon R. Guggenheim Foundation, 1980.

Donna Karan
Michault, Jessica. "Donna Karan Ready to Wear Spring Summer 2015 New York." *Now Fashion*.

Phelps, Nicole. "Donna Karan Spring 2015 Ready-to-Wear Collection." *Vogue*, September 8, 2014. https://www.vogue.com/ fashion-shows/spring-2015-ready-to-wear/ donna-karan.

KAWS (Brian Donnelly)
Celant, Germano. *KAWS*. New York: Rizzoli, 2022.

André Kim
Min, Ines. "Saying Goodbye to Andre Kim." *The Korea Times*, August 13, 2010. https://www.koreatimes.co.kr/ www/culture/2022/01/ 199_71393.html.

Onishi, Norimitsu. "A Longtime Shepherd of Korean Fashion." *New York Times*, September 15, 2007. https://www.nytimes.com/2007/09/15/world/asia/15kim.html.

Gustav Klimt
Brandstatter, Christian. *Klimt & Fashion*. New York: Assouline, 2003.

O'Connor, Anne Marie. *The Lady in Gold: The Extraordinary Tale of Gustav Klimt's Masterpiece, Portrait of Adele Bloch-Bauer*. New York: Vintage, 2015.

Yves Klein
Schjeldahl, Peter. "True Blue." *The New Yorker*, June 21, 2010. https://www.newyorker.com/magazine/2010/06/28/true-blue-3.

Franz Kline
Gaugh, Harry F. *Franz Kline*. New York: Abbeville Press, 1996.

Sandler, Irving. *The Triumph of American Painting: A History of Abstract Expressionism*. New York: Harper & Row, 1990.

Jeff Koons
Jones, Jonathan. "Jeff Koons' Louis Vuitton Bags: A Joyous Art History Lesson." *The Guardian*, April 12, 2017. https://www.theguardian.com/artanddesign/jonathanjonesblog/2017/apr/12/jeff-koons-louis-vuitton-bags-fashion-fragonard-rubens-titian.

Yayoi Kusama
Judah, Hettie. "Inside an Artist Collaboration," *Business of Fashion*, October 22, 2016. https://www.businessoffashion.com/articles/news-analysis/inside-an-artist-collaboration/.

Christian Lacroix
Borrelli-Persson, Laird. "Christian Lacroix Shares His Personal Highlights From a Life in the Haute Couture." *Vogue*, October 30, 2019. https://www.vogue.com/slideshow/christian-lacroix-picks-highlights-from-his-22-years-of-designing-couture.

Karl Lagerfeld
Moss, Charlotte. "The Old-World Artistry Behind the Modern House of Chanel," *Wall Street Journal Magazine*, May 2011.

Louis Vuitton
Cadogan, Dominic. "Louis Vuitton's Best Cult Art Collaborations." *Dazed*, April 13, 2017. https://www.dazeddigital.com/fashion/article/35567/1/louis-vuitton-art-collaborations-yayoi-kusama-richard-prince-cindy-sherman.

René Magritte
Sylvester, David. *Magritte*. New York: Abrams, 2010.

Man Ray
Man Ray. *Self-Portrait*. London: Penguin Classics, 2012.

Claude Monet
de Montebello, Philippe. *Monet's Years at Giverny: Beyond Impressionism*. New York: Metropolitan Museum of Art, 1978.

King, Ross. *Mad Enchantment: Claude Monet and the Painting of the Water Lilies*. New York: Bloomsbury, 2016.

Edvard Munch
Hall-Duncan, Nancy, and Robert Rosenblum. *Love, Isolation and Darkness: The Art of Edvard Munch*. Greenwich, CT: Bruce Museum, 1996.

Takashi Murakami
Schimmel, Paul ed. *©Murakami*. Los Angeles: Los Angeles Museum of Contemporary Art, 2007.

Wu, Ai-Ling. "Superflat Adds Complex Layers of Meaning to the 'Flattened Surface.'" CCTP 802 – Art and Media Interfaced, Spring 2017. Accessed January 2, 2022. https://blogs.commons.georgetown.edu/cctp-802-spring2017/author/aw1014/.

Louise Nevelson
Nevelson, Louise. *Dawns and Dusks: Taped Conversations with Diana Mackown*. N.P.: Encore Editions, 1980.

Rapaport, Brooke Kamin, ed. *The Sculpture of Louise Nevelson: Constructing a Legend*. New Haven: Yale University Press, 2007.

Sporn, Stephanie. "Louise Nevelson's Rare Jewelry Transforms Found Objects into Miniature Wearable Sculpture," *Galerie*, May 27, 2020. https://galeriemagazine.com/louise-nevelson-jewelry-by-artists/.

Guo Pei
Thurman, Judith. "The Empire's New Clothes," *The New Yorker*, March 14, 2016. https://www.newyorker.com/magazine/2016/03/21/guo-pei-chinas-homegrown-high-fashion-designer.

Wallace, Paula, ed. *Guo Pei: Couture Beyond*. New York: Rizzoli Electa, 2018.

Irving Penn
Hambourg, Maria Morris, and Jeff L. Rosenheim, eds. *Irving Penn: Centennial*. New York: Metropolitan Museum of Art, 2017.

Penn, Irving. *Passage: A Work Record*. New York: Knopf, 1991.

Pablo Picasso
Richardson, John, Pablo Picasso, and Marilyn McCully. *A Life of Picasso 3: The Triumphant Years, 1917–1932*. New York: Knopf, 2007.

Rubin, William. *Picasso and Braque: Pioneering Cubism*. New York: Museum of Modern Art, 1989.

Paul Poiret
Koda, Harold, and Andrew Bolton. *Poiret*. New York : Metropolitan Museum of Art, 2007.

Poiret, Paul. *King of Fashion: The Autobiography of Paul Poiret*. London: V&A, 2009.

Gerhard Richter
Richter, Gerhard. *Gerhard Richter: Panorama*. London: D.A.P./Tate, 2016.

Bridget Riley
Follin, Frances. *Embodied Visions: Bridget Riley, Op Art and the Sixties*. London: Thames & Hudson, 2004.

Riley, Bridget. *Bridget Riley: Works 1961-1966*. London: Ridinghouse, 2012.

Sterling Ruby
Prickett, Sarah Nicole. "Raf & Ruby." *T The New York Times Style Magazine*, June 10, 2014. https://www.nytimes.com/2014/06/10/t-magazine/raf-simons-sterling-ruby-dior-hauser-wirth.html.

Yves Saint Laurent
Musée Yves Saint Laurent Paris. https://museeyslparis.com/.

Elsa Schiaparelli
Talley, André Leon. *Schiaparelli and the Artists*. New York: Rizzoli, 2017.

Cindy Sherman
Axelrod, Nick. "Cindy Sherman Wears Chanel," *Women's Wear Daily*, August 31, 2010.

Brown, Laura. "Cindy Sherman: Street-Style Star." *Harper's Bazaar*, February 9, 2016. https://www.harpersbazaar.com/culture/features/a14005/cindy-sherman-0316/.

"Cindy Sherman Shoots Fashion for Harper's Bazaar," PhotoEphemera, November 16, 2009. https://photemera.blogspot.com/2009/11/cindy-sherman-shoots-fashion-for.html.

Esslemont, Chloe, "A Brief History of Cindy Sherman's Relationship with Fashion." *Dazed*, September 12, 2019. https://www.dazeddigital.com/fashion/article/45967/1/cindy-sherman-fashion-collaborations-inspirations-comme-des-garcons-supreme.

"Fashion, Cindy Sherman." Art21, September 9, 2011. https://art21.org/watch/extended-play/cindy-sherman-fashion-short/.

Stansfield, Ted, "Cindy Sherman Turns Mock Street-Style Star for Harper's." *Dazed*, February 12, 2016. https://www.dazeddigital.com/fashion/article/29782/1/cindy-sherman-turns-mock-street-style-star-for-harper-s.

Benjamin Shine
Real, Carolina. "Benjamin Shine: Creative, Explorer and Inventor." *Art Summit*, May 8, 2018. https://www.art-summit.com/benjamin-shine-the-fabric-sculptor/.

Raf Simons
Nast, Condé. 'Raf Simons Fall 2014 Menswear Collection'. Vogue, 15 January 2014. https://www.vogue.com/fashion-shows/fall-2014-menswear/raf-simons.

Edward Steichen
Ewing, William A., and Todd Brandow. *Edward Steichen: In High Fashion, the Condé Nast Years, 1923–1937*. Minneapolis: Foundation for the Exhibition of Photography, 2008.

Frank Stella
Editors. "Frank Stella at Paul Kasmin Gallery." *artcritical*, September 20, 2009. https://artcritical.com/2009/09/20/frank-stella-at-paul-kasmin-gallery/.

Laster, Paul. "Frank Stella." *Sculpture*, April 12, 2021. https://sculpturemagazine.art/frank-stella/.

L'Ecuyer, Kelly H., Gerald W. W. Ward, Yvonne J. Markowitz, and Michelle Tolini Finamore. *Jewelry by Artists: In the Studio, 1940–2000*. Boston: MFA Publications, 2009.

Mickalene Thomas
Sacharow, Anya, and Shawn Dahl. *Brooklyn Street Style: The No-Rules Guide to Fashion*. New York: Abrams, 2015

William Van Alen
Gray, Christopher. "Streetscapes/William Van Alen; An Architect Called the 'Ziegfeld of His Profession.'" *New York Times*, March 22, 1998. https://www.nytimes.com/1998/03/22/realestate/streetscapes-william-van-alen-an-architect-called-the-ziegfeld-of-his-profession.html.

Iris van Herpen
Borrelli-Persson, Laird. "10 Questions for Iris van Herpen as She Prepares to Celebrate 10 Years of Fashion Innovation at Couture." *Vogue*, June 30, 2017. https://www.vogue.com/article/iris-van-herpen-haute-couture-anniversary-interview.

Mead, Rebecca. "Iris van Herpen's Hi-Tech Couture." *The New Yorker*, September 18, 2017. https://www.newyorker.com/magazine/2017/09/25/iris-van-herpens-hi-tech-couture.

Tess. "Iris van Herpen's astonishing 3D printed fashion arrives at the High Museum of Art." 3ders, November 12, 2015. https://www.3ders.org/articles/20151111-atlanta-high-museum-of-art-3d-printed-fashion-designer-iris-van-herpen.html.

Victor Vasarely
Werner, Spies. *Victor Vasarely*. New York: Abrams, 1971.

Gianni Versace
"Evening Dress,"
Metropolitan Museum of Art.
https://www.metmuseum.org/
art/collection/search/83250.

Viktor & Rolf
Verner, Amy. "Viktor & Rolf
Fall 2015 Couture." *Vogue*,
July 8, 2015. https://www.
vogue.com/fashion-shows/
fall-2015-couture/viktor-rolf

Francesco Vezzoli
"Agents Provocateurs."
W Magazine, November 1, 2011.
https://www.wmagazine.com/
story/nicki-minaj-transformed-
by-francesco-vezzoli.

Tim Walker
Walker, Tim, and Robin Muir.
Tim Walker: Story Teller.
New York: Thames & Hudson,
2021.

Andy Warhol
Bürgi, Bernhard, Nina Zimmer,
and Maren Stotz. *Andy Warhol:
The Early Sixties—Paintings
and Drawings, 1961–1964*.
Ostfildern: Hatje Cantz Verlag,
2010.

Junya Watanabe
Borrelli-Persson, Laird.
"Shower Power: Revisiting
Junya Watanabe's Rain-Soaked
Spring 2000 Collection,"
Vogue, April 1, 2021.
https://www.vogue.com/
article/revisiting-junya-
watanabe-s-rain-soaked-
spring-2000-collection.

Fury, Alexander. Junya
Watanabe, One of Fashion's
Foremost Thinkers." *New York
Times Style Magazine*.
https://www.nytimes.
com/2016/10/17/t-magazine/
junya-watanabe-interview.html.

Smith, Roberta. "The Angel in
the Architecture." *New York
Times*, September 17, 2009.
https://www.nytimes.com/
2009/09/18/arts/design/
18kandinsky.html.

CREDITS

A book is a creation that requires the support and assistance of many people to become a reality. I would first and foremost like to thank Dr. Valerie Steele, my dear friend and longtime professional colleague, who wrote the book's preface and was an unending source of encouragement and invaluable fashion guidance. I am also deeply indebted to three colleagues who helped from the conception to completion of the project: Harold Koda, fashion scholar and former curator-in-chief of the Anna Wintour Costume Center at the Metropolitan Museum of Art; Shawn Waldron, curator of print sales and exhibitions, Getty Images; and Diana Edkins of Art Resource.

This book would not exist without the indispensable help of Ann Tanenbaum, founder and president of Tanenbaum International Literary Agency, and Kate Ellsworth, executive/editorial assistant, who guided the book from inception through every phase of development.

Of special note are the efforts of many professionals who contributed to the book's scholarship with their ideas and expertise. My thanks to Karen Hayward, specialist in Asian art; Hyonjeong "HJ" Kim Han, Joseph de Heer Curator of Asian Art at the Denver Art Museum; Escher expert Jeffrey Price of Artists' Market at Coventry Studio; Egyptologist Dr. Diana Larkin; Dr. Joan Pachner, sculpture expert and author of the Tony Smith catalogue raisonné; art historian Dr. Suzanne Stratton-Pruitt; Martine and Didier Haspeslagh of Didier Ltd.; and the knowledgeable librarians at the Art and Artifacts Division of the New York Public Library and the Thomas J. Watson Library at the Metropolitan Museum of Art for their help with countless research questions. Photographer and multifaceted expert Melitte Buchman deserves my gratitude for patiently helping me with a multitude of technical questions. Dr. Isabel Pavão-Horvath deserves special thanks for tirelessly reading and commenting on the manuscript.

I am particularly grateful to those who lent their special talents to the actualization of the book. Foremost are the professionals at Rizzoli International, whose publishing experience guided every aspect of this volume. I am grateful to publisher Charles Miers for his support and guidance and to Margaret Chace, associate publisher, who generously dedicated her time and talents to this book's creation. My heartfelt thanks to editor Loren Olson, who dedicated herself to the complex oversight of making this a book of quality, beauty, and edification. Thanks as well to production manager Alyn Evans for her significant contributions and to the designers of Studio Pilote Paris, for their stunning and memorable design. Image editor Supriya Malik deserves special praise for her unstinting efforts in securing the book's images from diverse sources. In this regard, we would like to thank Cole Hill at Condé Nast licensing; Mary Ellen Jensen at Alamy; Paola Ferrario at IMAXtree; Michael Mandel at Shutterstock; Diana Reeve at Art Resource; Remi Rebillard; Hauser & Wirth gallery, Brandi Pomfret at Tim Burton Productions; Melanie at Benjamin Shine's studio; Talia Rosen at Pace Gallery; Anthony Vessot at Louis Vuitton; Melissa Marra-Alvarez at FIT; David Arkin at KAWS's studio; Madeleine Paré at Xavier Hufkens; and Tonya Blazio-Licorish, archives content developer at PMC.

Finally, my personal thanks go to my entire family for their support and love, especially my triplet sons Alexander, Christopher, and Bradford, who are the source of my inspiration.

Nancy Hall-Duncan

First published in the
United States of America in 2022 by

Rizzoli Electa
A Division of Rizzoli International
Publications, Inc.
300 Park Avenue South New York,
NY 10010
www.rizzoliusa.com

Copyright © 2022 by Nancy Hall-Duncan

Publisher: Charles Miers
Associate publisher: Margaret Chace
Editor: Loren Olson
Copy editor: Natalie Danford
Fashion history advisor: Natalie Nudell
Production manager: Alyn Evans

Designed by Pilote Paris
(Yannick James, Mathieu Mermillon &
Yannis Pérez assisted by Félix Farjas)

2022 2023 2024 2025 / 10 9 8 7 6 5 4 3 2 1

Printed in Hong Kong

ISBN-13: 978-0-8478-7239-8
Library of Congress Control Number:
2022938069

Facebook.com/RizzoliNewYork
Twitter @Rizzoli_Books
Instagram.com/RizzoliBooks
Pinterest.com/RizzoliBooks
Youtube.com/user/RizzoliNY
Issuu.com/Rizzoli